The

CLUTIUS BOTANICAL
WATERCOLORS

PLANTS AND FLOWERS
OF THE RENAISSANCE

Brionia vehs alba

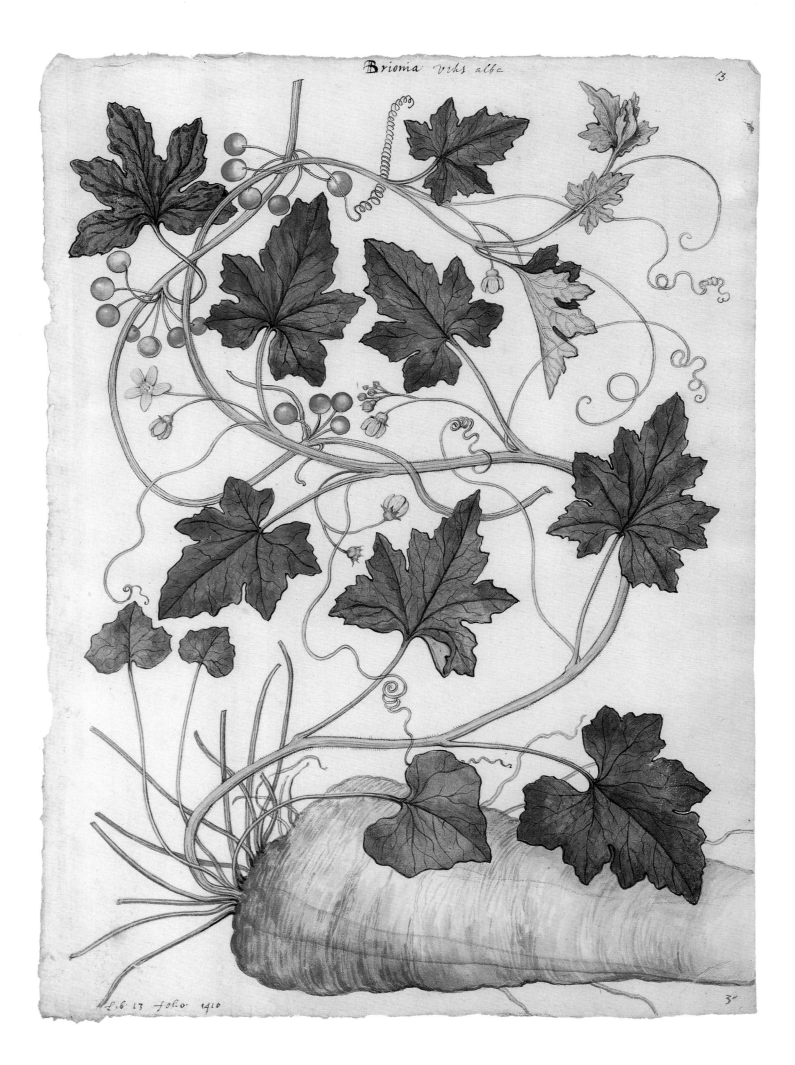

Lib 13 folio 1410

The CLUTIUS BOTANICAL WATERCOLORS

PLANTS AND FLOWERS OF THE RENAISSANCE

Claudia Swan

HARRY N. ABRAMS, INC., PUBLISHERS

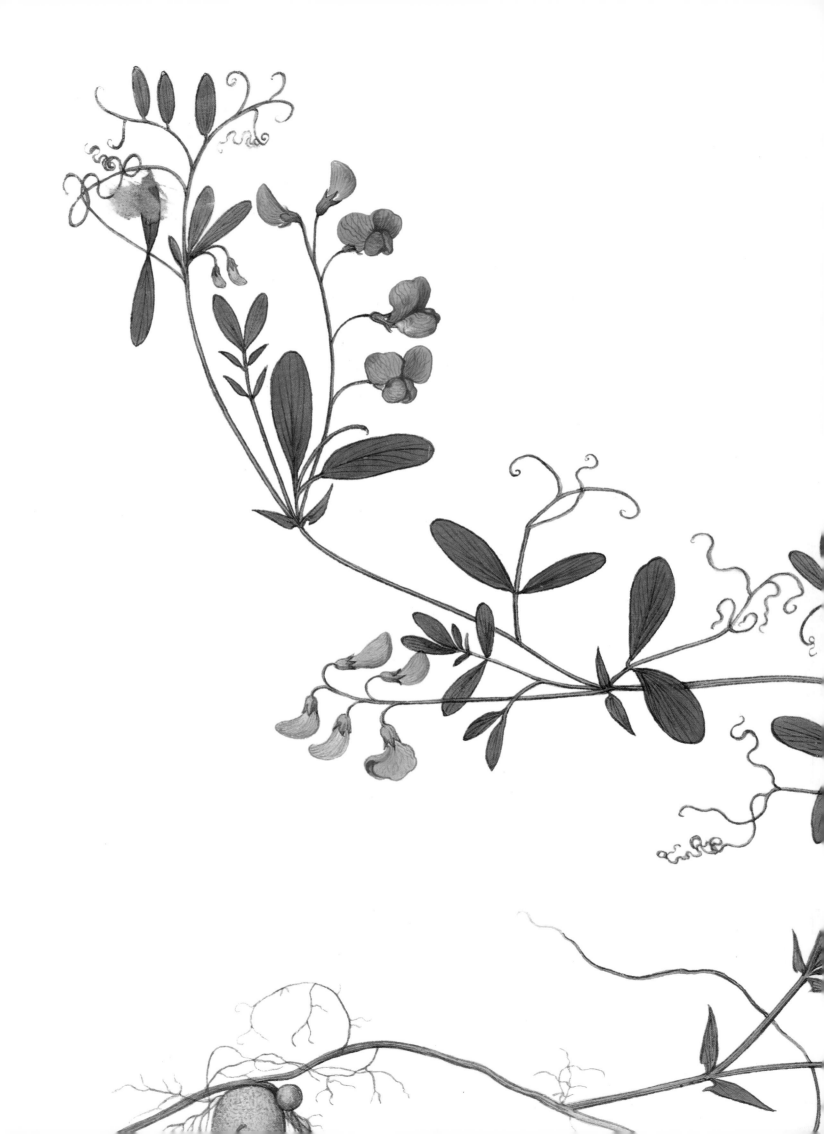

CONTENTS

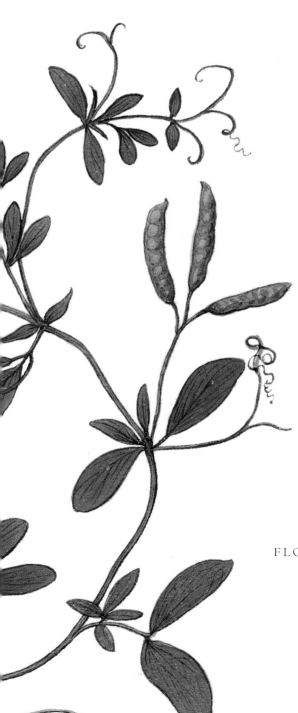

ACKNOWLEDGMENTS

In the autumn of 1993 I traveled to Kraków, Poland, for the first time to view the watercolors contained in the volumes known as the *Libri picturati* A.18–A.30 in the Jagiellon University Library. Hailed as the most significant body of sixteenth-century botanical illustrations produced in the Netherlands, they had been studied only intermittently and very few had been published. According to the scant existing literature, these nearly two thousand paintings on paper were made for the renowned Flemish naturalist Carolus Clusius sometime after 1560. I traveled east from Amsterdam in the hope of expanding my familiarity with Netherlandish natural-historical imagery of the time, the subject of my doctoral dissertation. My expectations were vastly exceeded by what I found in Kraków: Not only were the images spectacularly beautiful, but I realized, studying them, that they matched a description of paintings owned by the fairly obscure pharmacist Dirck Outgaertsz. Cluyt (Theodorus Clutius) at his death in 1598. Throughout my subsequent research and during the preparation of this book, a number of individuals and institutions have offered their generous support and earned my gratitude.

I first went to eastern Europe on a travel fellowship from the Samuel H. Kress Foundation, and conducted related research while supported by grants from the Center for Advanced Study in the Visual Arts (National Gallery of Art), the Fulbright Foundation, the Friends of the Mauritshuis, and the Whiting Foundation. Piotr Hordynski and Marta Jaworska of the Jagiellon Library in Kraków have been unremittingly generous with their time and expertise; without their help this publication would not have been possible. Henriette Bosman-Jelgersma's research on Clutius was the foundation of my own, and her enthusiasm made it pleasurable. The staffs of the Rare Books Room at the University of Amsterdam Library, the Dousa Zaal and the Rijksherbarium at Leiden University, and the Rijksprentenkabinet in Amsterdam have been consistently helpful. Other friends and colleagues who have offered assistance and guidance include Paolo Berdini, S. A. C. Dudok van Heel, Florike Egmond, Jan Piet Filedt Kok, David Freedberg, Annapurna Garimella, Eli Gottlieb, Joan Griswold, Donald Jurney, Patrick and Monique de Koster, Peter Mason, Sarah McPhee, Giuseppe Olmi, Andrew Solomon, Jan van der Waals, Elizabeth Wyckoff: To all of them I extend my warm thanks. I am grateful for the recent assistance of a Faculty Research Grant from the College of Arts and Architecture at The Pennsylvania State University, and for the support of my colleagues in the preparation of this manuscript. Łukasz Schuster and Adam Wierzba, who photographed the Clutius watercolors in the course of long summer days in Kraków, and the botanist and art historian Sam Segal, who identified the plants reproduced here, generously gave of their expertise. The various ways in which my editor at Abrams, Eve Sinaiko, has cultivated this book exceed the call of duty, and even of friendship, and I thank her.

This book is dedicated to the keepers of my favorite gardens of all—F. G. van Beuningen and Marianne and Jon Swan.

Whether because they reveal more than the eye is able to see or because they speak the facts of the natural world in the language of pictures, scientific images are widely admired. Often they are valued as much for their functional, didactic uses as for their artistic qualities—a dual capacity that goes back to a moment in history when science and art had not yet diverged and when the naturalistic rendering of the natural world was a primary task of the visual artist, as its description was the work of the scientist. That moment was the Renaissance. Think of the linear grace with which Leonardo da Vinci recorded (and by recording analyzed) the natural world, or the subtlety with which Albrecht Dürer captured shifting colors and effects of natural light in his watercolor studies of plants and animals. The naturalistic representation of these specimens vies with the beauty of the natural forms themselves; and in neither case does accuracy or legibility undermine artistic value. These works by two renowned Renaissance artists—one Italian, the other northern, from Nuremberg—serve to exemplify the long-standing and complex relations between art and science.

Where does the artistry of Dürer's watercolor end and the science of it begin? This is a difficult question, for the keen eye that observed this clump of grasses and the sod they grew in recorded it with the skilled hand of an artist trained in the fifteenth century, a time when accurate rendering of material reality was greatly prized. Throughout the Renaissance, techniques such as rationalized perspective, which allowed for an increasingly convincing registration of the empirical world, were developed and refined. Insofar as perspective or optics rest on scientific premises, science came to serve the ends of art.[1] And where accurate images of the natural world aided its observation and study, art came in its turn to benefit science. The documentation of the natural world and of its various morphologies was perhaps the highest priority of science in the early modern era. The plants in Dürer's watercolor *The Large Piece of Turf,* for example, are so accu-

rately described that they are identifiable in botanical terms—these plants are typical of the Franconian region of Germany, and of the flora that grows at the edge of meadows. Moreover, Dürer has represented them in the stage of their growth that occurs in the month of May.[2]

The story of the symbiotic relation between art and science in and following the Renaissance is a particularly fascinating one. But the historical context of this interaction is crucial as well. In the sixteenth and early seventeenth centuries, during what is commonly called the Scientific Revolution, the practice and production of science depended largely on the evidence of observation. The study of the plant world was then still tied to medicine but was beginning to take shape as the purely morphological study we now call botany, and scholars worked doggedly to describe and catalogue nature. Drawings and prints—woodcuts and, after about 1600, engravings—served to record and disseminate their observations. With the invention of the printing press in the mid-fifteenth century scientific authors were able to publish multiple, exactly identical, and therefore trustworthy images. Gradually, the texts of herbals that had survived from antiquity in the form of hand-copied manuscripts were issued in printed form and came to be heavily illustrated. The availability of these classical texts in relatively affordable editions permitted enterprising doctors, pharmacists, and amateurs of plant lore to compare the plants they had at hand and that grew in their native lands with plants described by classical authorities, among them Theophrastus (third century BCE) and Dioscorides and Pliny (both first century CE). Numerous plant varieties not mentioned in the classical texts were thus discovered throughout Europe. Images served as a basis for comparison of local varieties with the plants the classical authors had compiled; in those cases where the plants at hand could not be matched to plants previously described, pictures were the means to record and catalogue them.

The great studies of the plant world published in the sixteenth century constitute a revolution in the study of science because they contained pictures. The *Herbarum*

vivae eicones (Lifelike Images of Plants) by Otto Brunfels, published in Strasbourg in the 1530s, for example, or the *New Kreüterbüch* (New Herbal) by Leonhart Fuchs, issued in 1543 in Basel, and the Flemish herbals by Rembertus Dodonaeus, Matthias Lobelius, and Carolus Clusius are famed for their copious and conscientiously rendered illustrations. Hans Weiditz, reputed to have been a student of Dürer, is responsible for the elegant full-page woodcuts that adorn Brunfels's book. Indeed, his text is a rehashing of classical sources, and the merits of the volume lie in the illustrations. (Brunfels's title indicates that the author himself knew where his contribution to botany lay.) Fuchs's herbal, which contains more than five hundred woodcuts, also contains portraits of the artists involved in its production—Albrecht Meyer, who drew the plants; Heinrich Füllmaurer, who transferred Meyer's drawings to woodblocks; and Veyt Rudolff Speckle, who incised the woodblocks for printing. ❧ The emphasis Fuchs placed on the rendering of plants, complete (as he states in the subtitle of the book) with "roots, stems, leaves, flowers, fruits, and in sum the entire form," speaks for the meticulous observation of the plant world that characterized these efforts. Fuchs does not merely recommend the informational value of his illustrations; he proudly states that they are "artfully rendered and portrayed," and promotes his work as unprecedented and entirely new. The high quality and scientific value of his woodcuts and those of other herbals have much to do with artistic developments of the time. Whether or not Weiditz studied with Dürer, the refinement and accuracy that characterize his work for Brunfels owe much to the example of the Nuremberg master.

❧ Who used these volumes, and how? One imagines that readers of these great herbals may have pored over them more or less randomly, curious to absorb the

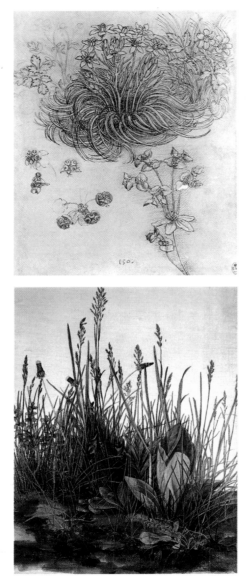

Leonardo da Vinci (1452–1519)
STAR-OF-BETHLEHEM AND OTHER FLOWERS
c. 1506–8, red chalk and ink on paper, Royal Library, Windsor Castle, RL12424.

Albrecht Dürer (1471–1528)
THE LARGE PIECE OF TURF
1503, watercolor and black ink, heightened with white, on paper affixed to cardboard, Graphische Sammlung Albertina, Vienna.

information they contained. But they were also meant for more directed and practical use. In the sixteenth century medical doctors were trained in the identification and uses of plants as purgatives, painkillers, anti-inflammatories, calmatives, and so forth. Indeed, the entire plant world was a potential pharmacopoeia, as it is today. The study of plants was therefore first and foremost devoted to learning their uses. Herbals of the period tend to be organized as follows: Each plant recorded is represented by an image, which usually shows the plant in full, complete with roots. The roots were used not only for pharmaceutical ends, but also as an aid in the identification of individual varieties. The plates are identified by name and the image is accompanied by a text that describes the plant, its forms, and its growth cycle. Often the locations where the plant is known to grow are noted. The "nature" of the plant is indicated, according to the theory of the four humors still prevalent in medical practice at the time. Finally, the effects and uses of the plant are described. Very often such volumes concluded with an index of the properties and virtues of the plants described, organized not by plant, but by ailment. The index to Dodonaeus's great sixteenth-century Flemish herbal, the *Crûÿdeboeck* (Herbal), for example, ranges from abscesses and apoplexy to various romantic complaints to earaches, eye maladies, and a long list of urinary problems.

❧ It is important to recall that all of the plants described in an herbal, from roses, lilies, and ferns to nettles, elderberries, and apples, were accorded medicinal properties. Dodonaeus gives us a great deal of information on each plant. After listing the kinds of peony, for example (there are two, male and female), he describes the forms of each and indicates where they grow (they are cultivated in local gardens) and when they flower and seed. He states the plant's names in other languages (both classical

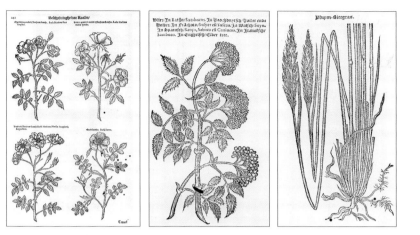

Anonymous sixteenth-century artists
ROSES, ELDERBERRY, and GRASSES
three woodcuts in Matthias Lobelius, *Kruydtboeck*, Antwerp:
C. Plantin, 1581, University Library, Rare Books Room, Amsterdam.

and modern); the derivation of its common name (the peony is named after the physician Paeon, who first identified the plant); its temperament (the peony is dry in the second degree and hot in the first); and, finally, its "virtues and effects." The peony has five medicinal uses, according to Dodonaeus, including the capacity, when a concoction is made of the dried root, to sooth stomach ailments. If the root of the male peony is worn around the neck (especially by small children) it may cure severe colds. Ten or twelve red seeds taken in wine reportedly stopped menstruation; fifteen or sixteen of the black seeds in wine may be effective, the Flemish doctor claims, in suppressing night visions and melancholic dreams. Some plants are recommended for cooking and household use: Hop, for example, may be decocted to purge the blood of corrupt humors or, in the spring, when its tendrils are tastiest, eaten in salad. The roots of ferns have several reputed medicinal uses, and when the leaves of both male and female ferns are placed under mattresses, they are said to repel bugs and other vermin.[3]

These great herbals, compiled by ambitious amateurs of the plant world, were often nationally specific. Dodonaeus's *Crûÿdeboeck*, first published in Antwerp in 1554 and reprinted until well into the seventeenth century, was modeled on Fuchs's German herbal of 1543, and many of the woodcuts it contained were copied from Fuchs's *New Kreüterbûch*. Nonetheless, Dodonaeus's publisher commissioned the herbal as a specifically Netherlandish volume. To compile their observations on plants, authors took to scouring the countryside for specimens to record. An odd

and extremely rare volume, one of the founding documents of sixteenth-century botany, the *Botanologicon* (Cologne, 1534) by Euricius Cordus (1486–1535) offers a fine introduction to the new mode of observation prevalent among students of the plant world. Early in the text Cordus addresses his fellow medical students:

> Whenever it pleases you, let us go forth. I will not keep you back; nevertheless I, just as if none of you were here, shall follow my usual practice of taking along a little book or two. I take the greatest delight in these sallyings into the country, where I can have before me, fresh and growing, those herbs which I have read about at home, and may compare them with the pictures of others which I carry in memory; also taking such note of their names and reputed virtues, as I may gather from such old women whom I meet upon the way. By the use of all these means I am the better able to arrive at a sound conclusion, or at least a more probable opinion, about the identity of a thing. . . . If it please you, we will first enter this my little garden by the house.[4]

Such outings, referred to as "botanizing" or "herborizing," were crucial pursuits of sixteenth-century naturalists. Cordus summarizes contemporary methods effectively: The scholar worked to identify plants by integrating the study of texts—the "little books" he refers to were probably printed texts on the plant world—with the study of "fresh and growing herbs," images, and information gleaned from herb or root women who plied their trade in the woods and fields.[5] The field of study ranged from gardens maintained by medical professionals (doctors as well as

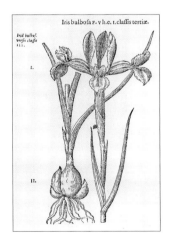

Anonymous sixteenth-century artist
IRIS
woodcut, in Carolus Clusius, *Rariorum Plantarum Historia*,
Antwerp: C. Plantin, 1601, University Library,
Rare Books Room, Amsterdam.

pharmacists) and amateurs to the untamed countryside beyond city walls. The ends of such identification were medical, which is to say pharmaceutical. A central factor in the development of this mode of study was the capacity of images—and in particular, the exactly repeatable images generated by print technology—to establish morphologies.[6] In his unillustrated *Botanologicon* Cordus speaks of images stored in memory. But at the very time of its publication the first great illustrated herbal, Otto Brunfels's *Herbarum vivae eicones* of 1530–36, appeared in Strasbourg.

The Clutius botanical watercolors present a closely related chapter in the history of sixteenth-century medical botany. Produced in the immediate context of the great Flemish herbals, they are original, unique images, rather than prints, and do not appear to have been intended for publication. Indeed, the bulk of these exquisite watercolors has gone unpublished to the present day. The images reproduced here have been selected from a vast store (roughly 1,800 images) of late sixteenth-century sheets presently in the collection of the Jagiellon University Library in Kraków, Poland. The complete body of work is housed in a set of thirteen volumes known as the *Libri picturati* A.18–A.30. Their provenance cannot be fully determined. By the last decade of the sixteenth century these stunning images were in the possession of the esteemed Netherlandish pharmacist Dirck Outgaertsz. Cluyt (1546–98), whose name in its Latinized form is Theodorus Clutius. In his hands they played a new and fundamental role in the medical curriculum at Leiden University. The circumstances under which the *Libri picturati* watercolors were produced are not yet wholly clear, and it is not possible to attribute them to a single artist (the works are unsigned).

In 1594 Clutius moved from his

Jacques de Gheyn II (1565–1629)
THE LEIDEN UNIVERSITY GARDEN
engraving, in Pieter Pauw, *Hortus Publicus Academicae Lugduno-Batavae*, Leiden: Raphelengius, 1601, Rijksherbarium/Hortus Botanicus, Leiden University.

Jacques de Gheyn II
CAROLUS CLUSIUS
engraving, in Carolus Clusius, *Rariorum Plantarum Historia*, Antwerp: C. Plantin, 1601, University Library, Rare Books Room, Amsterdam.

native city of Delft, in the province of Holland, where for many years he had been the successful proprietor of a pharmacy called the Pomegranate, to Leiden. There he assumed a position at Leiden University, the first university in the northern provinces of the Netherlands, founded in 1575 by William of Orange to help consolidate the independence of the northern Netherlandish provinces from the Spanish crown. A year prior to Clutius's arrival, the plots of the university *hortus,* or garden, were dug. The *hortus* was a primary locus of study for students of medicine, and its holdings were unequaled in the region. As such, it required careful tending by a professional, someone able to convey his knowledge of its specimens and their medicinal uses to the young students. The director originally hired to oversee the garden was the celebrated botanist and prolific author Charles de l'Escluse (Carolus Clusius, 1526–1609), the Latin form of whose name differs from Cluyt's by only one letter, causing infinite confusion in the literature. By 1594 it was painfully clear, however, that Clusius would bring little more than his fame to the university. He refused to teach and took little part in the practical, day-to-day tasks of maintaining the garden. Clutius was hired by the trustees of the university to perform those duties. The pharmacist supervised management of the garden, drew up extensive indices of its contents, and made his personal collections available to students. A document drafted after his premature death in 1598 (he was only fifty-two) identifies these collections, which the medical students hoped to secure for their future use. This document clearly indicates the use to which the *Libri picturati* watercolors were put; in it the students claim that Clutius's collection comprised more than four thousand dried specimens and "six books of all sorts of herbs and flowers, painted 'from the life,' which serve us in the winter in lieu of the garden."[7]

Following Clutius's death an appraisal was made of his "paintings" by the artist Jacques de Gheyn II and another fellow, identified only as "his brother-in-law Pieter." There is every reason to believe that the works de Gheyn and this Pieter appraised were the watercolors contained in the six volumes mentioned by the students. De Gheyn had established himself as an artist in Leiden in 1595 and quickly developed contacts with the faculty at the university.[8] His engraved plan of the university *hortus,* published in 1601, and the remarkable watercolor and gouache plant and insect studies he produced between 1600 and 1604 attest to his sustained interest in the natural sciences. De Gheyn sold his own watercolors, painted on sheets of vellum and framed in gold ink, to the Habsburg emperor Rudolf II, for interest in matters botanical was not confined to the schools. That he was asked to appraise the watercolors in Clutius's collection speaks both for de Gheyn's interest in functional scientific renderings and for the value of the images themselves. Several years after Clutius's death the enterprising doctor Anselm de Boodt, active in court circles in Prague, made an effort to procure watercolors from Clutius's family's collection. In a letter dated 1602 to Carolus Clusius, de Boodt recalled having seen a "painted herbarium" at the home of the widow Clutius in Leiden, which contained roughly 1,050 images.[9] The painted herbarium de Boodt hankered after but couldn't afford was the collection of paintings de Gheyn had appraised, the same body of images that served the medical students as a "garden in winter."

While highly valued for their artistry at the time, these watercolors were also a prized pedagogical aid. During the warmer seasons the students, grounded in the classical texts on the medicinal uses of plants, studied and practiced the identification of living plants among the plots of the garden. Classes were held there; public demonstrations took place on regular occasions. De Gheyn's 1601 engraving shows us a robed professor holding forth to a group of attentive students in its farther reaches. It was crucial that medical students be able to name and identify plants as they grew, and know at what stages in their growth cycle they were most potent for particular uses. This new mode

Anonymous seventeenth-century artist
CAROLUS CLUSIUS AND THEODORUS CLUTIUS
woodcut, in Theodorus Clutius, *Van de Byen*, Leiden:
J. C. van Dorp, 1598. Rijksherbarium/Hortus
Botanicus, Leiden University.

of study, with its emphasis on direct observation, came to depend on the evidence of university gardens and collections of specimens, or *simplicia* (simples, the makings of pharmaceutical remedies). Behind the Leiden garden, and also visible in de Gheyn's engraving, a long *ambulacrum,* or gallery, was built to house plants in the winter as well as the university's growing collection of dried specimens. Just as Clutius's specimens were an extension of the university's collection, so too his watercolors were an extension of the garden. These watercolors were so accurate and informative that they could serve *as* a garden—a painted garden—when the actual garden was dormant.

The role the Clutius watercolors played in the medical curriculum at Leiden depended on—and may help us to analyze—the way they were composed. The majority are painted on folio-size sheets of sturdy sixteenth-century paper (the average dimensions are about 17¾ × 11¼", or 45 × 30 cm) and the plants fill the individual sheets.[10] All but seven of the sheets are vertical in orientation; two double-page images are horizontally aligned (see pages 36–37, 90–91). In most cases the plants are shown in full and actual size and are arranged with care on the sheets, so that their various surfaces—the backs and fronts of leaves and the variegated forms of stems, petals, leaves—are all fully visible. Generally, root structures are as painstakingly described as other features: firm, bulbous, or tuberous roots (see pages 20, 26) or wispy, fibrous webs imitate actual growth patterns (see pages 19, 32, 84). An iris is drawn with its root cut, showing the interior structure and color (page 25). Where roots are not shown, in the case of many of the larger shrubs and trees, the branches are usually depicted cut at an angle, so that the interior is visible as well, aiding identification.

The careful positioning of the plants and the delicacy with which they are colored contribute significantly to their recognizability. In a number of cases plants are depicted with broken or bent stems, folded and positioned so that the entire plant can be contained within the space of a single sheet (see pages 20, 21, 35, 96, 110, 119). In other cases plants are painted sprawled across the page, their forms gracefully disposed to extend to its outer edges,

with flowers or fruits placed decisively to punctuate these arrangements (see pages 52, 90–91, 112, 113, 116). In particular those images of plants with cut, bent, and folded stems mimic the pages of *herbaria,* in which pressed and dried specimens were preserved for study. A central difference between such volumes of dried specimens affixed to sheets of paper and these watercolors is, of course, the living color of the paintings. Like the pages of Renaissance *herbaria,* these sheets contain the flattened forms of plants and flowers; unlike their dried counterparts, however, these plants preserve their vivid colors over time. The range and subtlety of colors in these paintings are astonishing, and the artist's hand is remarkably deft. Consider, for example, the depths of blue in the blackthorns (page 78), with their soft glints of reflected light; the fine gradations of coloring in the plums (page 74); the sudden shift from delicate linear patterns on the leaves and flowers of the bladder senna (page 53) to the iridescent surface of its hanging seedpod. Some thirty-five sheets are unfinished, or rendered only in ink and minimally colored or shaded. A drawing of branches of two trees is typical of this group. Indeed, all of the unfinished watercolors are of trees; since they do not differ radically in stylistic terms from the other watercolors, they may have been left unfinished at the time of Clutius's death.[11]

✣ Who painted these watercolors? Not a single one is signed or dated. It is not inconceivable that Clutius himself made some; he is known to have painted specimens of plants and was considered by Matthias Lobelius, a contemporary botanist and friend, "wonderfully talented and artful in all things."[12] It is also known that Clutius had an artist in his employ who painted plants. There is reason to believe that more than one artist was at work here and that a portion of the present col-

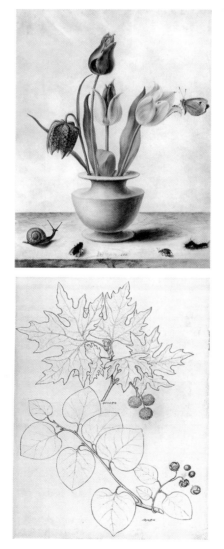

Jacques de Gheyn II
A Snakeshead and Three Tulips in a
Vase with Five Insects
1600, watercolor and gouache on vellum,
fol. 2r of the *Lugt Album,* Collection Frits Lugt,
Institut Néerlandais, Paris.

Anonymous sixteenth-century artist
Branches of Two Trees
ink and watercolor on paper (unfinished),
Libri picturati A.20, fol. 33v,
Jagiellon University Library, Kraków.

lection was painted in the 1560s, too early for Clutius to have commissioned it. He may have acquired it at some later point; these drawings would have formed a core group around which Clutius built the nearly encyclopedic collection of images that survives today.[13] The drawings, by their sheer beauty and accomplishment, invite our curiosity: Who was the artist, so sensitive to nature's forms, who conceived of these slight shifts of hue in the leaves of peas, a sea of carefully differentiated greens parceled out among the delicately veined foliage (page 97)? Who orchestrated that pattern of stems and sprouts, laid gracefully across the page, and the manner in which they emerge one from another, at the very end of the uppermost tip? The ruddy apples, nestled among furled and folded leaves, are virtuoso, lyrical renderings (page 75). Consider the snail posted on a branch of black currants, or the green cricket making its way through the spiny forms of a nettle—both creatures accurately echo the forms and coloring of the plants they inhabit (pages 83, 129), and their charm lies in their quiet, witty presence. The artistry in evidence throughout these pages is, of course, ultimately the artistry of nature. In effect, these images reveal less about the individual hand of an author than about the art of nature itself.

✣ Art pays homage to nature, but also vies with it. Many of the plants in the Clutius watercolors are depicted simultaneously at various stages of maturation. This natural implausibility—that a branch of an apple tree should at the same time flower and bear fruit, for example, or that the delicate flowers of the black currant should decorate a stem of the plant directly above the ponderous forms of the ripe berries—is cleverly maneuvered. In such cases, the flowering and fruit-bearing branches are separated by an almost imperceptible break in the branches themselves. The artist thus indicates that these

forms are continuous with one another in one sense (that of kind), and crucially discrete in another (that of season). A pea pod (page 97) growing from the stem of its plant is opened to reveal nine green peas, to show growth patterns both inside and out. Dried peas are shown as well. Similarly, the coloring of the red currants (page 82) ranges to show berries at various stages of ripeness, from bitter, hard, and white to plump, red, and edible. Here again, the purpose is to record plant forms as fully as possible and make them botanically identifiable: To know a plant is to be able to identify it at different stages in its maturation. In a larger sense, the artist-scientist has done what nature cannot: shown the whole life of the plant at once.

Because they are so carefully composed, these sheets are eminently legible. Most are also individually and painstakingly labeled and inscribed in a late sixteenth-century hand. The name of each plant is recorded in a number of languages—for example, the elder is named in Greek, Latin, Italian, French, German, and Flemish, as is the mandrake, among many others (pages 66, 108). Additional inscriptions include citations of classical authors on botany—Dioscorides, Galen, Pliny, and Theophrastus—and of modern students of the plant world—Cordus, Bock, Mattioli, Lobelius, and Dodonaeus. Farther down on the sheets is information about when the plants blossom and seed and where they grow, with frequent references to "students of botany" and "our gardens" (see pages 49, 102). In keeping with contemporary practice, these primary inscriptions are written in two manners, italic and vernacular, and while the authorship of the italic inscriptions—everything in Latin, including the abbreviations of the modern languages—eludes positive identification, the vernacular portions have been identified as by Theodorus Clutius, so we may surmise that the references to "our gardens" are either to the gardens of the North in general (as compared to Italy and the South) or to the Leiden botanical gardens themselves.[14]

These inscriptions can be quite charming. In the first plate (page 19), for example, the name of the cyclamen plant is written at top center and again, in Greek, Latin, Italian, French, German, and Flemish, within the central cartouche. Below the roots of the plant we read: "Grows in the shade, under trees and in brambly thickets and in the wild. It blossoms from the month of August, when it loses its leaves, until the end of September." At the left of the plant are references to Dioscorides's *Materia medica*, book 2, chapter 158, and Galen's *De simplicium medicamentorum facultatibus*, book 7, where the cyclamen and its medicinal uses are described.

The crocus (page 30) is named to the right of the illustration, again in ancient and modern languages. Below the list of names are citations referring to Dioscorides's *Materia medica*, book I, chapter 25, Galen's *De simplicium medicamentorum facultatibus*, book 7, and Pliny's *Historia naturalis*, book 21, chapter 6. Below these notations is the following inscription: "Grows abundantly throughout Germany and Burgundy. As for our regions, it is rare, and it is cultivated in gardens. It blossoms in March and its leaves, which have not yet sprouted at the time, last until May, to die in the summer. It propagates numerous roots below the soil. Gesner tells us how to cook it in his *Hortis*."[15]

In the detailed plate illustrating mosses and lichens (page 134), numerous individual name labels identify the different plants. At the right of the large clump of lichen we read: "It clings forcibly to stones; it is also found in cold and humid gardens, and equally in rocky and leafy places." At the left is written: "It protrudes its stems, with little star-shaped flowers, in the months of June and July." The lichen depicted at the lower left corner of the sheet "is found in our regions on all sides of the winding valleys beyond Heyst [in the southern Netherlands], on all sides of the valleys, near the sea." Above the cluster of small red flowering lichen (second from left, below) is inscribed: "This moss grows frequently around Bruges . . . around the month of May."

That the authors of the inscriptions and the authors of the drawings worked hand in hand may be deduced from the fact that in some cases inscription and drawing intersect. A number of these sheets bear inscribed cartouches, the most delightful of which is a *trompe l'oeil* card hanging from a buckled leather strap on a stem of the goat's rue clearly painted simultaneously with the plant (page 103). Text and image work together on a number of levels to make these natural forms fully present and identifiable. The nature of the inscriptions—they locate the plants linguistically, geographically, and bibliographically in the medical literature—is in complete accordance with the role these images played in the medical curriculum.

Interspersed among the folio-size watercolors in the *Libri picturati* A.18–A.30 are a number of other floral

watercolors, as many as 115 in number, painted on smaller sheets of paper (about 15¾ × 10⅝″, or 40 × 27 cm), and clearly by a different artist for a different purpose. The paper dates to the turn of the seventeenth century and in one case at least there is a definite internal link between these floral renderings and the botanical works we can trace to Clutius. The white daffodils painted on the larger-format paper (page 29) have been copied onto a sheet of the smaller paper (page 140) with some salient alterations in style. This direct link reveals a distinct difference between the two bodies of work.

The group of smaller drawings comprises almost exclusively ornamental, flowering plants of the sorts that were rapidly gaining popularity throughout Europe at the time: daffodils, delphiniums, lilies, poppies, and tulips—exotic, highly valued varieties just beginning to be cultivated in private gardens. Most are represented without roots, and the sheets bear no inscriptions. It seems likely that these watercolors were produced not with scientific or academic aims in mind, but rather as the loose-leaf pages of an artist's model book. They may well have been intended for use as templates for flower still-life paintings, a genre whose birth and rise in the early seventeenth century coincided with developments in the scientific study of flora and in the market for flowering plants. A classic early flower still life such as the 1608 *Large Flower Pot* by the Flemish artist Jan Brueghel the Elder (1568–1625) is representative of many similar works. Roses, tulips, other flora, and a variety of insects are gathered in a wildly unrealistic but highly naturalistic assemblage. These flowers could never be found together in life as they are in paint, since they blossom at different times; moreover, it would take a more-than-gifted florist to pack so many tender stems into a single vessel. The production of this sort of fictive, ever-

lasting bouquet depended on exactly the kind of watercolor source-album under discussion. These rootless records of prized varieties in full blossom provided all of the information necessary to a painter who wished his or her canvases to blossom, as Brueghel boasted to one of his patrons, even in the winter.[16]

One clue to the attribution of these smaller watercolors is found in the correspondence of Anselm de Boodt, the Flemish doctor in Prague who attempted to procure the Clutius watercolors in 1602. De Boodt mentions a painter from Delft named Elias, to whom he attributes some of the contents of the painted *herbarium* belonging to Clutius's widow. While in the Netherlands in the late 1590s de Boodt had commissioned two hundred watercolors from this Elias; upon receipt of them in Prague, however, he was sorely disappointed to find that they had not been painted "from life." If we take this to mean that they were not painted in full, with roots, and at various stages of maturity, then these works might correspond to the smaller-format watercolors in the Kraków volumes. Moreover, this Elias may be one Elias Verhulst, who designed a large floral bouquet engraved in 1599—a work that, like Brueghel's, may have been based on model-book images. These are the preliminary grounds on which the smaller-format watercolors of flowers are attributed here to Elias Verhulst, an artist about whom we know all too little, but who appears to have occupied an axial position in the crossroads of art and science in the Netherlands around 1600.[17]

That the Clutius botanical watercolors should comprise images explicitly directed to scientific or academic use only amplifies the historical complexity of the collection. Much work remains to be done on these extraordinary albums, a multivolume account of the plant world long recognized as

Jan Brueghel the Elder (1568–1625)
LARGE FLOWER POT
1608, oil on panel, Kunsthistorisches Museum, Vienna.

Hendrick Hondius, after Elias Verhulst
LARGE FLOWER BOUQUET
1599, engraving, Graphische Sammlung Albertina, Vienna.

the most important body of sixteenth-century Netherlandish scientific images extant today. They were produced at a historical moment when sharp analytical attention to the contents of gardens coincided with appreciation of their metaphoric meanings, when nature's bounty was understood as the resource of intellectual inquiry. This painted winter garden preserves more than the forms of the plants it describes. It speaks for a number of crucial aesthetic and scientific considerations—above all, for the idea that beauty and usefulness, art and science, are complementary.

NOTES

1. See Samuel Y. Edgerton, *The Heritage of Giotto's Geometry: Art and Science on the Eve of the Scientific Revolution*, Ithaca: Cornell University Press, 1991; Martin Kemp, *The Science of Art: Optical Themes in Western Art from Brunelleschi to Seurat*, New Haven: Yale University Press, 1989.

2. Fritz Koreny, *Albrecht Dürer and the Plant and Animal Studies of the Renaissance*, exh. cat., Boston: Little Brown, 1988, p. 178.

3. Rembertus Dodonaeus, *Crûÿdeboeck*, Antwerp: J. van der Loë, 1554, chapters 16 (Peony), 59 (Hop), and 60 (Ferns).

4. Euricius Cordus, *Botanologicon*, Cologne: Johannes Gymnicus, 1534, pp. 26–27, trans. Edward Lee Greene, in *Landmarks of Botanical History*, ed. Frank N. Egerton, Stanford, Calif.: Stanford University Press, 1983, vol. 1, pp. 366–67. Cordus was the father of the more widely renowned pharmacist Valerius Cordus (1515–44), whose annotated edition of Dioscorides was published posthumously. The younger Cordus died in Rome after traveling there from Bologna on foot in order to study plants along the way.

5. On the contribution of herb women to the study of plants in the sixteenth century and later, see Agnes Arber, *Herbals, Their Origin and Evolution: A Chapter in the History of Botany, 1470–1650*, Cambridge, England: Cambridge University Press, 1986 (1st ed., 1912), pp. 319–20.

6. See Peter Parshall and David Landau, *The Renaissance Print*, New Haven: Yale University Press, 1994, "Printed Herbals and Descriptive Botany," pp. 245–58, and Claudia Swan, "*Ad vivum, naer het leven*, From the Life: Defining a Mode of Representation," *Word & Image* 11 (1995), pp. 353–72. The term "exactly repeatable pictorial statement" was coined by William M. Ivins, Jr., in his *Prints and Visual Communication*, Cambridge, Mass.: MIT Press, 1969 (1st ed., 1953).

7. For a more complete discussion and full citation of this and related documents, see Claudia Swan, "Lectura, Imago, Ostensio: The Role of the *Libri picturati* A.18–A.30 (Jagiellon Library, Kraków) in Botanical Instruction at the Leiden University," in *Natura-Cultura, L'Interpretazione del mondo fisico nei testi e nelle immagini* (proceedings of the International Congress, Mantua, 1996), Florence: Leo S. Olschki (forthcoming, 1998) and idem, "Jacques de Gheyn II and the Representation of the Natural World in the Netherlands ca. 1600," Ph.D. diss. (Columbia University, New York), 1997, chapters 5 and 6, with further bibliography.

8. See Swan, "Jacques de Gheyn II," and I. Q. van Regteren Altena, *Jacques de Gheyn: Three Generations*, the Hague: Martinus Nijhoff, 1983, esp. vol. 1, chapter 3.

9. Leiden University Library, Codex Vulcanus 101; M.-C. Maselis, et al., eds., *De Albums van Anselmus de Boodt (1550–1632): Geschilderde natuurobservatie aan het Hof van Rudolf II te Praag*, Tielt: Lannoo, 1993, p. 204.

10. For an overall description, and discussion of the watermarks found on the sheets, see P. J. P. Whitehead, G. van Vliet, and W. T. Stearn, "The Clusius and Other Natural History Pictures in the Jagiellon Library, Kraków," *Archives of Natural History* 16 (1989), pp. 15–32, with all prior references. This article also provides an account of the rediscovery of these and other albums in Kraków in 1977; they had been considered lost after their removal from the Preussischer Staatsbibliothek in Berlin in 1941.

11. The unfinished sheets have fewer inscriptions and these do not conform to the "standard" type of inscription found on the majority of the images.

12. Matthias Lobelius, *Kruydtboeck*, Antwerp: C. Plantin, 1581, p. 296.

13. See Helena Wille, "Peeter van Coudenberghe, Karel van Sint Omaars en Conrad Gessner," in Guy de Munck, et al., *Peeter van Coudenberghe Apotheker-Botanicus (1517–1599) en Tijdgenoten*, exh. cat., Antwerp: KAVA, 1996, pp. 30–39.

14. See Swan, "Jacques de Gheyn II," chapter 6. This has been confirmed by S. A. C. Dudok van Heel, Gemeentearchief, Amsterdam. In one case at least (A.20/38), the two styles of handwriting occur seamlessly in a single continuous sentence. The further inscriptions on the folios, in different hands and inks and located at the edges or tops of the sheets, attest to the drawings' having passed among several owners at various times. These are not as consistent as the primary sort and, with the exception of the occasional hand of Clusius in the minuscule notations found on a number of sheets, cannot be positively attributed.

15. The reference is to Conrad Gesner, *Horti Germaniae*, in Valerius Cordus, *Annotationes in Pedacii Dioscoridis Anazarbei de materia medica*, Strasbourg: J. Rihelius, 1561.

16. See Beatrijs Brenninkmeyer-de Rooij, *Roots of Seventeenth-century Flower Painting: Miniatures, Plant Books, Paintings*, Leiden: Primavera Pers, 1996, p. 50.

17. On Verhulst, see Maselis, et al., *De Albums van Anselmus de Boodt*; John Michael Montias, *Artists and Artisans in Delft: A Socio-economic Study of the Seventeenth Century*, Princeton: Princeton University Press, 1982, pp. 52ff.; and Sam Segal, *Flowers and Nature: Netherlandish Flower Painting of Four Centuries*, The Hague: SDU, 1990, pp. 167–69.

PLATE LIST

Plants are listed by common English name and modern Latin name; the Libri picturati volume and folio numbers follow. Where more than one plant appears on a single sheet, and the plants are individually identified, listings are from left to right and from top to bottom. In many cases, the common modern names do not correspond with those inscribed on the sheets; sixteenth-century botanical nomenclature was not standardized and has been superseded by the Linnaean binominal classification familiar to readers today, employed here for clarity.

A NOTE ON THE SELECTION

The watercolors now in the *Libri picturati A.18–A.30* in the Jagiellon University Library in Kraków played a significant role in the medical curriculum at Leiden University in the last decade of the sixteenth century. They functioned as didactic aids within an academic, medical context. The works selected for reproduction here are representative of the contents of those volumes; the selection was made, however, with an eye to the pleasure of the modern reader and lover of botanical illustrations. The present order of the watercolors in the thirteen relevant volumes in Kraków does not follow the original order in the "six books" that belonged to Theodorus Clutius in 1598; the watercolors were bound in the leather volumes that still contain them in the later seventeenth century. The order imposed on the collection at that time adheres to seventeenth-century taxonomic practice, which has since been rendered obsolete by the Linnaean system of classification. I have chosen to arrange the watercolors by broad and generally recognizable categories, rather than according to a current botanical taxonomy. The relative distribution of each of the categories in this publication does not reflect that in the volumes in Kraków; to select images of plants that adhere to each of the categories cited here would have meant excluding many beautiful flowers for the sake of balance, and emphasizing typological distinctions of little interest to general readers. I trust, however, that botanists, horticulturists, and historians alike will take pleasure in the variety published for the first time here and the accurate modern identifications of the plants.

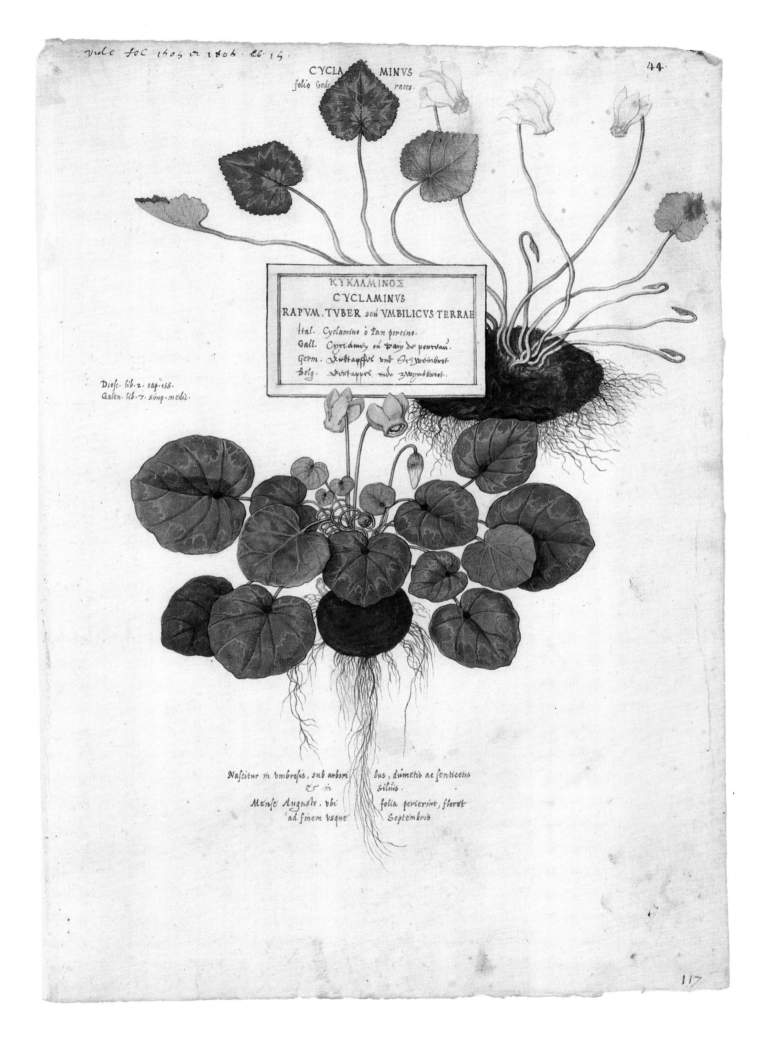

Diosc. lib. 3. cap. 134.

Nascitur & seritur eisdem
quibus precedens locis:
floretq; eodem tempore.

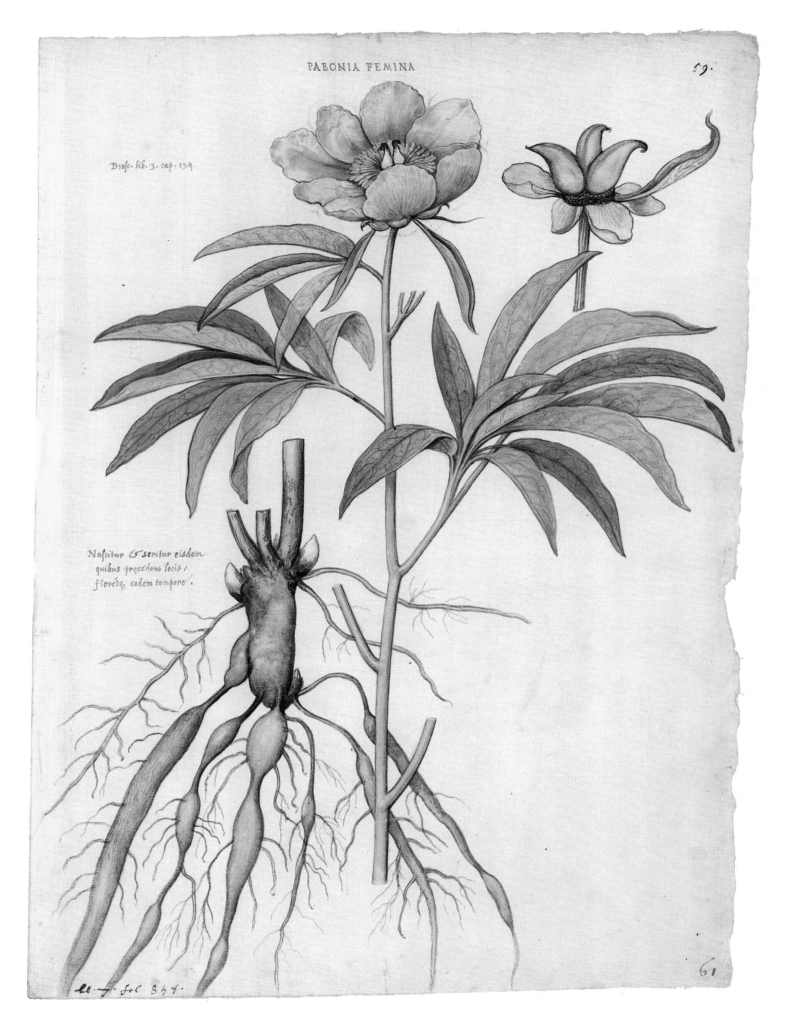

ll. f. fol. 347.

61

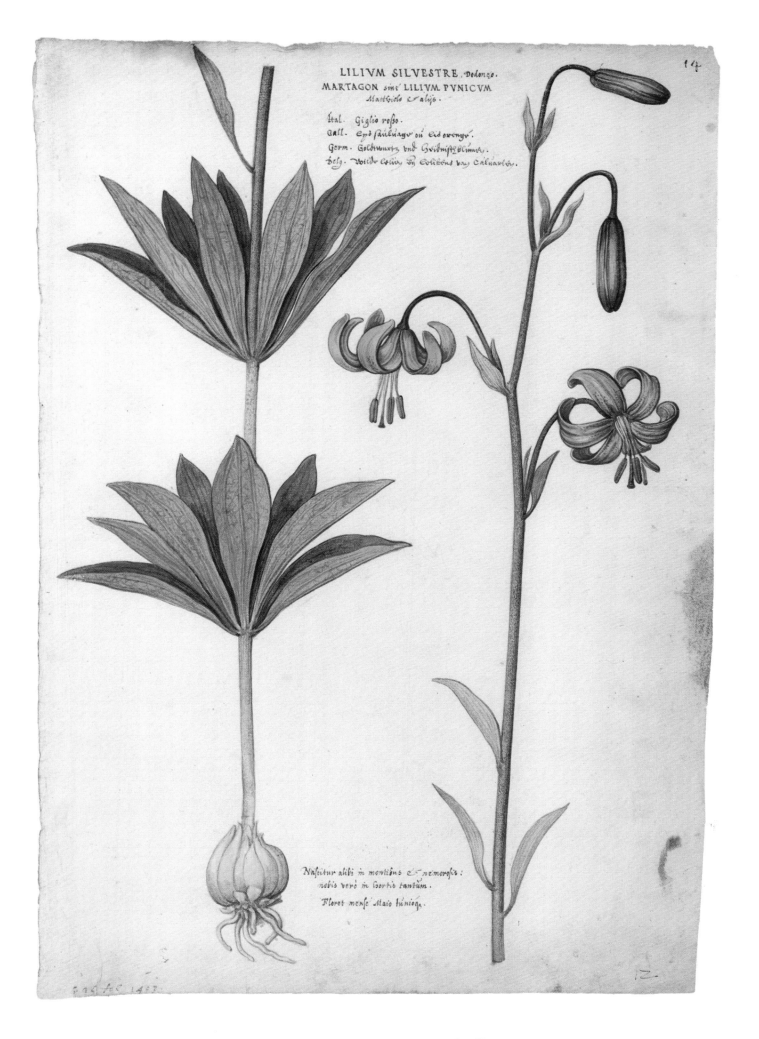

LILIVM SILVESTRE, Dodonæo.
MARTAGON sive LILIVM PVNICVM
Matthiolo & alijs.

Ital. Giglio rosso.
Gall. ...
Germ. Goldtwurtz vnd ...
Belg. ...

Nascitur alibi in montibus & nemorosis:
nobis verò in hortis tantùm.

Floret mense Maio Iunioq.

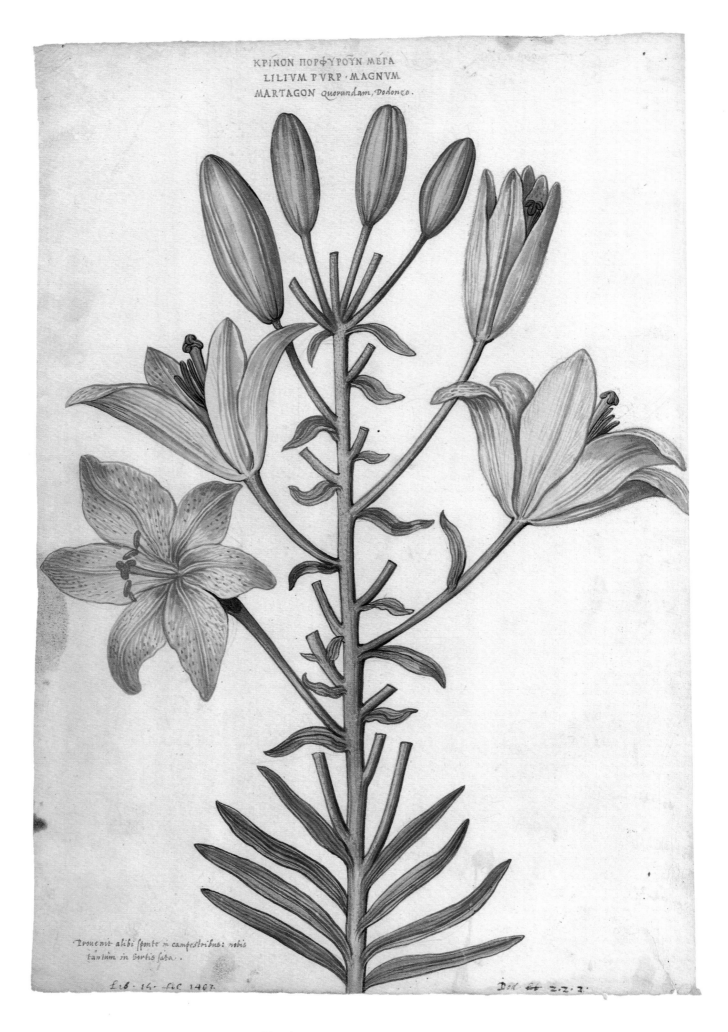

KPINON ΠΟΡΦΥΡΟΥΝ ΜΕΓΑ
LILIVM PVRP · MAGNVM
MARTAGON *Quorundam, Dodonæo.*

*Prouenit alibi sponte in campestribus: nobis
tantùm in hortis sata.*

Feb · 14 · feb 1467 *Dod· et z.z.z.*

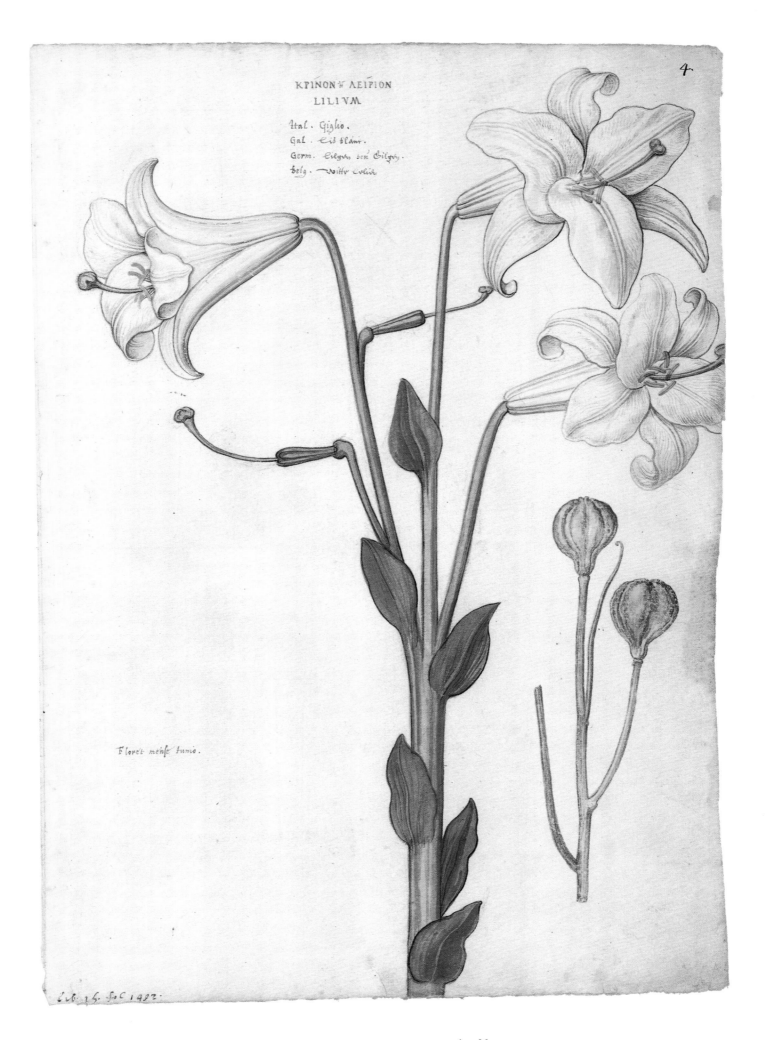

KPINON ἢ ΛΕΙΡΙΟΝ
LILIVM

Ital. Giglio.
Gal. Lis blanc.
Germ. Cilgen von Gilgen.
belg. Witte Lelie

Floret mense Iunio.

4.

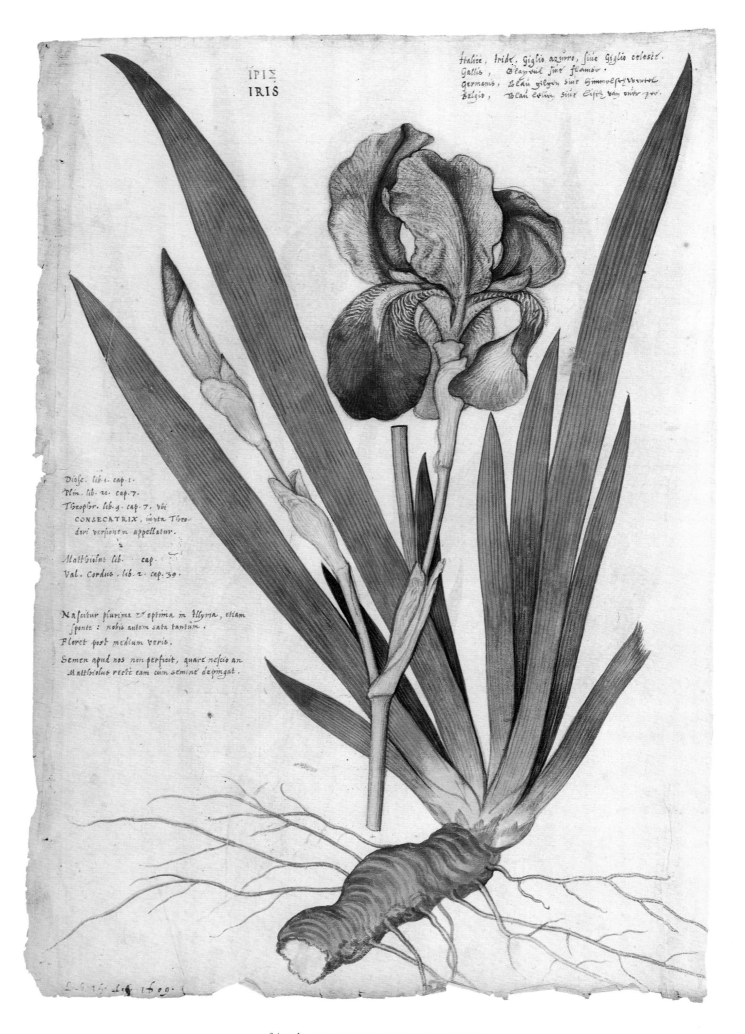

ÍΡΙΣ
IRIS

Italiæ, Iride, Giglio azurro, siue Giglio celeste.
Gallis, Glayeul siue flambe.
Germanis, Blau gilgen siue Himmelschwurtzel
Belgis, Blau lilien siue Lisch van onser ...

Diosc. lib. 1. cap. 1.
Plin. lib. 21. cap. 7.
Theophr. lib. 4. cap. 7. ubi
CONSECATRIX, iuxta Theo-
dori versionem appellatur.

Matthiolus lib. cap.
Val. Cordus. lib. 2. cap. 39.

Nascitur plurima & optima in Illyria, etiam
sponte: nobis autem sata tantum.
Floret post medium veris.

Semen apud nos non perficit, quare nescio an
Matthiolus recte eam cum semine depingat.

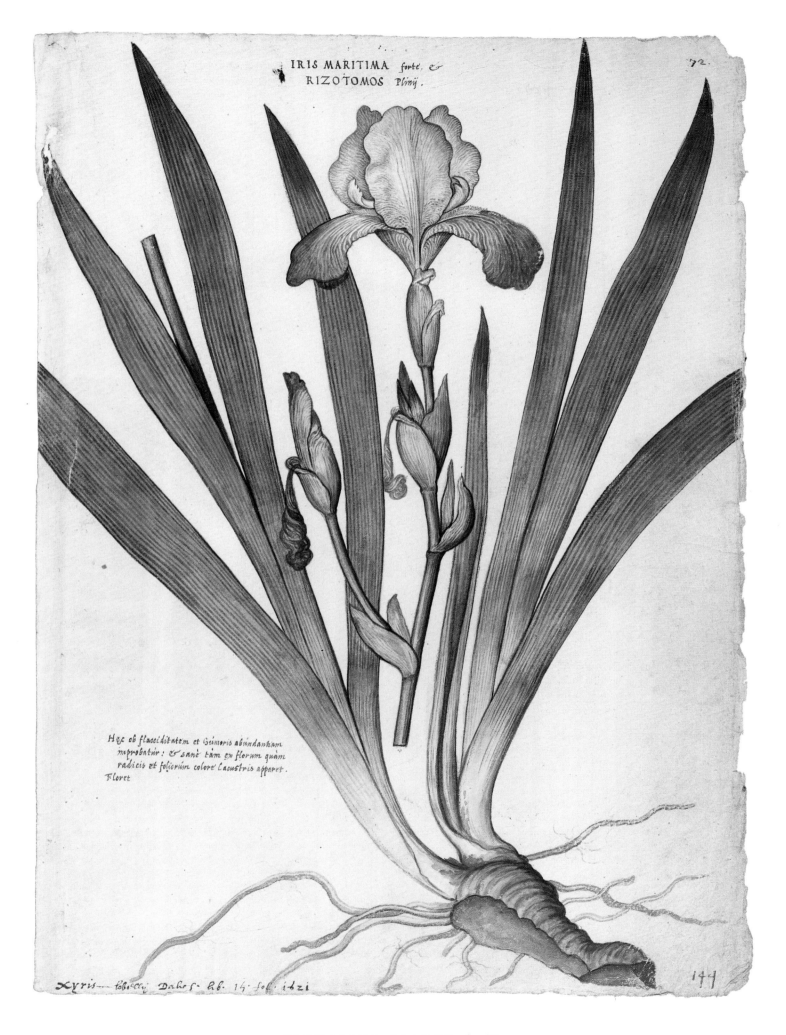

IRIS MARITIMA *forte. &*
RIZOTOMOS *Plinij.*

*Hęc ob flacciditatem et ßumoris abundantiam
improbatur: & sane tam ex florum quam
radicis et foliorum colore Lacustris apparet.
Floret*

72.

144

Xyris — tobellij Dalis. lib. 14. fol. 1621

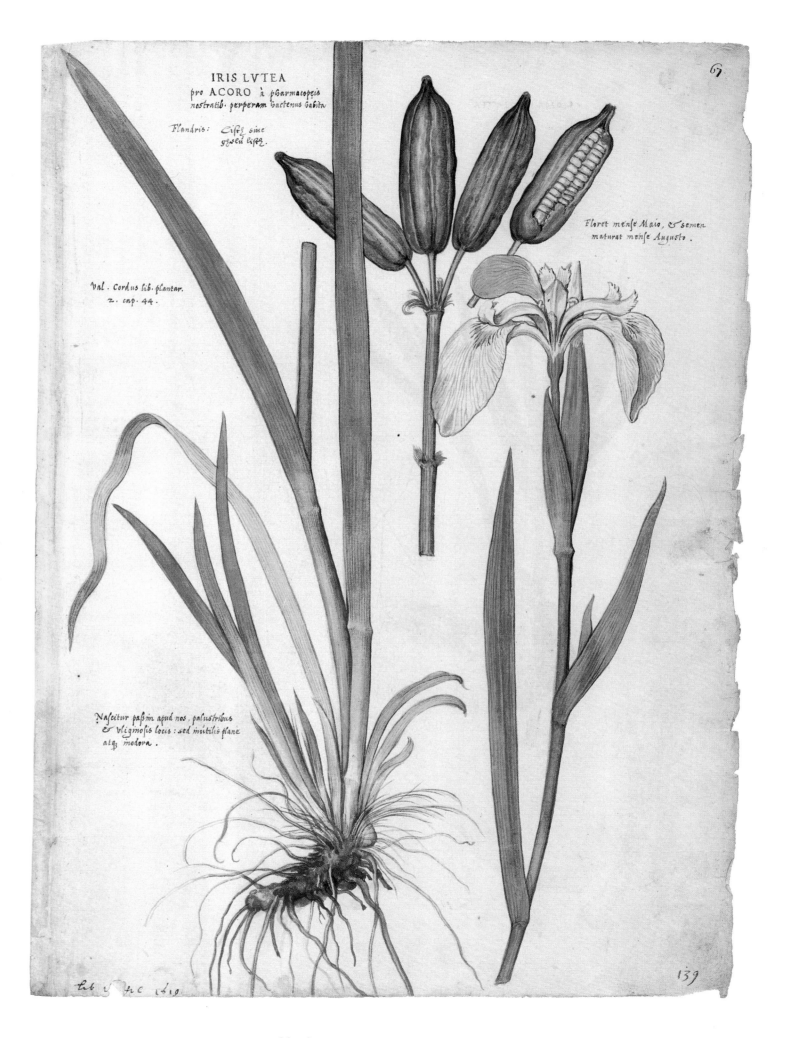

IRIS LVTEA
pro ACORO à pharmacopeis
nostratib. perperam hactenus habita

Flandris: Lisch sive
geele lisch.

Val. Cordus lib. plantar.
z. cap. 44.

Floret mense Maio, & semen
maturat mense Augusto.

Nascitur passim apud nos, palustribus
& uliginosis locis: sed inutilis plane
atq3 inodora.

139

LILIVM THEOPHRASTI, *Dodonæo*.
LILIVM CONVALLIVM, *vulgo*.
Gall. *Muguet* Germ. *Mayenblümlin*
belg. *Meyblæmkens vnder Lislikens vel der Dalen*.

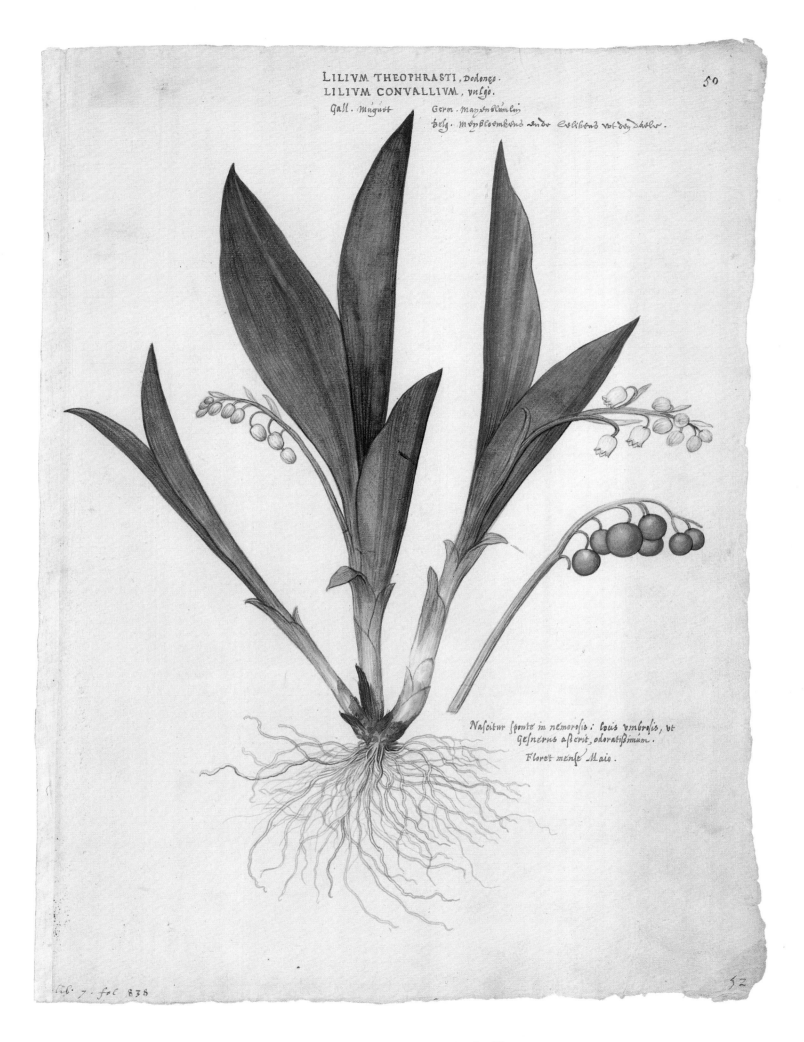

Nascitur sponte in nemorosis: locis vmbrosis, vt
Gesnerus asserit, odoratissimum.

Floret mense Maio.

lib. 7. fol. 838

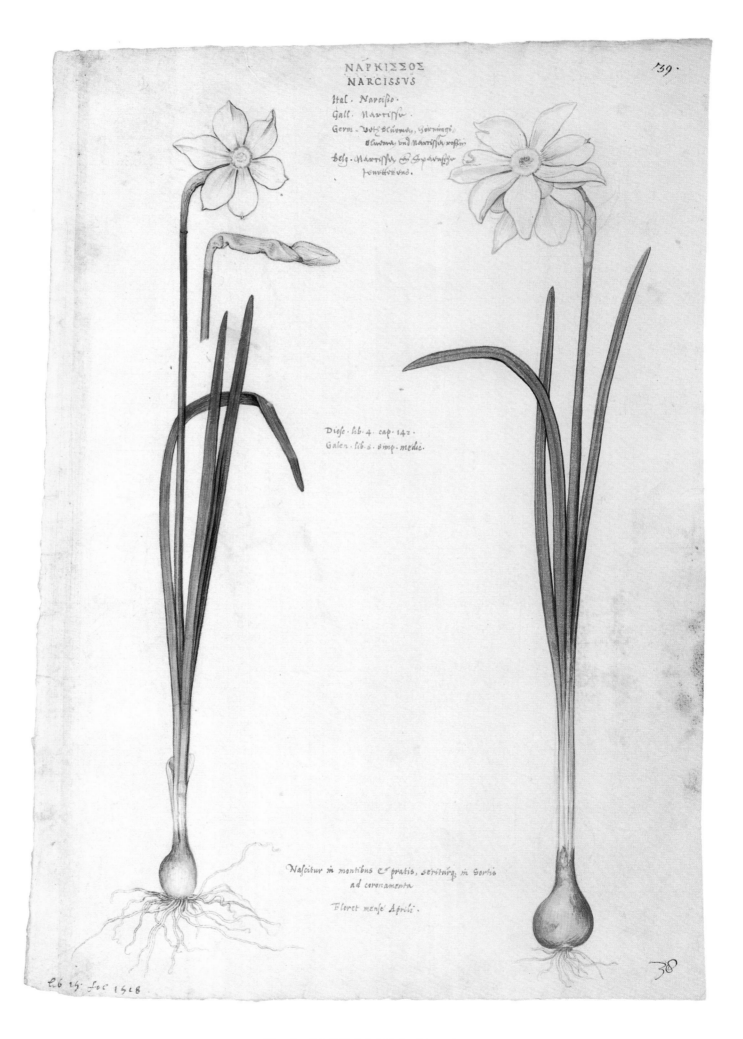

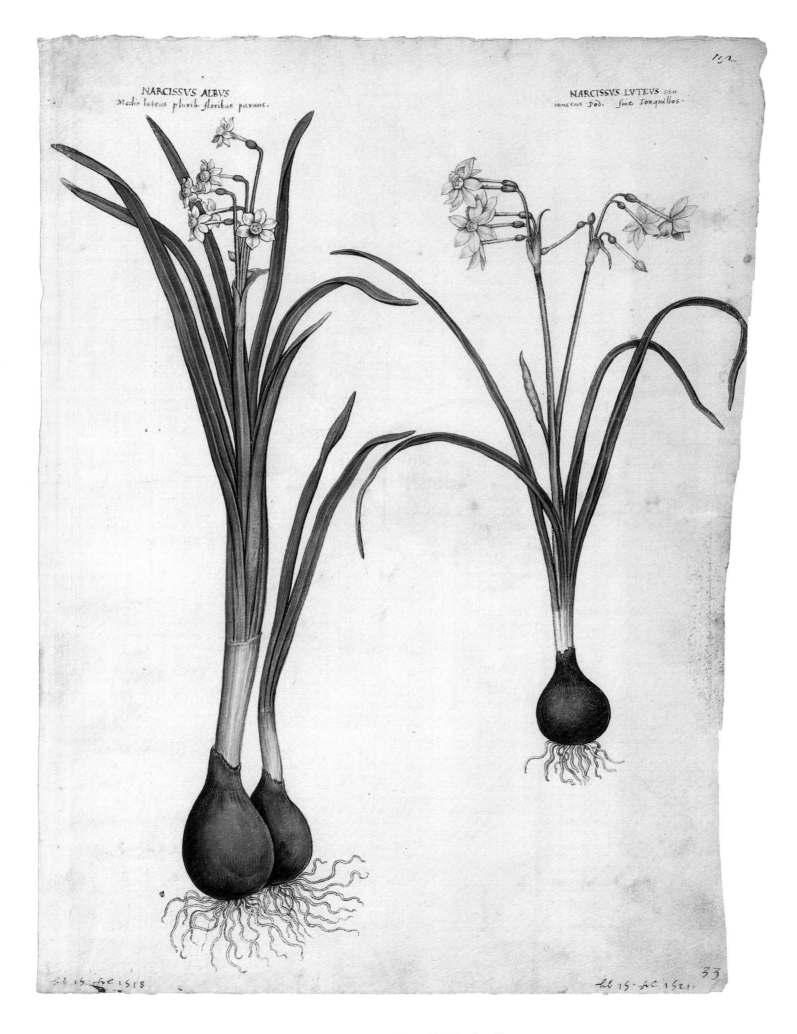

NARCISSVS ALBVS
Medio luteus plurib. floribus paruus.

NARCISSVS LVTEVS seu
iunceus Dod. siue Ionquillos.

feb 15 fec 1518

feb 15 fec 1521.

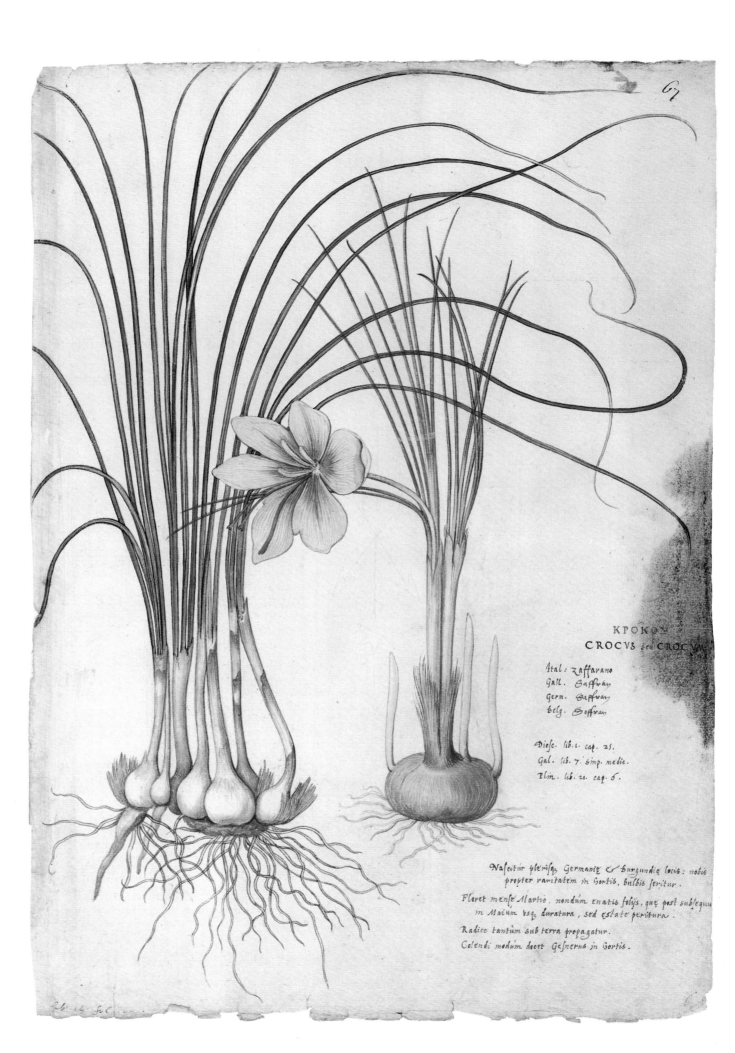

ΚΡΟΚΟΝ
CROCVS *seu* CROCVM

Ital: Zaffarano
Gall. Saffran
Germ. Saffran
Belg. Soffran

Diosc. lib. 1. cap. 25.
Gal. lib. 7. simp. medic.
Plin. lib. 21. cap. 6.

Nascitur plerisq; Germaniæ & Burgundiæ locis: nobis
propter raritatem in Hortis, bulbis seritur.

Floret mense Martio, nondum enatis folijs, quæ post sublequua
in Maium vsq; duratura, sed estate peritura.

Radice tantum sub terra propagatur.

Colendi modum docet Gesnerus in Hortis.

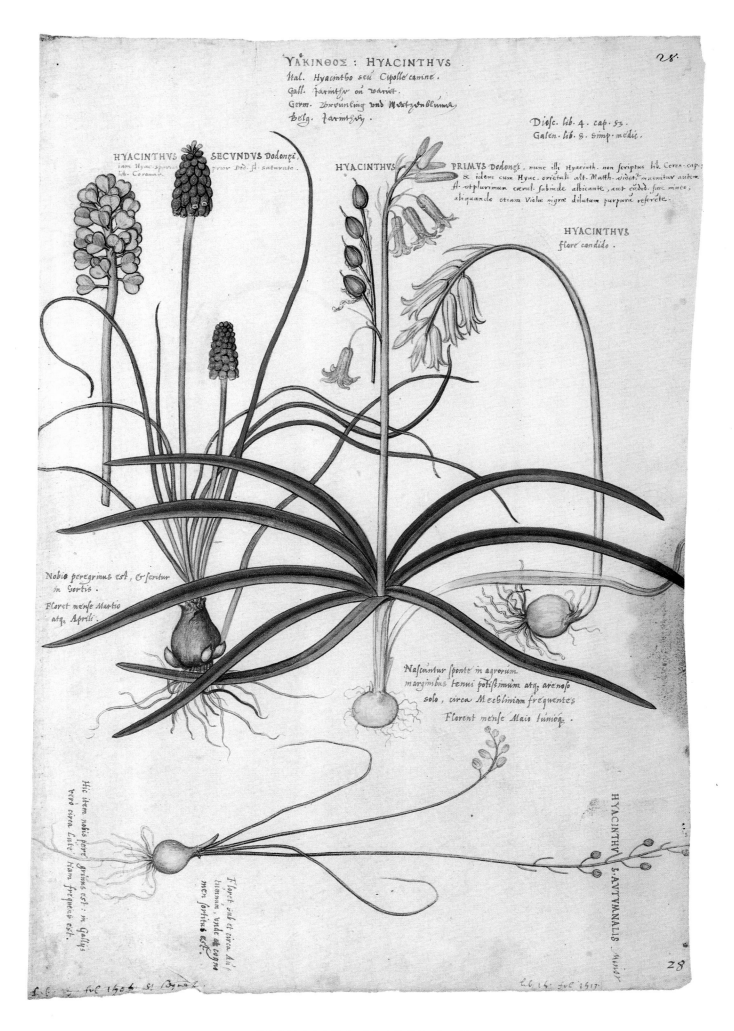

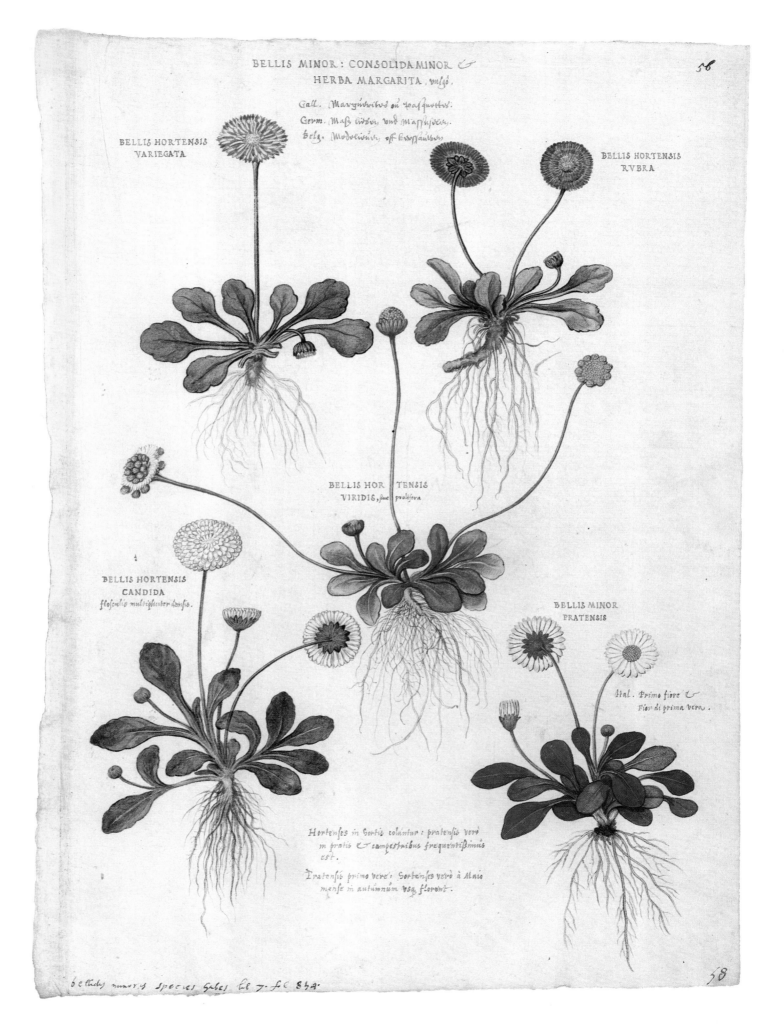

BELLIS MINOR: CONSOLIDA MINOR &
HERBA MARGARITA, vulgò.

Gall. Marguerites ou pasquettes:
Germ. Maß lieben, und Maßliebe,
Belg. Madelieven, oft Meußgaukens.

BELLIS HORTENSIS
VARIEGATA

BELLIS HORTENSIS
RVBRA

BELLIS HOR TENSIS
VIRIDIS, sive prolifera

BELLIS HORTENSIS
CANDIDA
flosculis multipliciter densis.

BELLIS MINOR
PRATENSIS

Ital. Primo fiore &
Fior di prima vera.

Hortenses in hortis coluntur: pratensis verò
in pratis & campestribus frequentißimus
est.

Pratensis primo verè: hortenses verò à Maio
mense in autumnum usq florent.

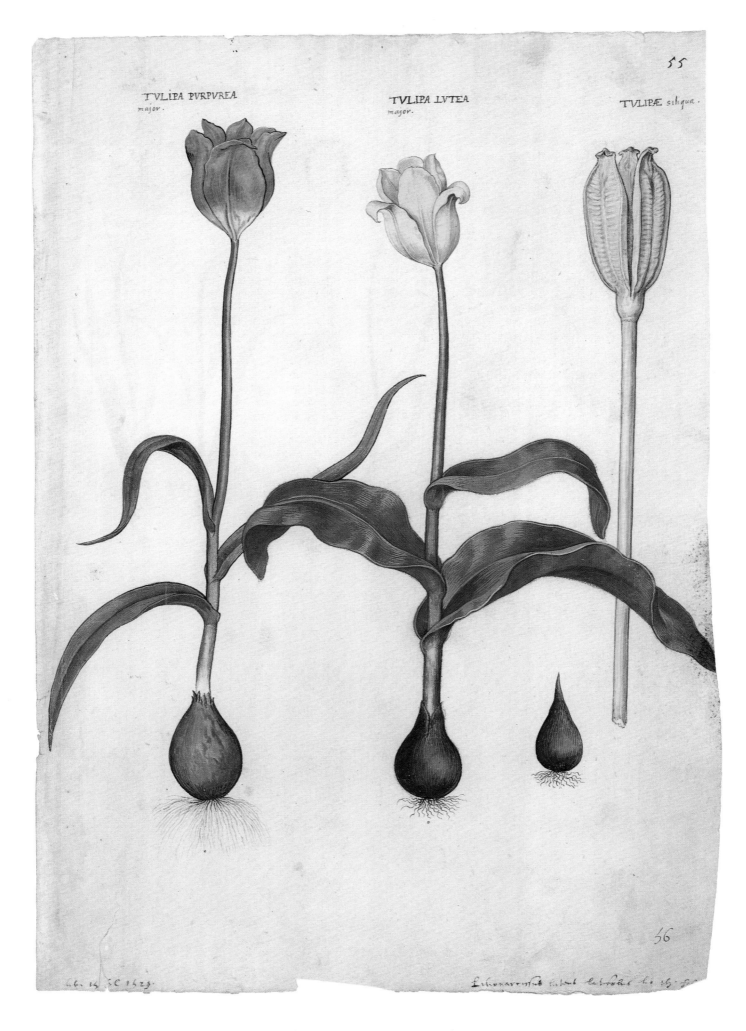

TVLIPA PVRPVREA
major.

TVLIPA LVTEA
major.

TVLIPÆ *siliqua.*

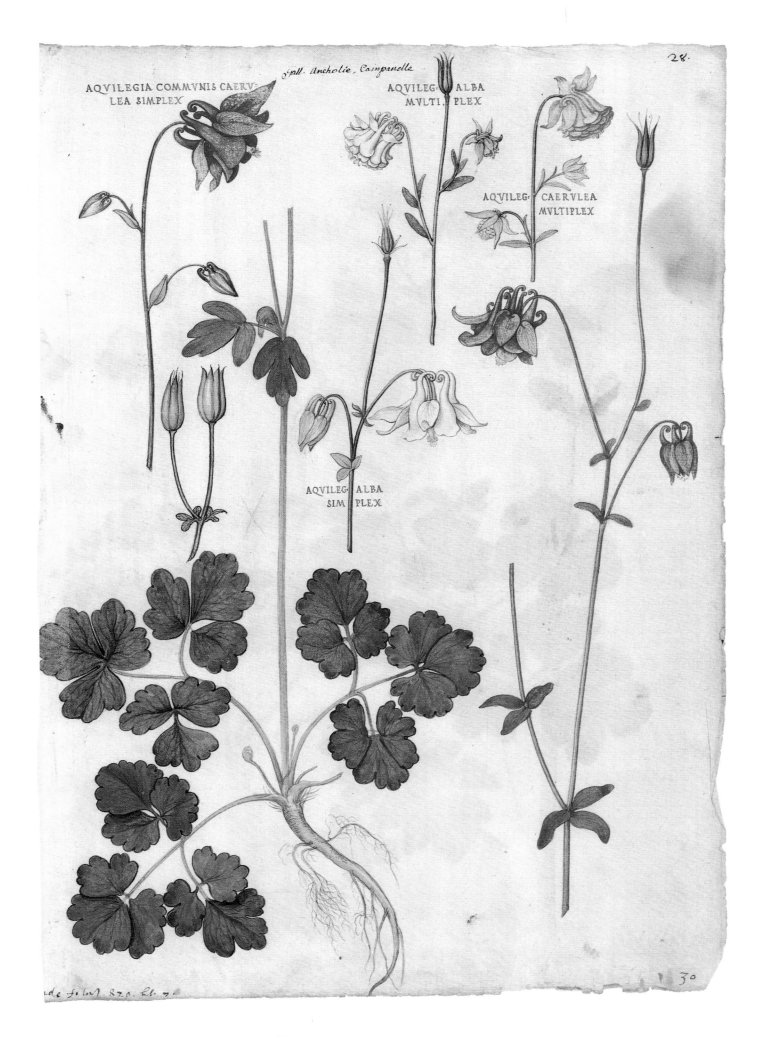

AQVILEGIA COMMVNIS CAERV-
LEA SIMPLEX

gall. Ancholie, Campanelle

AQVILEG ALBA
MVLTI PLEX

AQVILEG CAERVLEA
MVLTIPLEX

AQVILEG ALBA
SIM PLEX

de folus 820. lib. 4.

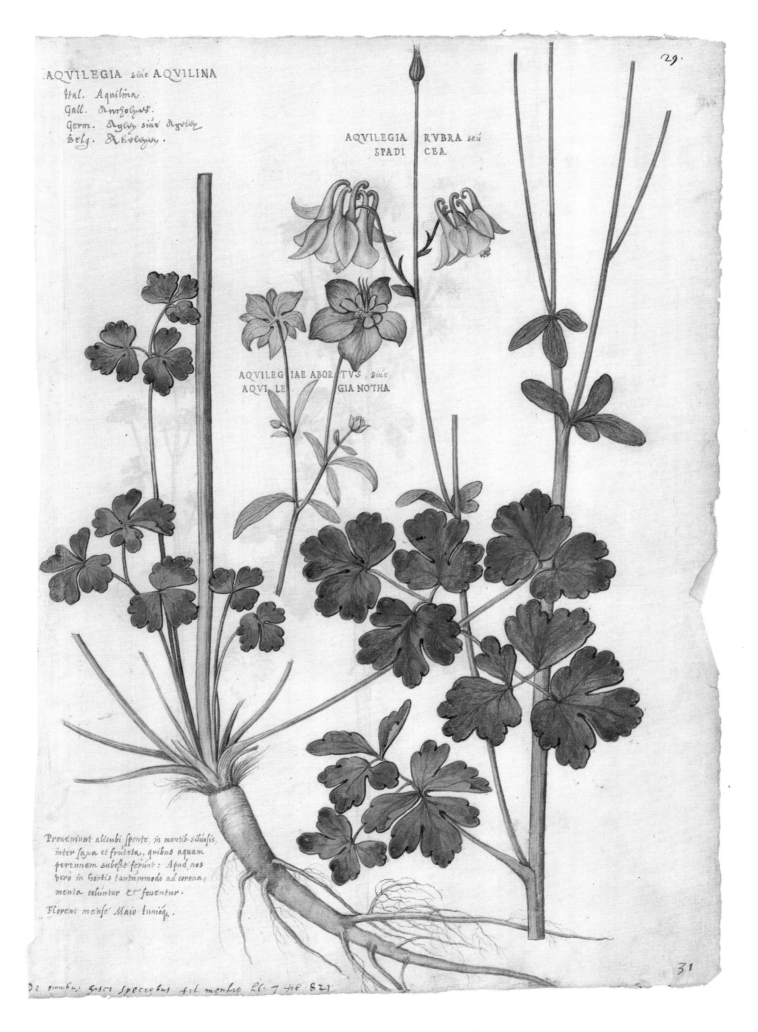

AQVILEGIA siue AQVILINA

Ital. *Aquilina.*
Gall. *Ancholrie.*
Germ. *Agley siue Agerlei.*
Belg. *Akeleyen.*

AQVILEGIA RVBRA seu
SPADI CEA.

AQVILEGIAE ABORTVS, siue
AQVI LE GIA NOTHA

*Prouemunt alicubi sponte, in montib. siluosis,
inter saxa et fruteta, quibus aquam
perennem subesse serunt: Apud nos
vero in hortis tantummodo ad corona*
menta coluntur et souentur.

Florent mense Maio Iunioq.

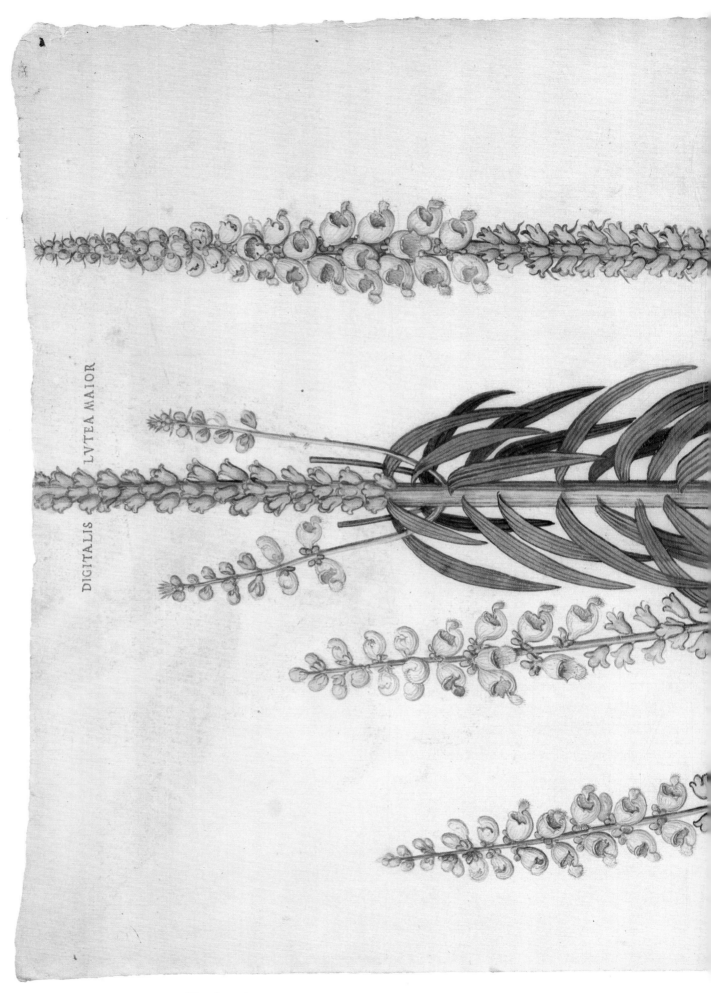

DIGITALIS LVTEA MAIOR

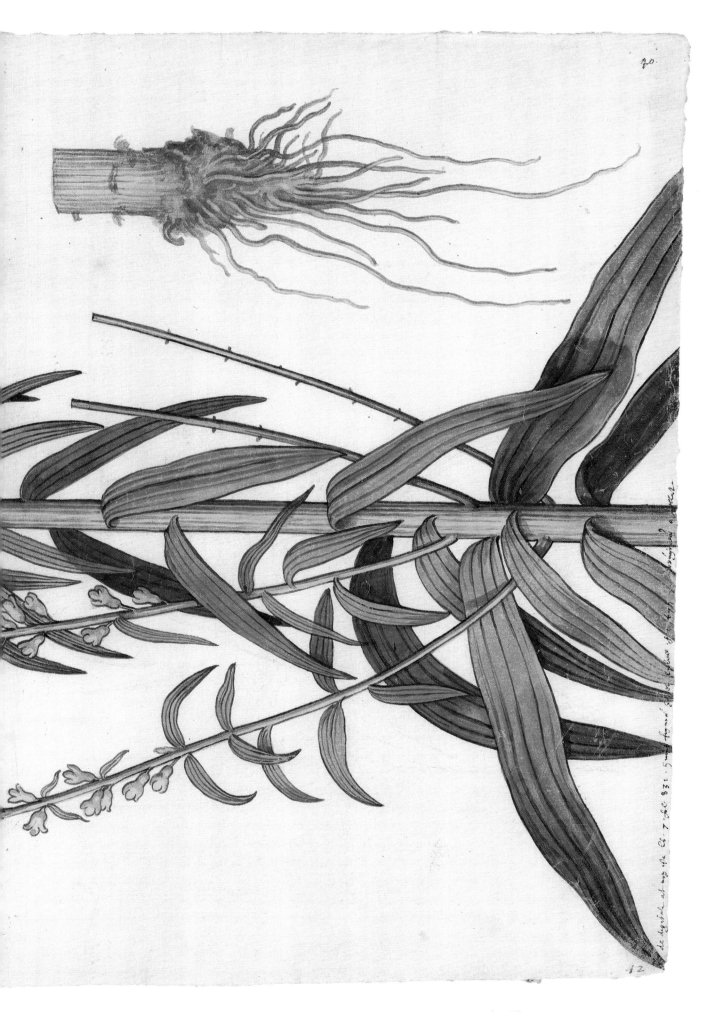

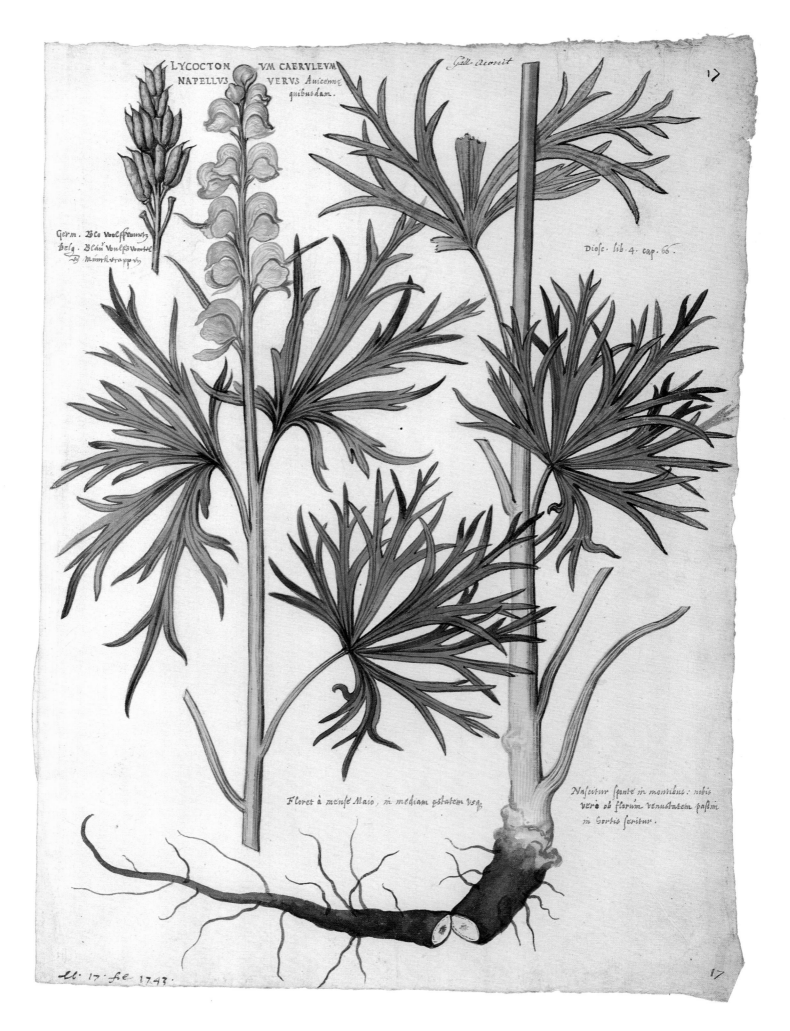

LYCOCTON VM CAERVLEVM
NAPELLVS VERVS Auicenne
quibusdam.

Gall. Aconit

Germ. Blo Woolffrantz
Belg. Blau Woolfs Wortel
Dy Munchskrappen

Diosc. lib. 4. cap. 66.

Floret à mense Maio, in mediam gstatem vsq,

Nascitur sponte in montibus: nobis
verò ob florum venustatem passim
in hortis seritur.

M. 17. fle 1743.

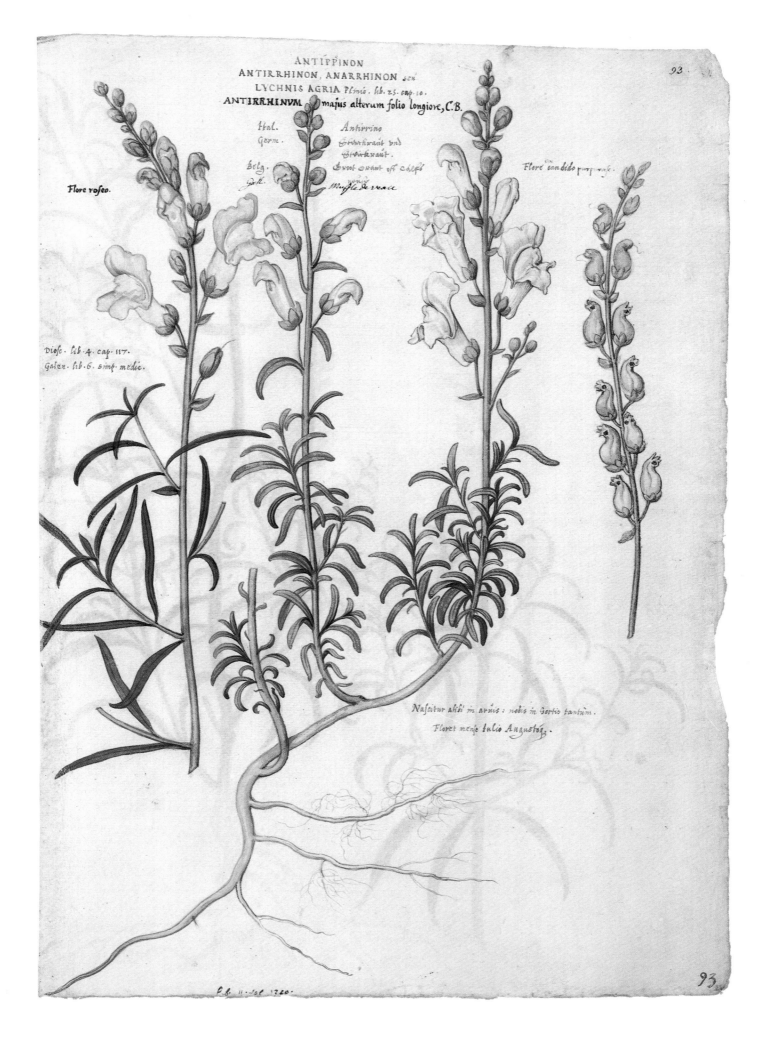

ANTÍPPINON
ANTIRRHINON, ANARRHINON *seu*
LYCHNIS AGRIA *Plinio. lib. 25. cap. 10.*
ANTIRRHINVM *majus alterum folio longiore, C.B.*

Flore roseo.

Ital. Antirrino
Germ. Frauchraut vnd
 Storchraut.
Belg. Groot Orant oft calfs
Gall. snuÿt
 Mufle de veau

Flore candido purpurante.

Diosc. lib. 4. cap. 117.
Galen. lib. 6. simp. medic.

Nascitur alibi in aruis: nobis in hortis tantùm.

Floret mense Iulio Augusto.

C.C. II. Iul. 1700.

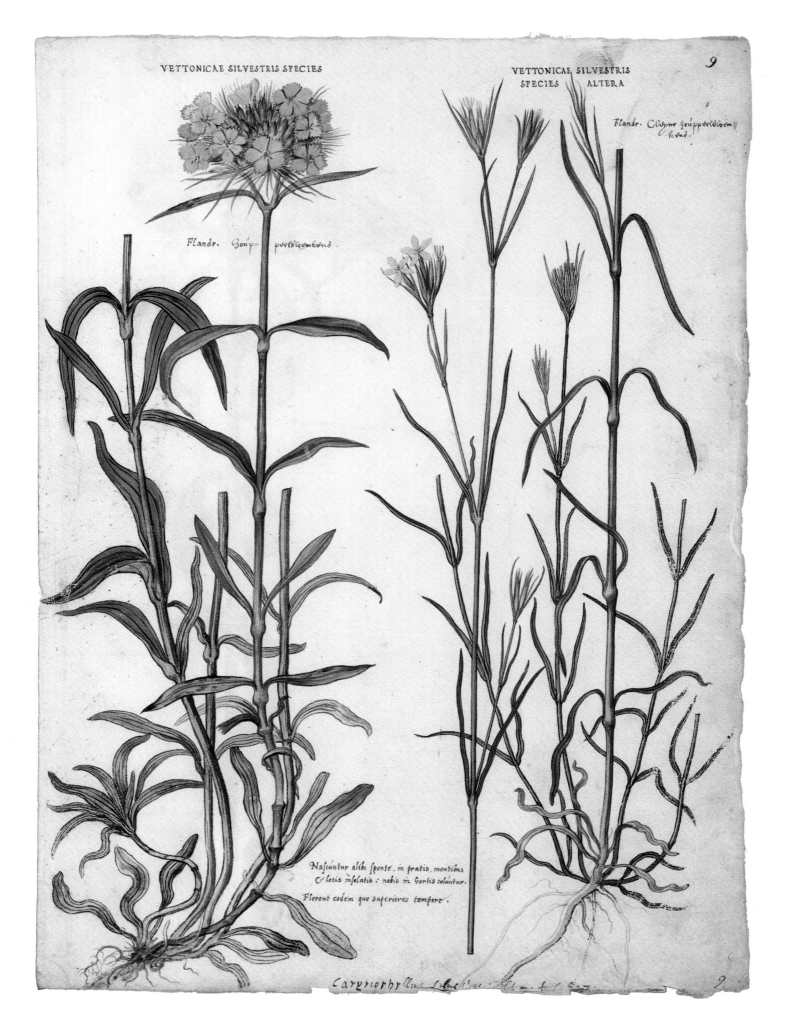

VETTONICAE SILVESTRIS SPECIES

VETTONICAE SILVESTRIS
SPECIES ALTERA

9

Flandr. Gouy-

Flandr. Clsynr Gouppwelbbem

Flandr. Gouy- pwelblomkens.

Nascuntur alibi sponte, in pratis, montibus & locis insolatis: nobis in hortis coluntur.

Florent eodem quo superiores tempore.

Caryophyllus Silvestris

9

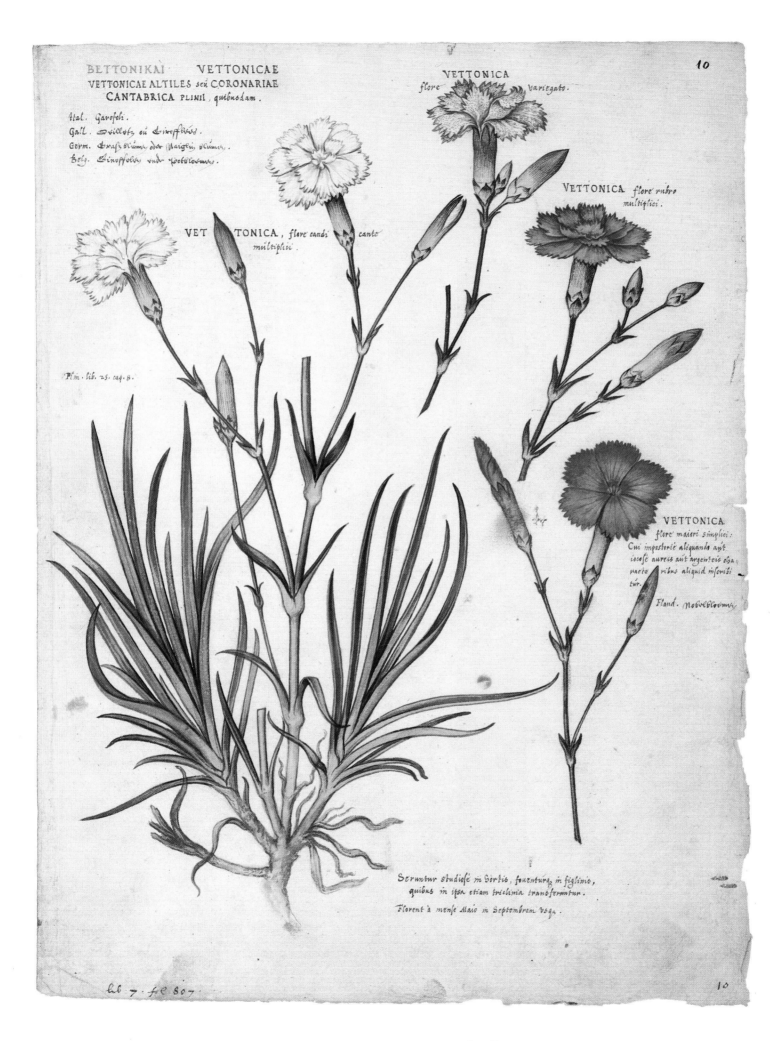

BETTONIKAI VETTONICAE
VETTONICAE ALTILES seu CORONARIAE
CANTABRICA PLINII, quibusdam.

Ital. Garofoli.
Gall. Oeillets ou Girofflées.
Germ. Grasz blume oder Margen blume.
Belg. Ginoffolen vnd Nobelbloemen.

VETTONICA
flore variegato.

VETTONICA, flore candi cante
multiplici.

VETTONICA flore rubro
multiplici.

Plin. lib. 25. cap. 8.

VETTONICA
flore maiori simplici:
Cui imposturie aliquando aut
iocose aureis aut argenteis cha
racte ribus aliquid inscribi
tur.

Fland. Nobelbloemen.

Seruntur studiose in hortis, fouentur in figlinis,
quibus in ipsa etiam trichnia transferuntur.

Florent à mense Maio in Septembrem vsqz.

lib. 7. fol 807.

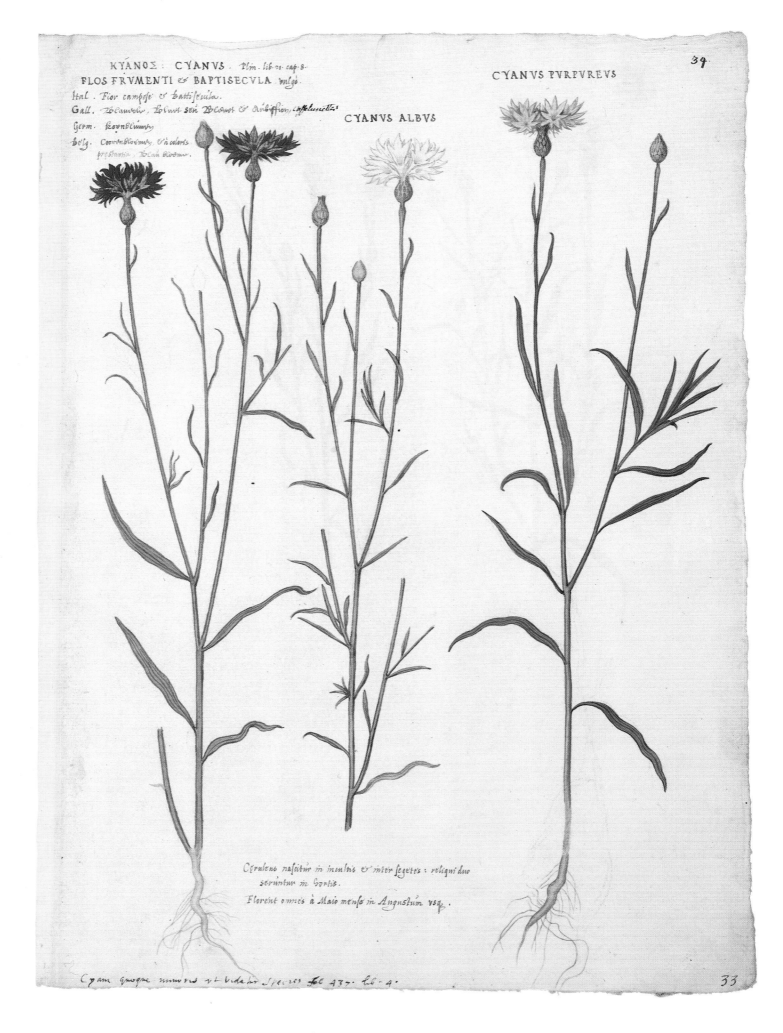

KYANOΣ: CYANVS. *Plin. lib. 21. cap. 8.*
FLOS FRVMENTI & BAPTISECVLA *vulgò.*

Ital. *Fior campeste & battisecula.*
Gall. *Bleauoir, Bluet seu Bleavet & Ambisson, Casselunette.*
Germ. *kornblumen.*
Belg. *Coornbloemen, 't'n coloris prestantia, Blau bloemen.*

CYANVS ALBVS

CYANVS PVRPVREVS

Cæruleus nascitur in incultis & inter segetes : reliqui duo seruntur in hortis.

Florent omnes à Maio mense in Augustum vsq.

Cyani quoque numerus vt videbit Species fol. 437. lib. 4.

33

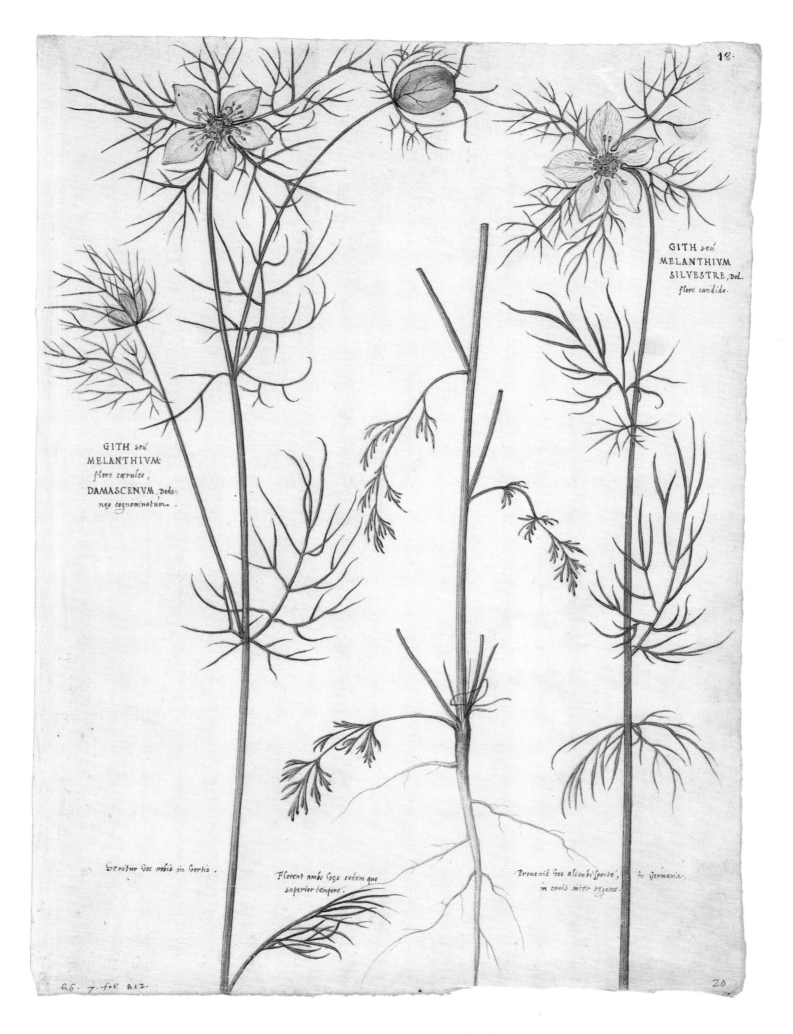

GITH *seu*
MELANTHIVM
SILVESTRE, *Dod.*
flore candido.

GITH *seu*
MELANTHIVM:
flore cæruleo,
DAMASCENVM, *Dodo-*
næo cognominatum.

Seritur hoc nobis in hortis.

Florent ambo hæc eodem quo
superior tempore.

Prouenit hoc alicubi sponte,
in aruis inter segetes.

in Germania,

Cap. 7. fol. 812.

20

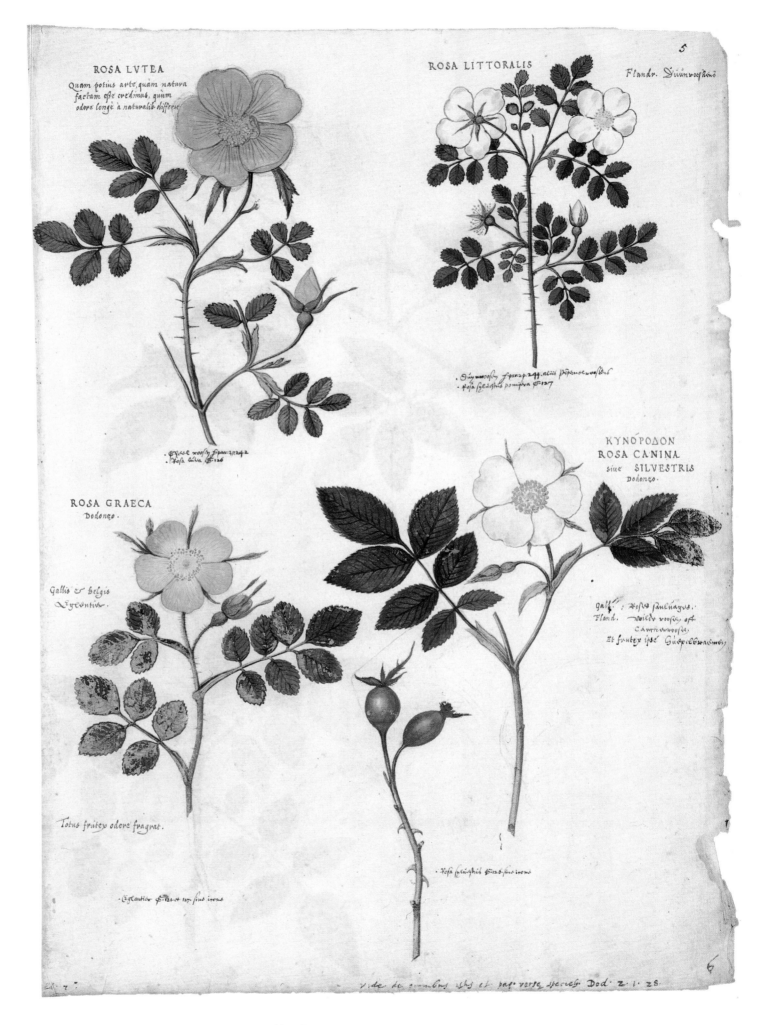

ROSA LVTEA

ROSA LITTORALIS

ROSA GRAECA

KYNÓPOΔON
ROSA CANINA
siue SILVESTRIS

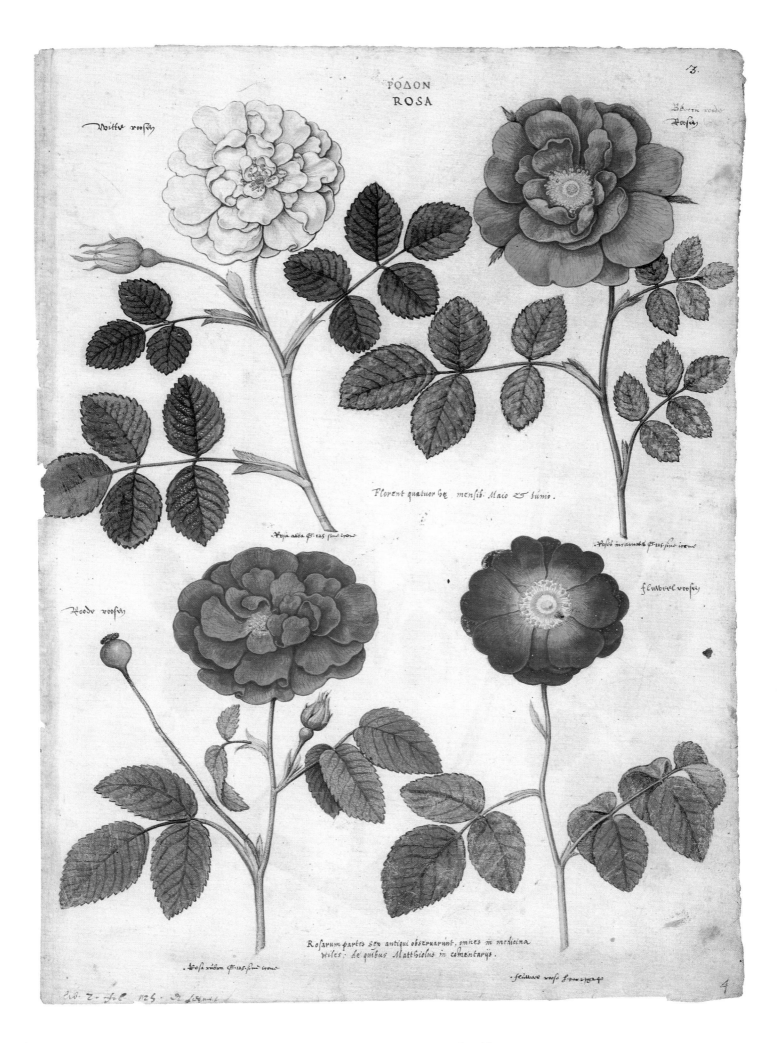

ΡΌΔΟΝ
ROSA

Witte roosen

Bruin roode
Roosen

Florent quatuor hq mensib: Maio et Iunio.

Rosa alba fl. 125 sine irone

Rosa incarnata fl. 125 sine irone

Hoode roosen

f Cinbrec roosen

Rosarum partes sex antiqui obseruarunt, omnes in medicina
vtiles: de quibus Matthiolus in comentarys.

Rosa rubra fl. 125 sine irone

feininre roosen f. pre 2 p 40

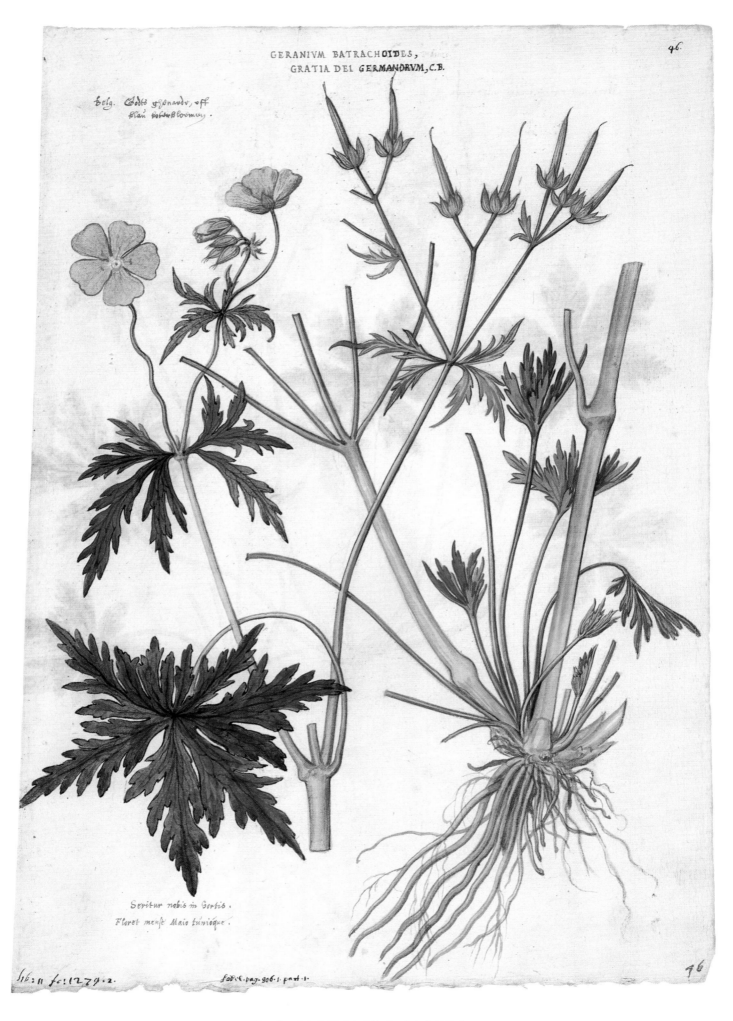

GERANIVM BATRACHOIDES,
GRATIA DEI GERMANDRVM, C.B.

Belg. Godts ghenaedr, oft
klaû voberbloemen.

Seritur nobis in Hortis.
Floret mense Maio tunioque.

lib:11 fc:1279.2 fob:C.pag.906.1.part.1.

46.

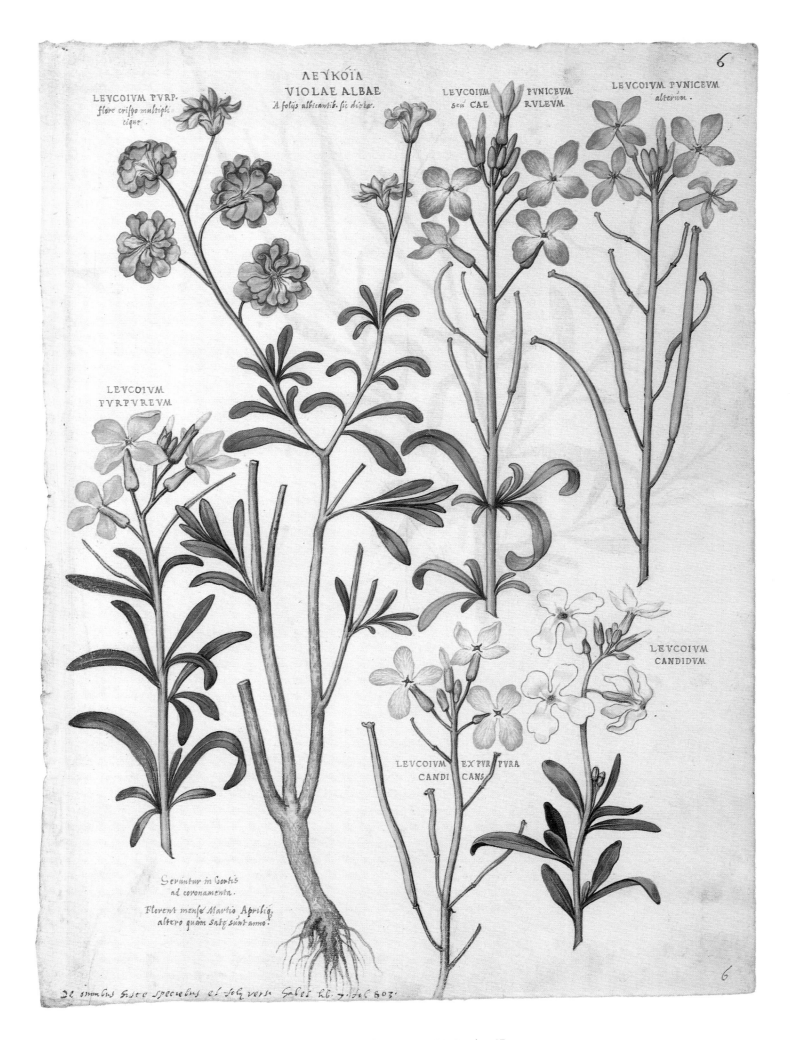

ΛΕΥΚΟΪΑ
VIOLAE ALBAE
A folijs albicantib. sic dictæ.

LEVCOIVM PVRP.
flore crispo multipli
ciqnr.

LEVCOIVM
PVRPVREVM

LEVCOIVM
seu CAE
PVNICEVM
RVLEVM

LEVCOIVM PVNICEVM
alterum.

LEVCOIVM
CANDIDVM

LEVCOIVM EX PVR PVRA
CANDI CANS.

Seruntur in hortis
ad coronamenta.

Florent mense Martio Aprilíq;
altero quàm satq; sunt anno.

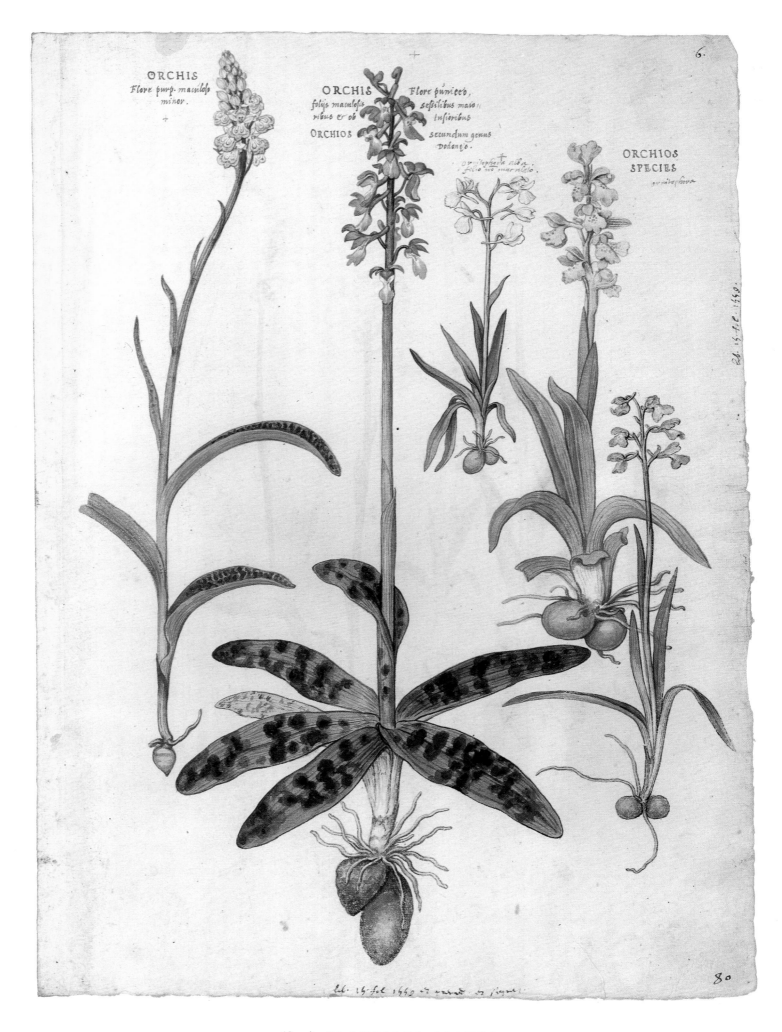

ORCHIS
Flore purp. maculosa
minor.

ORCHIS Flore puniceo,
folijs maculosis sessilibus maio-
ribus & ob Inferioribus
ORCHIOS secundum genus
Dodonei.

ORCHIOS
SPECIES

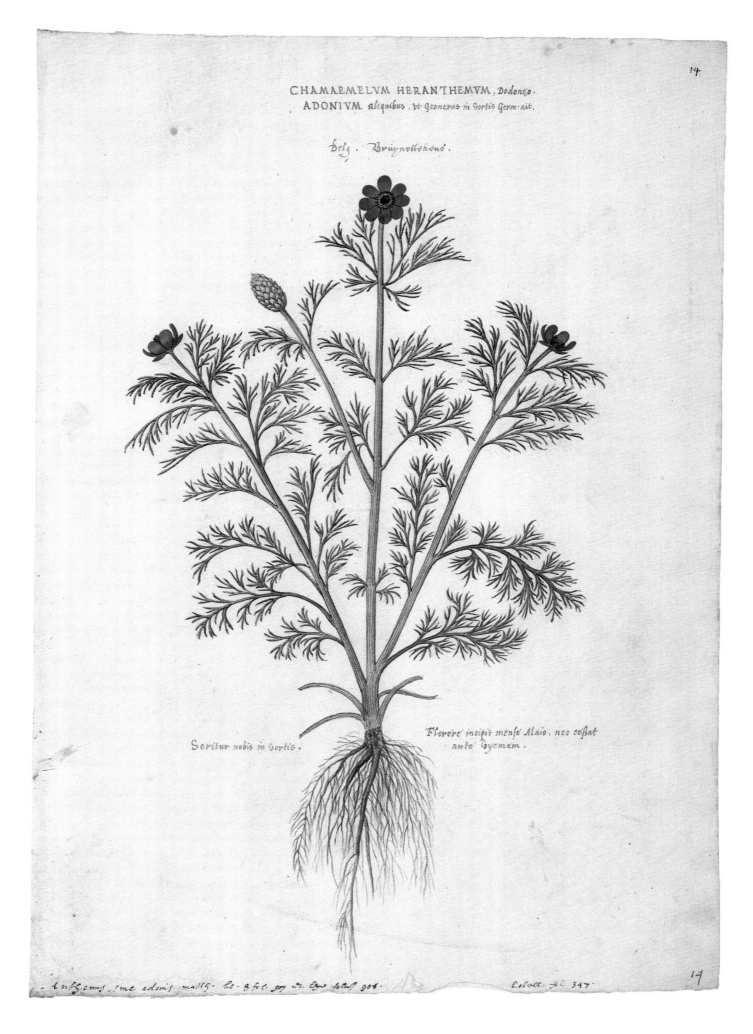

CHAMAEMELVM HERANTHEMVM, *Dodoneo.*
ADONIVM *aliquibus, vt Gesnerus in Hortis Germ. ait.*

Belg. *Bruynotteken*.

Seritur nobis in Hortis.

Florere incipit mense Maio, nec cessat ante hyemem.

Lobell. fol. 347.

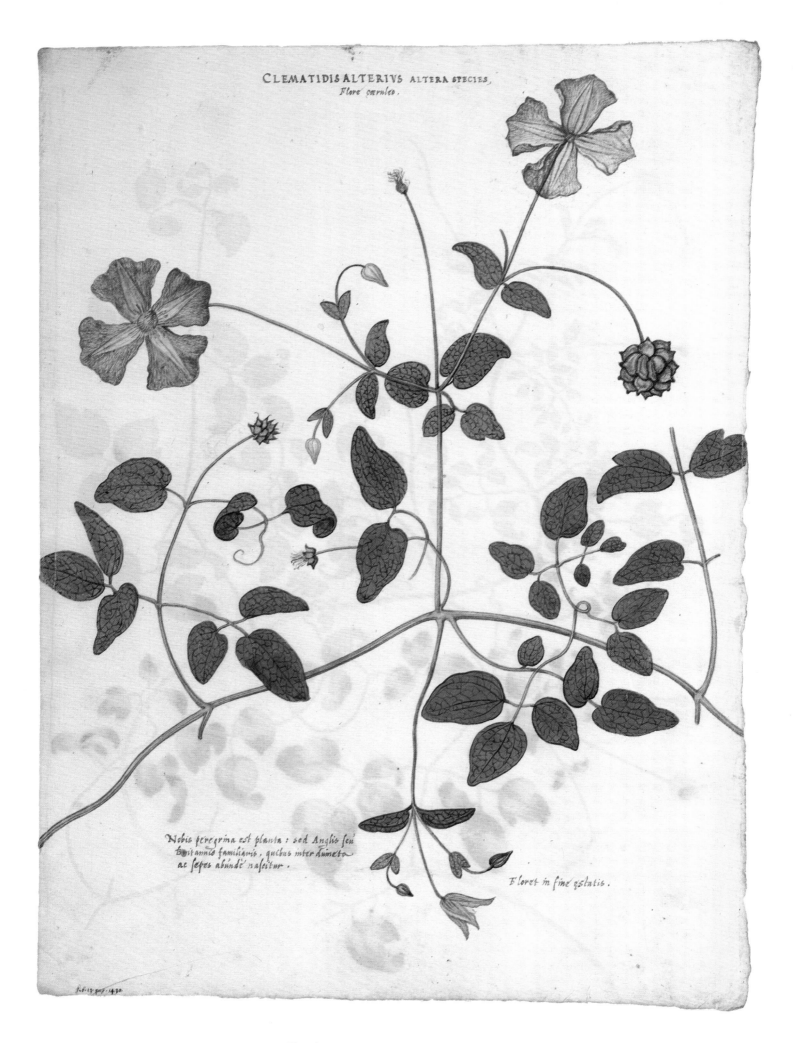

Nobis peregrina est planta : sed Anglis seu
Britannis familiaris, quibus inter dumeta
ac sepes abundè nascitur.

Floret in fine æstatis.

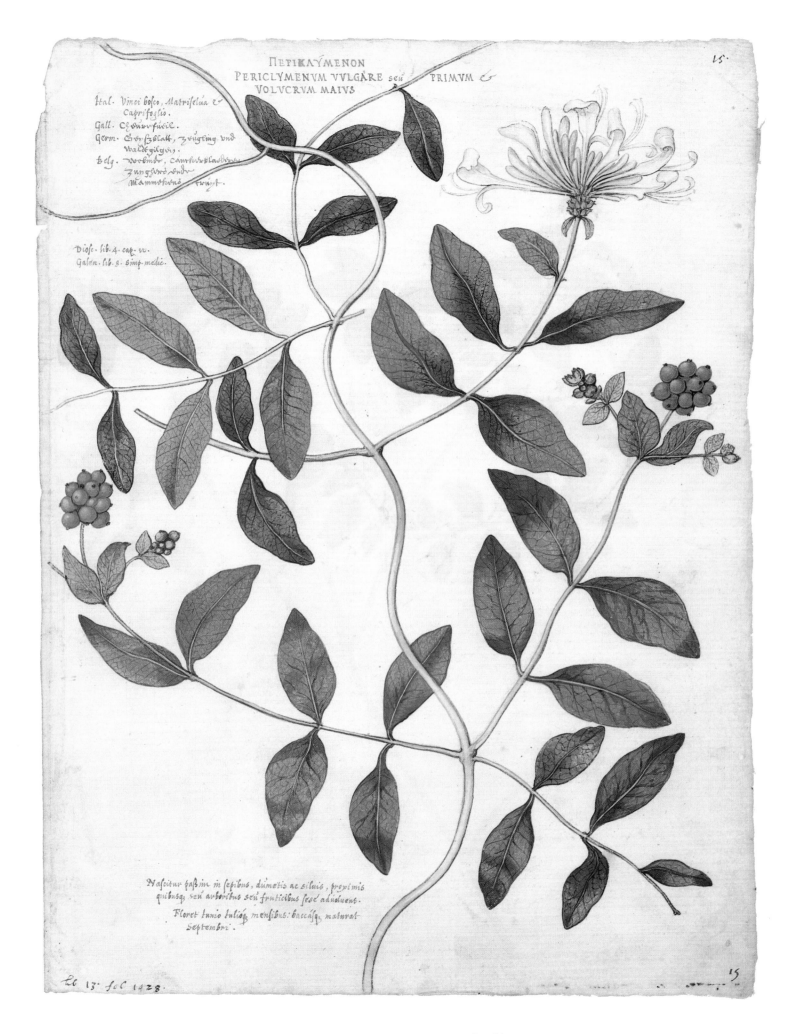

ΠΕΡΙΚΛΎΜΕΝΟΝ
PERICLYMENVM VVLGARE seu PRIMVM &
VOLVCRVM MAIVS

Ital. *Vinci bosco, Matrisselua &*
Caprifoglio.
Gall. *Ce ouer fueil.*
Germ. *Geyssblatt, Zeugling vnd*
Waldtgilgen.
Belg. *Welrberb, Camfuerplasblom,*
Zungsbet vnd
Mammokens kruyt.

Diosc. *lib. 4. cap. vi.*
Galen. *lib. 8. simp. medic.*

Nascitur passim in sepibus, dumetis ac siluis, proximis
quibusq; seu arboribus seu fruticibus sese adiuduens.

Floret Iunio Iulióq; mensibus: baccásq; maturat
Septembri.

ce 13. fol 1428.

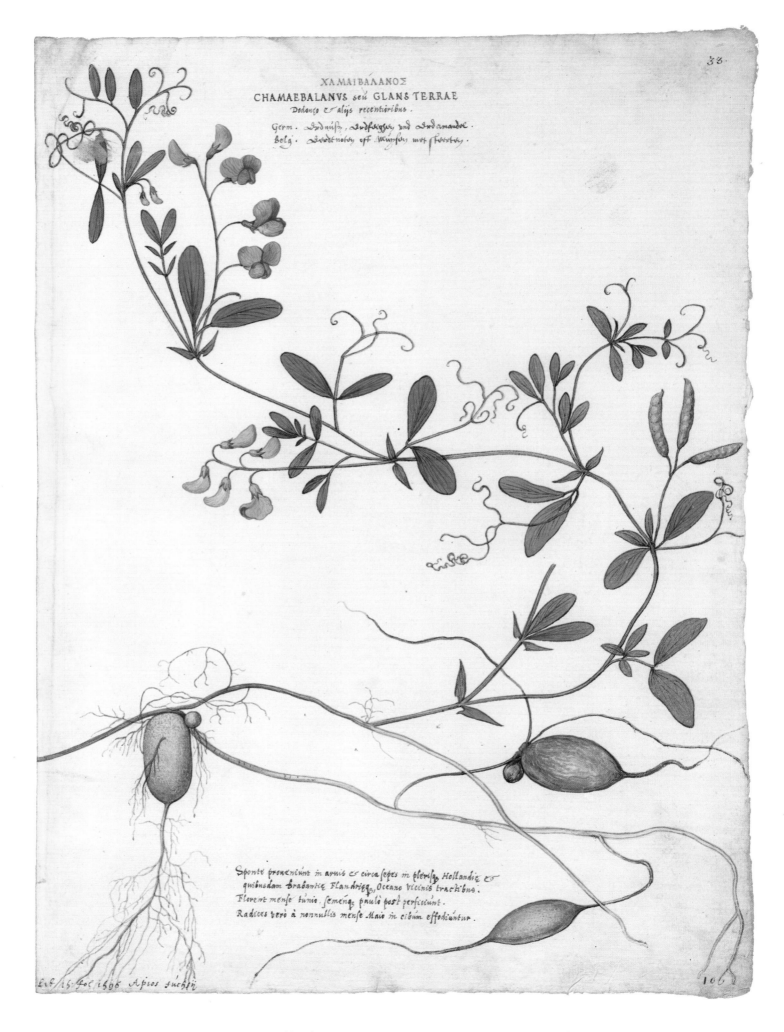

ΧΑΜΑΙΒΑΛΑΝΟΣ
CHAMAEBALANVS seū GLANS TERRAE
Dodonço & alijs recentioribus.

Germ. *Erdnüss, Erdfeigen vnd Erdamandel*
Belg. *Erdtnoten oft Muysen met staerten.*

Sponte proueniunt in arnis et circa sepes in plerisq Hollandiæ et quibusdam Brabantiæ Flandriæq, Oceano vicinis tracsibus. Florent mense Iunio. semenq paulo post perficiunt. Radices vero à nonnullis mense Maio in cibum effodiuntur.

Exb/ 15 Joc 1596 Apios sucsen

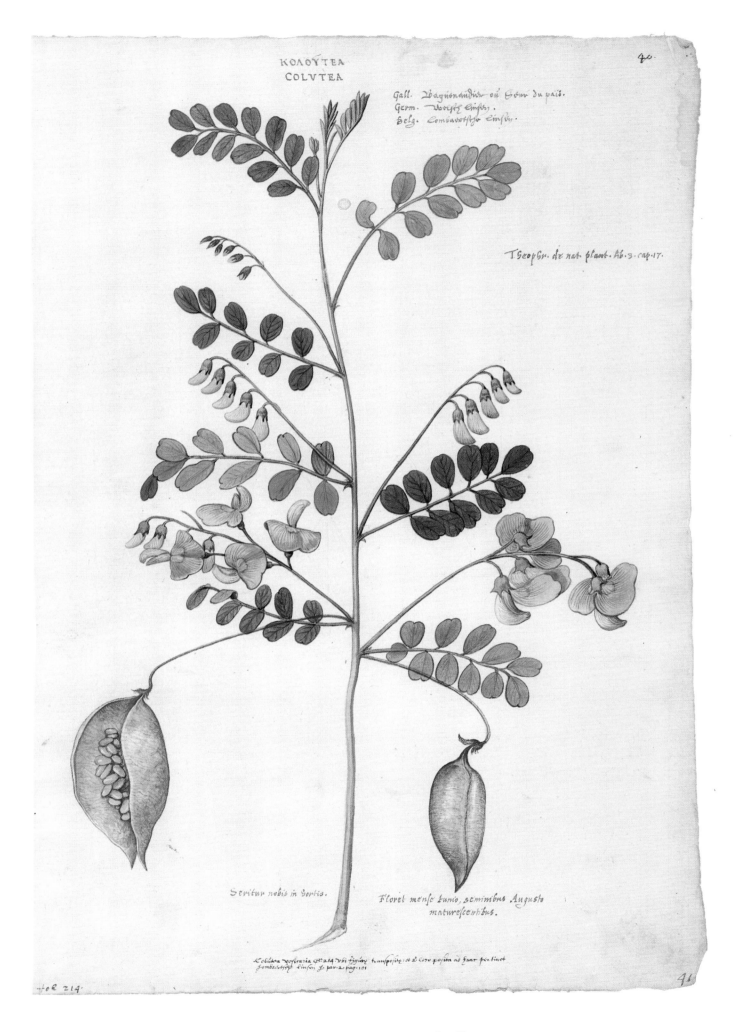

KOΛOΫTEA
COLVTEA

Gall. *Baguénaudier où Séne du país.*
Germ. *Vogelsch Linsen.*
Belg. *Lombardtsche Linsen.*

Theophr. de nat. plant. lib. 3. cap. 17.

Seritur nobis in hortis.

Floret mense Iunio, seminibus Augusto maturescentibus.

Colutea vesicaria & 214 ubi figura transposita: H & toto posita ad hanc pertinet Lombardtsche Linsen L par. 2. pag. 101

fol 214.

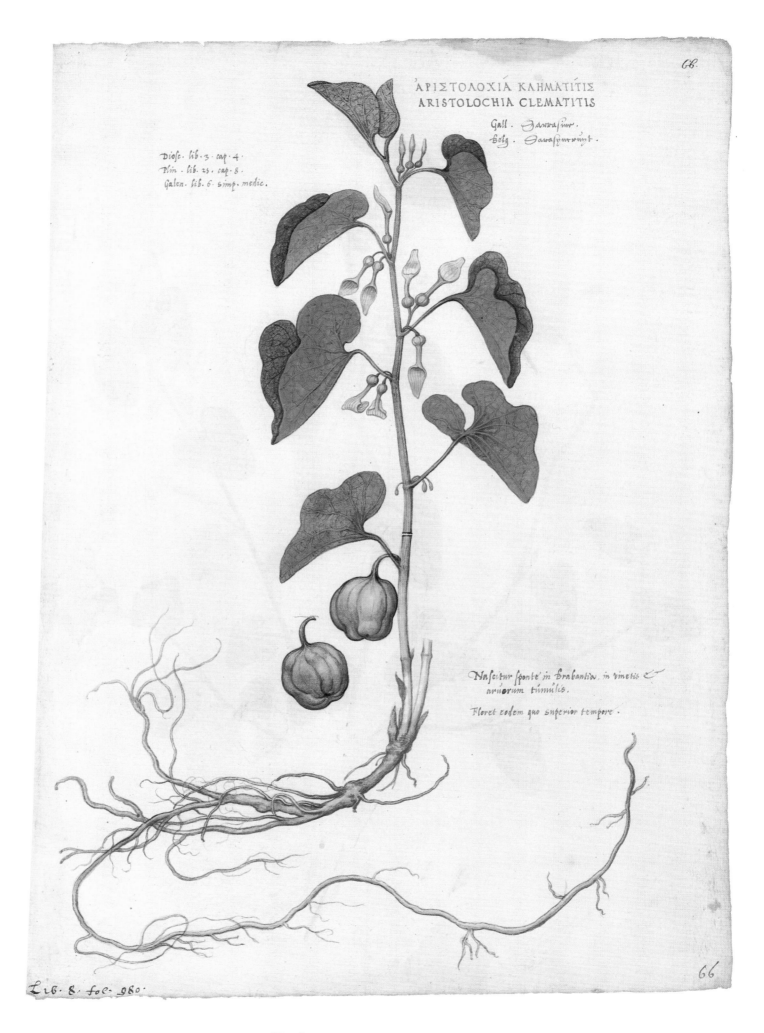

ΆΡΙΣΤΟΛΟΧΙΆ ΚΛΗΜΑΤΊΤΙΣ
ARISTOLOCHIA CLEMATITIS

Gall. *Sarrasin.*
Belg. *Sarasyncruyt.*

Diosc. lib. 3. cap. 4.
Plin. lib. 25. cap. 8.
Galen. lib. 6. simp. medic.

Nascitur sponte in Brabantia, in vinetis &
arborum tumulis.

Floret eodem quo superior tempore.

Lib. 8. fol. 980.

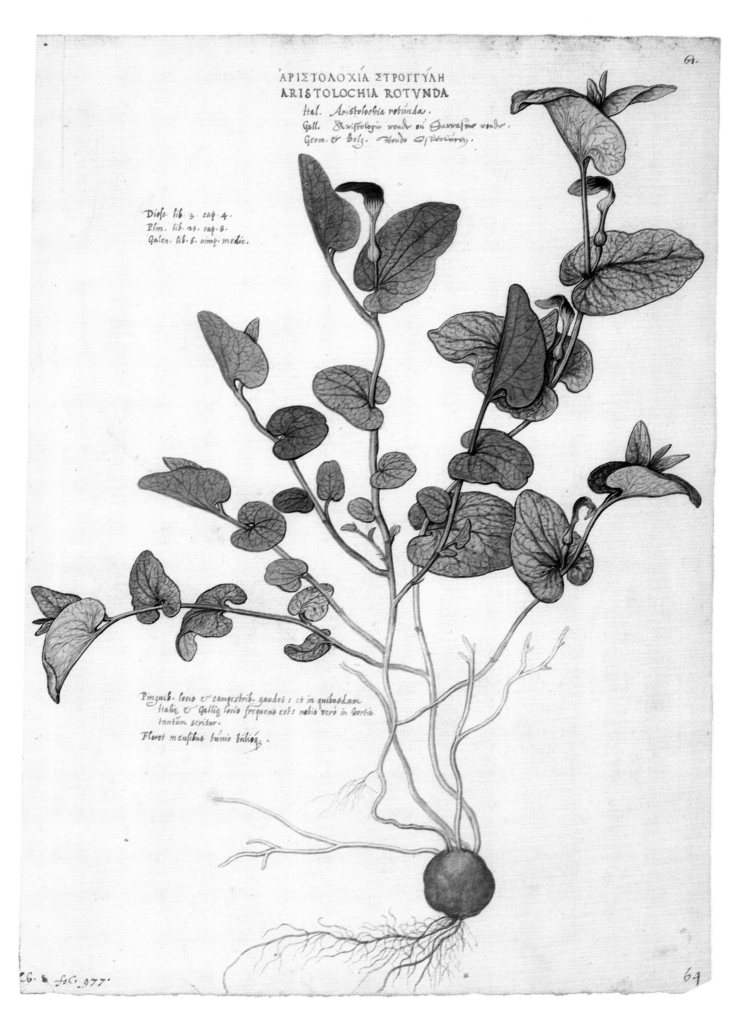

ΑΡΙΣΤΟΛΟΧΙΑ ΣΤΡΟΓΓΥΛΗ
ARISTOLOCHIA ROTVNDA
Ital. Aristolochia rotunda.
Gall. Aristologie ronde ou Sarrasine ronde.
Germ. & Belg. Ronde Osterlucey.

Diosc. lib. 3. cap. 4.
Plin. lib. 25. cap. 8.
Galen. lib. 6. simp. medic.

Pinguib. locis & campestrib. gaudet : et in quibusdam
Italiæ & Galliæ locis frequens est: nobis verò in hortis
tantùm scritur.
Floret mensibus Iunio Iulióq;

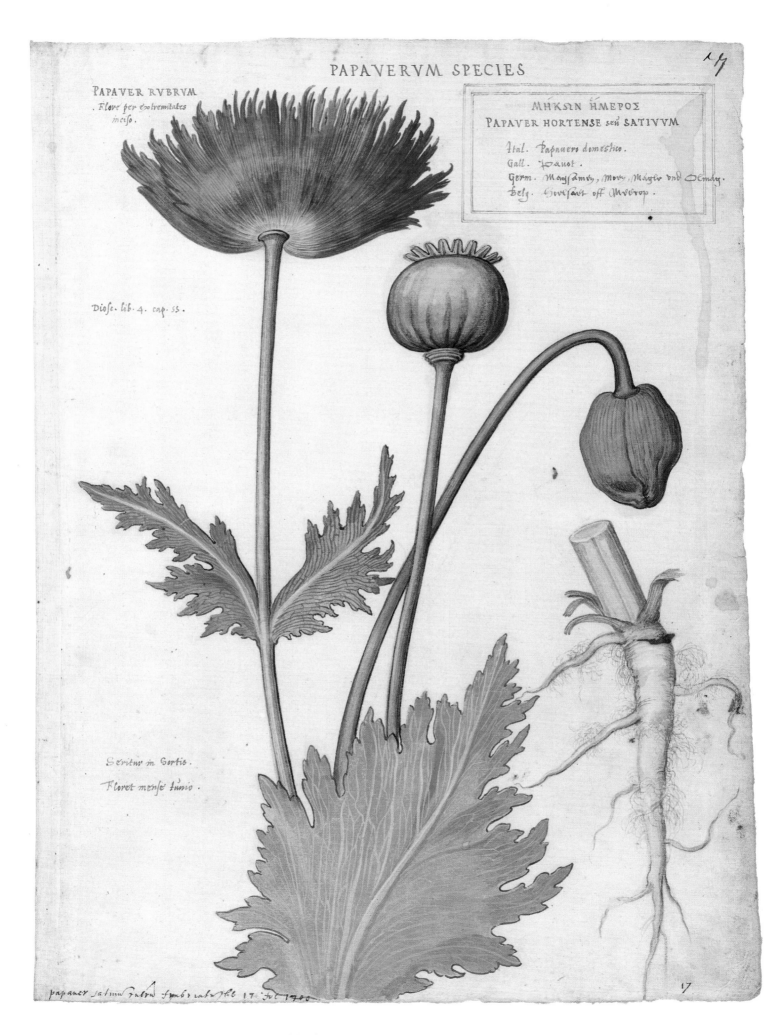

PAPAVER RVBRVM
. Flore per extremitates
inciso.

ΜΗΚΩΝ ΉΜΕΡΟΣ
PAPAVER HORTENSE seu SATIVVM

Ital. Papauero domestico.
Gall. Pauot.
Germ. Magsamen, Mone, Magen vnd Olmag.
Belg. Hovesaut off Mueron.

Diosc. lib. 4. cap. 55.

Seritur in Hortis.

Floret mense Iunio.

papaver salinu rubru fymbriatu the 17 Jul 1700.

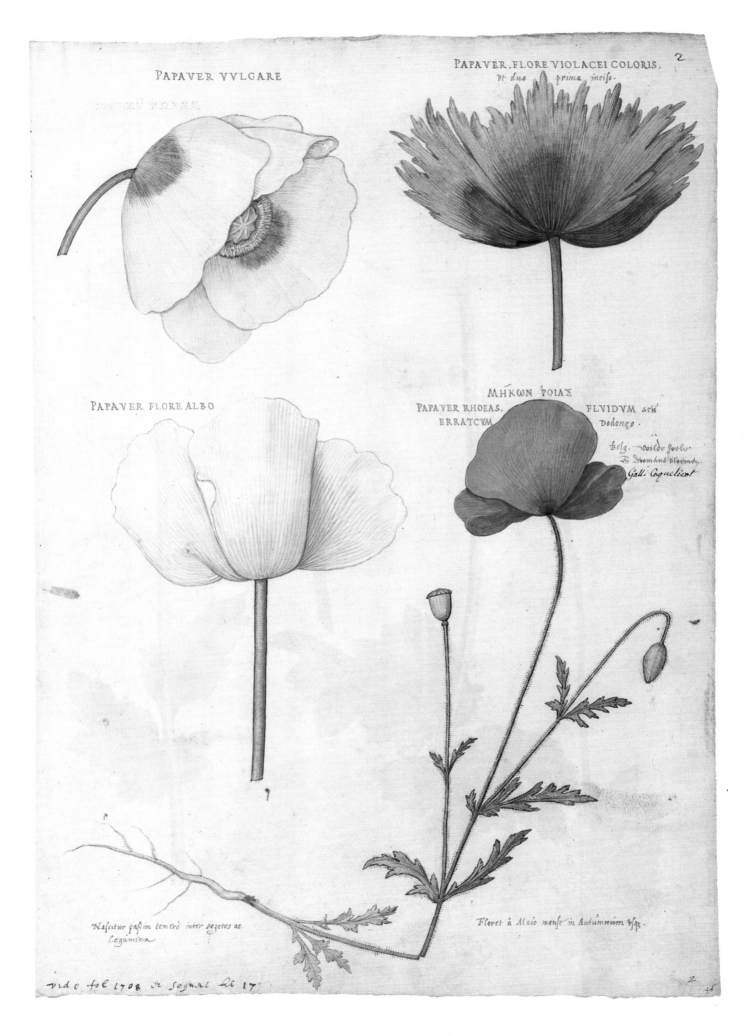

PAPAVER VVLGARE

PAPAVER, FLORE VIOLACEI COLORIS,
Vt duo prima inciso.

PAPAVER FLORE ALBO

ΜΗΚΩΝ ΡΟΙΑΣ
PAPAVER RHOEAS, FLVIDVM seu
ERRATCVM Dodongo.

Belg. wilde gouh.
B Doomhns bloemdy,
Gall. Coquelicot

Nascetur passim temtre inter segetes ac
Legumina

Floret à Maio mense in Autumnum Vsq.

vide fol 1708 et Sognal lib 17.

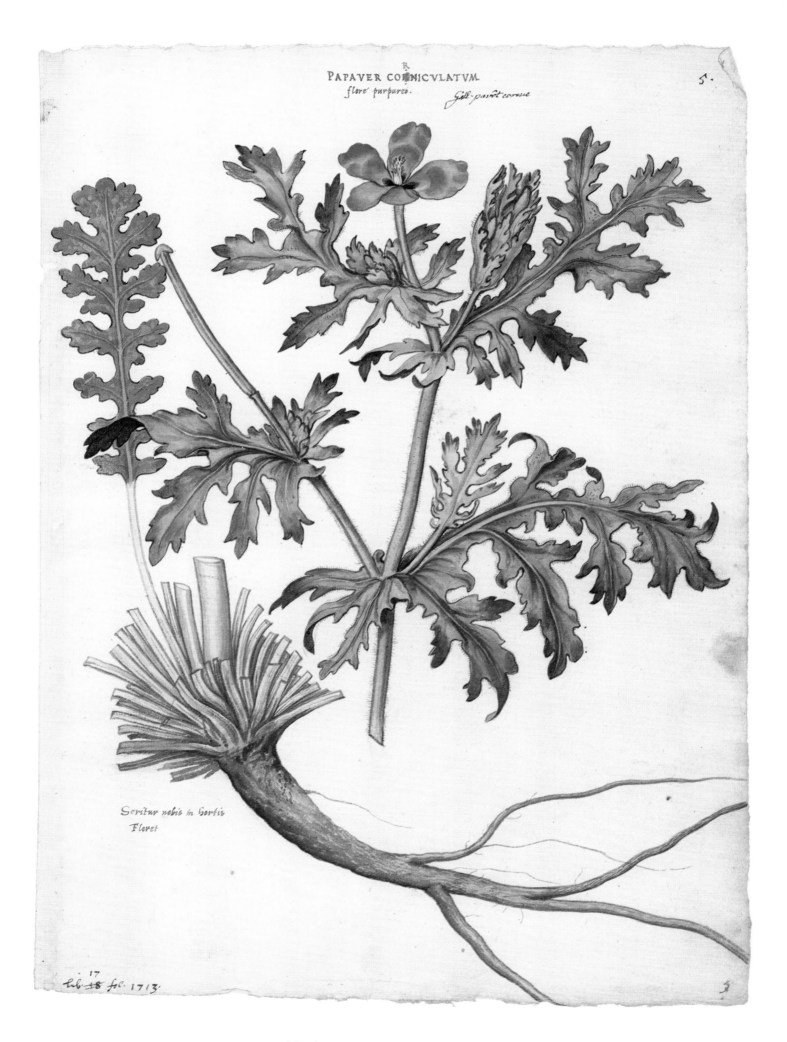

PAPAVER CORNICVLATVM
flore purpureo. Gill-pavot cornue

R

5.

Seritur nobis in hortis
Floret

17
lib. 18 fol. 1713. 3

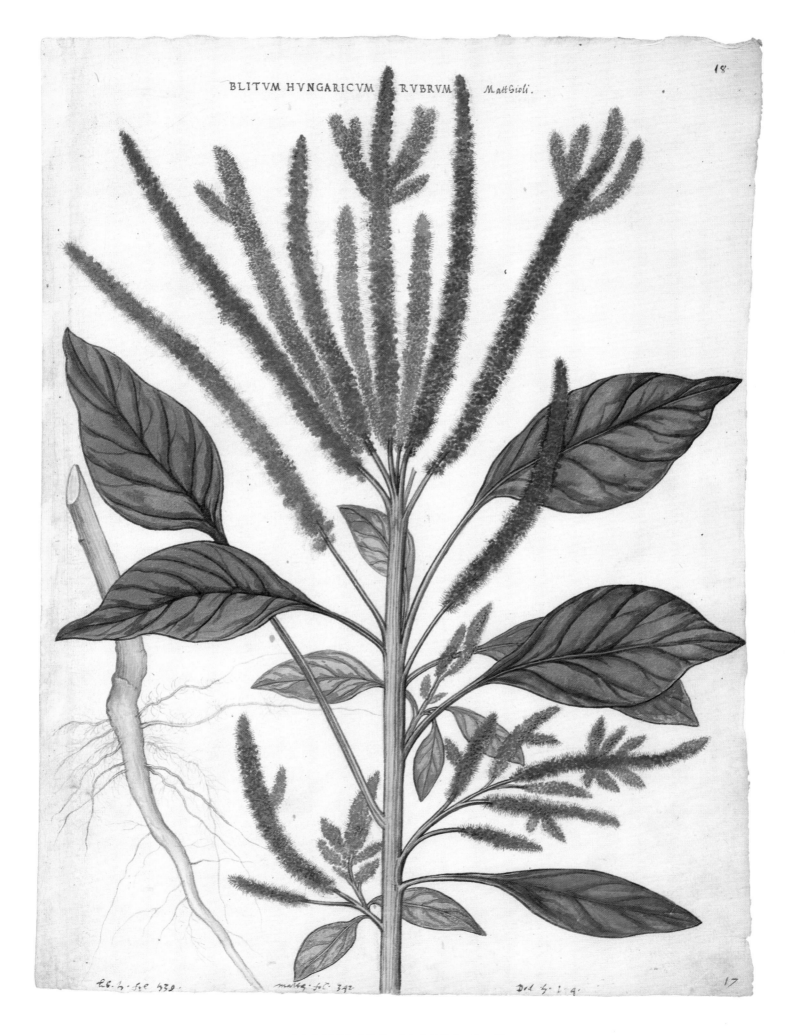

BLITVM HVNGARICVM RVBRVM Mattgioli.

18·

17

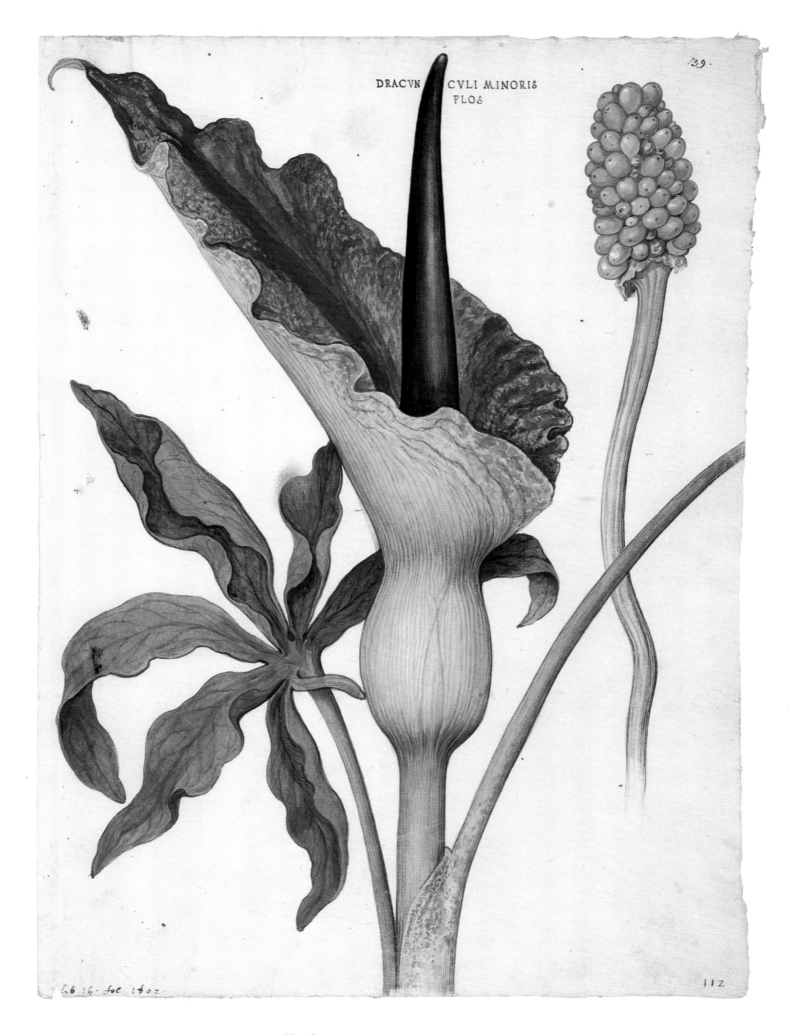

DRACVN CVLI MINORIS
PLOS

139.

112

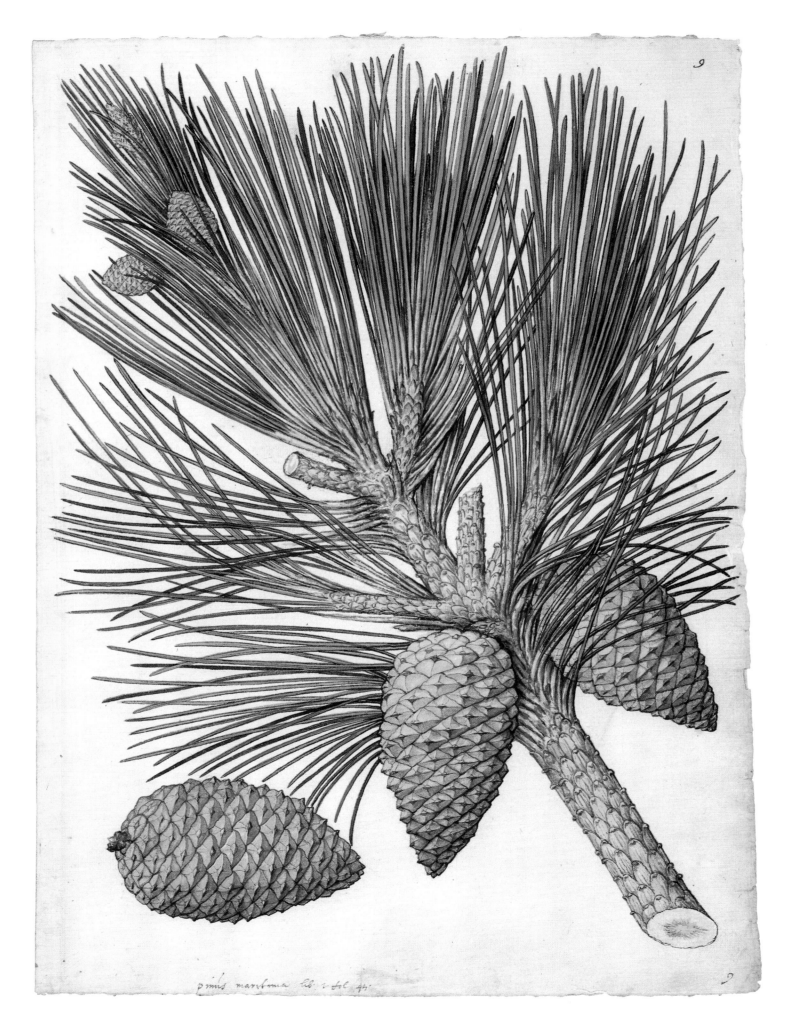

9

pinus maritima lib. 1 fol. 44.

2

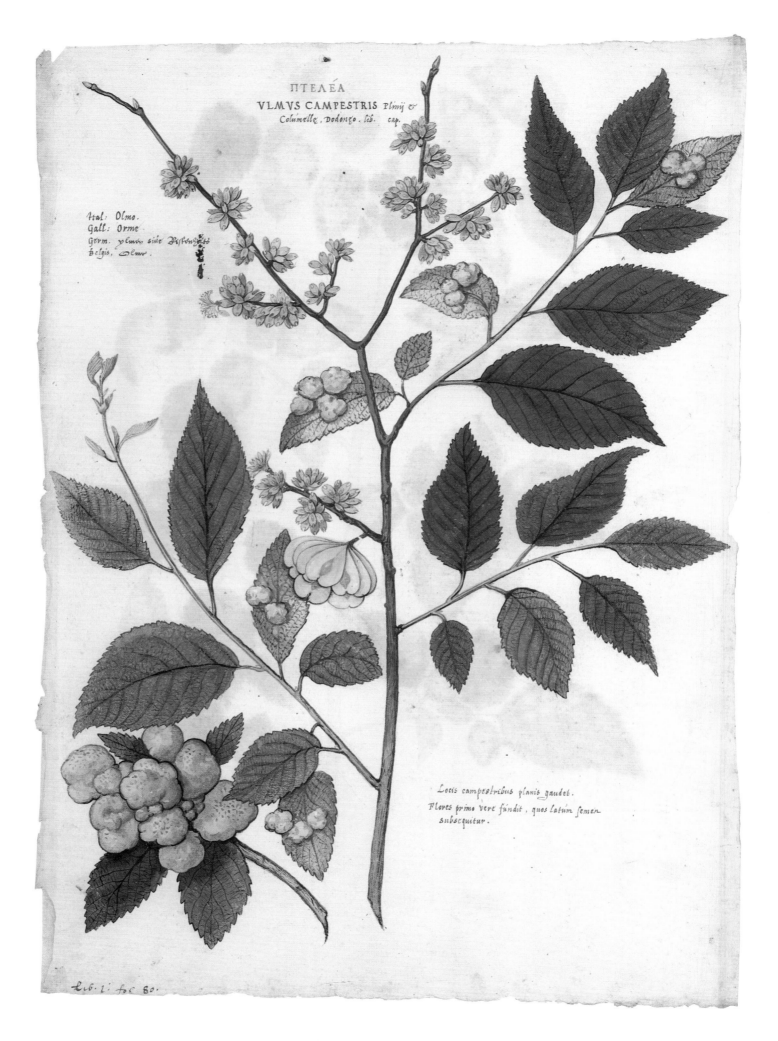

ΠΤΕΛΕΑ

VLMVS CAMPESTRIS *Plinij &*
Columellæ, Dodonæo . lib. cap.

Ital: Olmo.
Gall: Orme
Germ. *ylmen siue Asskenpeti*
Belgis, Olme.

Locis campestribus planis gaudet.
Flores primo vere fundit , quos latum semen
subsequitur.

lib. 1. foc 60.

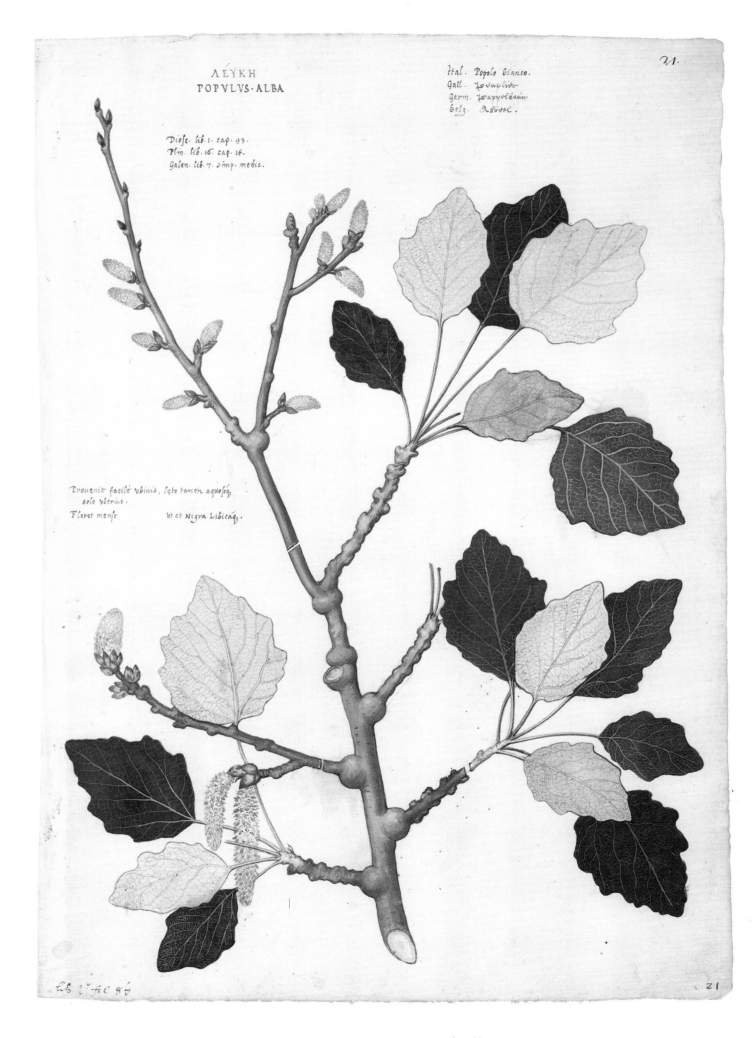

ΛΕΥΚΗ
POPVLVS·ALBA

Ital. Popolo Bianco.
Gall.
Germ.
Belg.

Diosc. lib. 1. cap. 93.
Plin. lib. 16. cap. 18.
Galen. lib. 7. simp. medic.

Prouenit facile vbinis, lęto tamen aquosoq,
solo vberius.
Floret mense vt et Nigra Libicaq,.

21

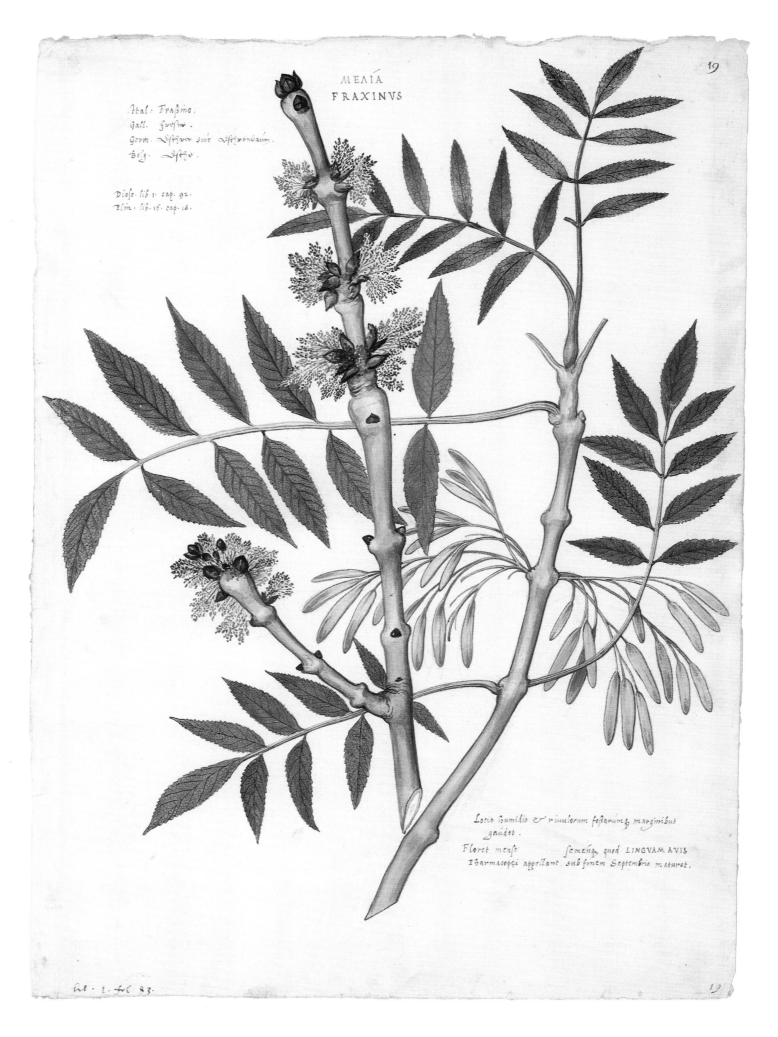

MEΛIA
FRAXINVS

Ital· Fraßino·
Gall· furfut·
Germ· Eschern sint Eschernbaum·
Belg· Esche·

Diosc· lib·1· cap· 92·
Plin· lib· 16· cap· 16·

Locus humilis & riuulorum fossarumq, marginibus
gaudet·
Floret mense semenq, quod LINGVAM AVIS
Pharmacopæi appellant· sub finem Septembris maturat·

lib· 1· fol· 83· 19

SALIX AQVATICA ALTERA

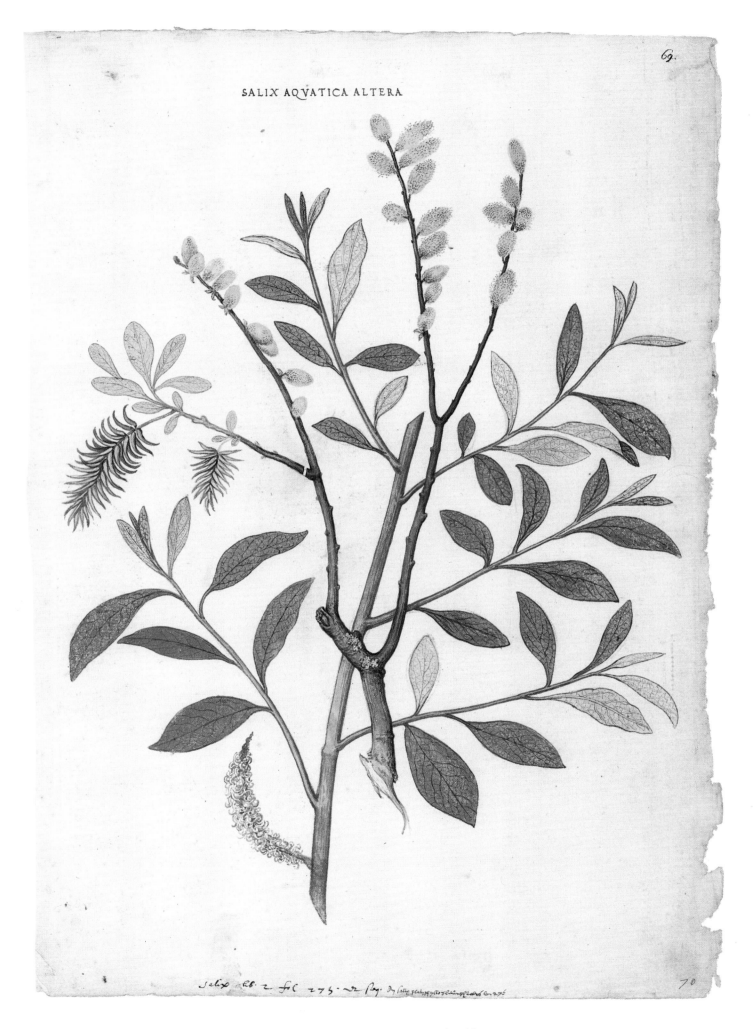

Salix alb. 2 fol 275. v2 seq. Dy salix [handwritten notes]

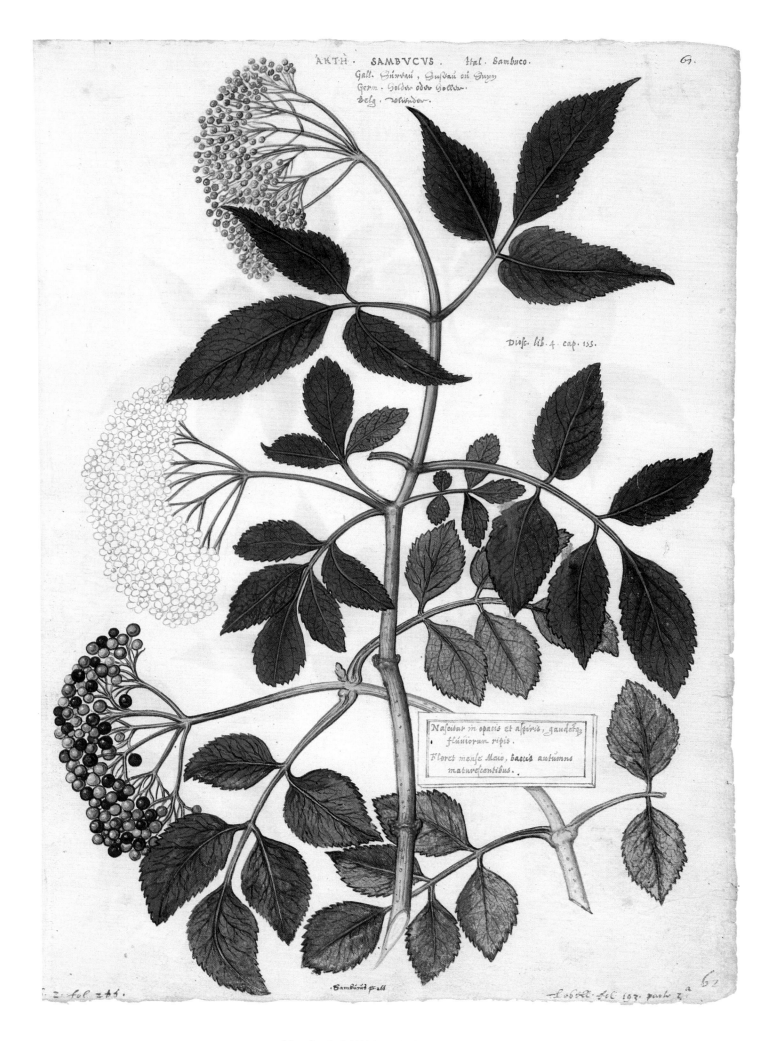

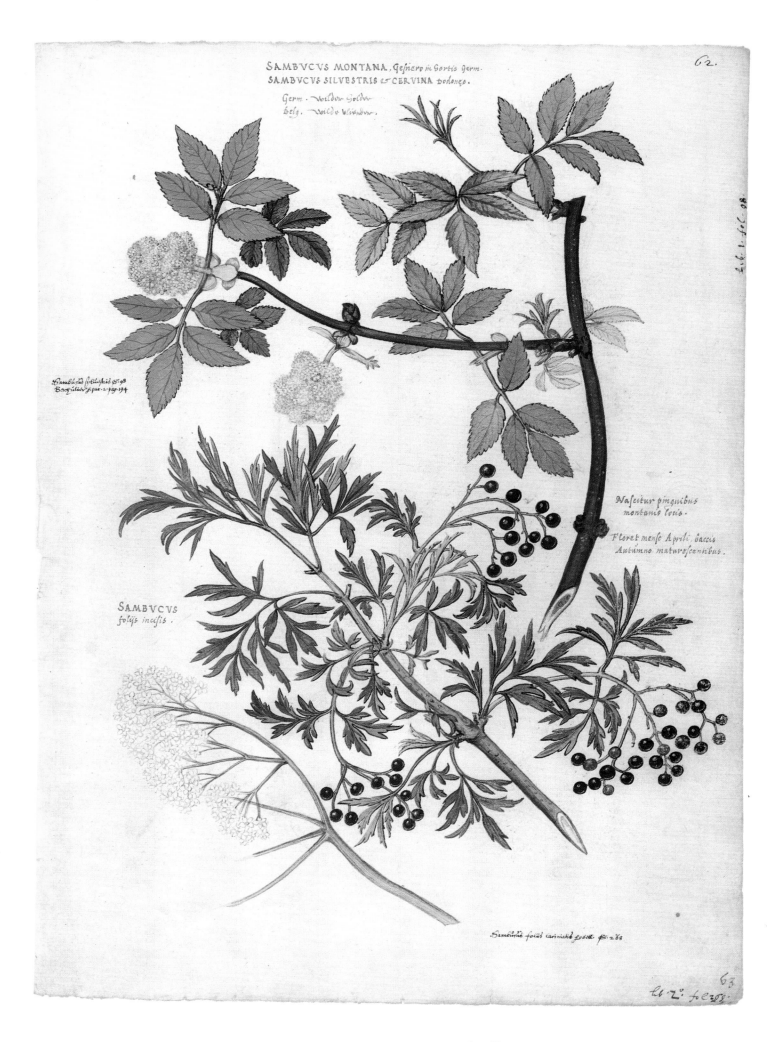

SAMBVCVS MONTANA, *Gesnero in Hortis Germ.*
SAMBVCVS SILVESTRIS *et* CERVINA *Dolonço.*

Germ . *Wilder Holder*
Belg . *wilde vlierder* .

Sambucus sylvestris 95-98
Bauhinus par. 2 pag. 194

SAMBVCVS
folijs incisis .

Nascitur pinguibus
montanis locis .

Floret mense Aprili, baccis
Autumno maturescentibus .

Sambucus folijs laciniatis Loesel. p. 288

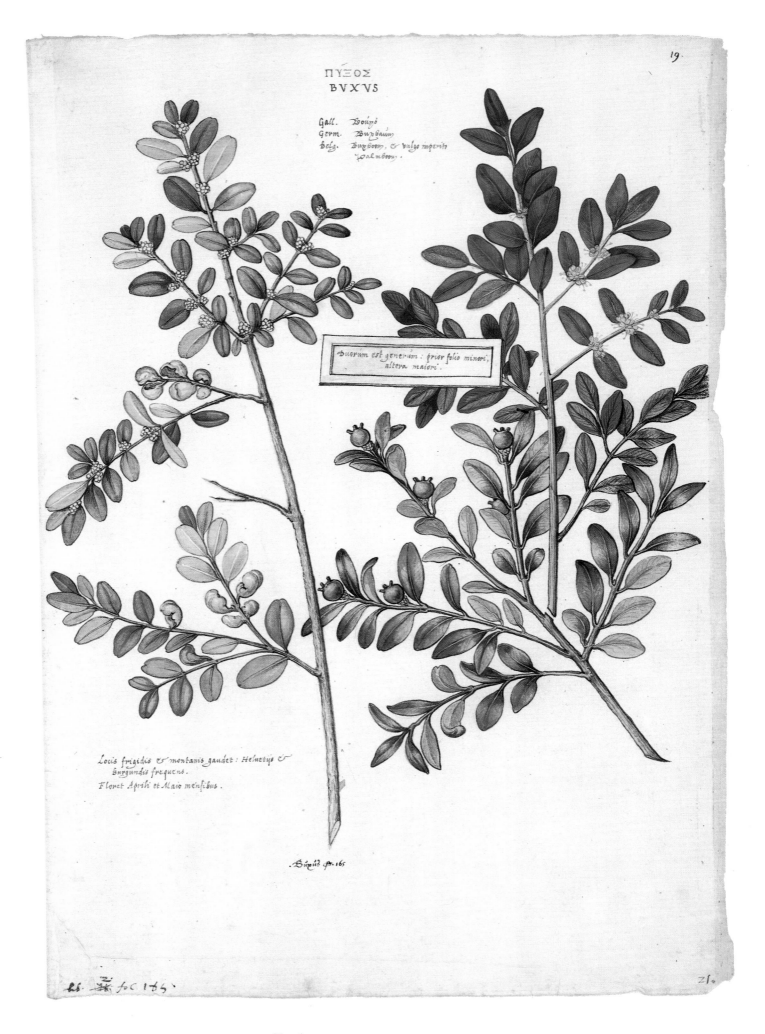

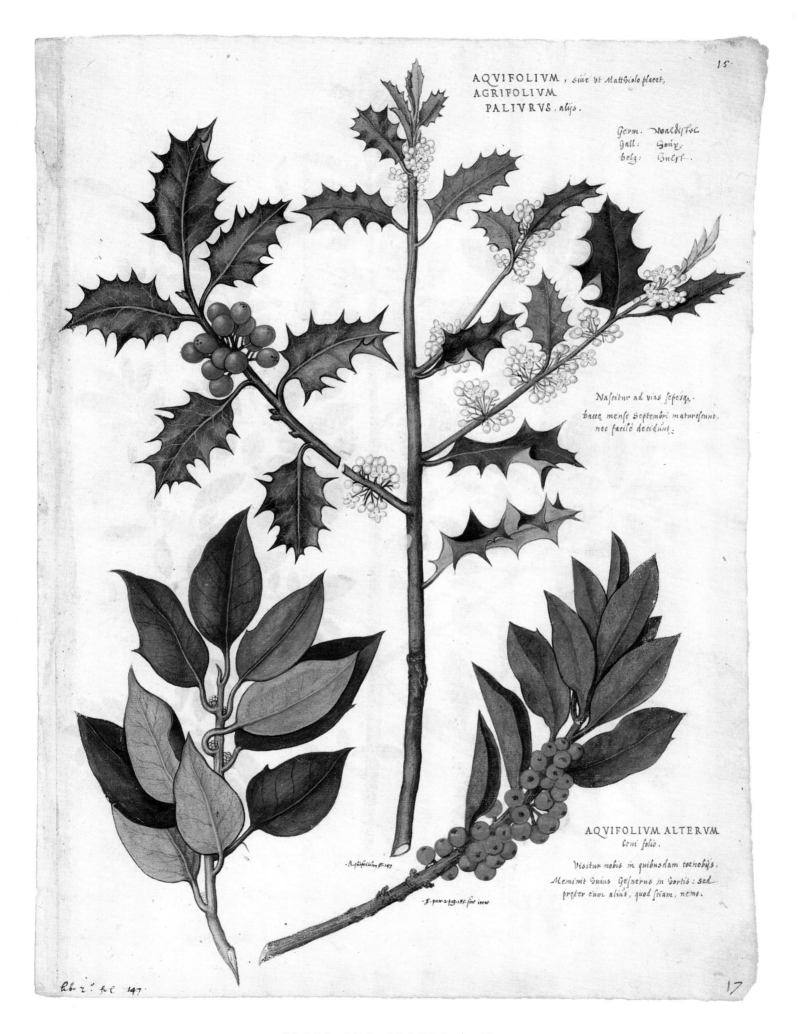

AQVIFOLIVM, *siue vt Matthiolo placet,*
AGRIFOLIVM
PALIVRVS, *aliis.*

Germ. Woaldistoc
Gall: Houx.
Belg: Huest.

Naſcitur ad vias ſepeſq̃.

bacce menſe Septembri matureſcunt,
nec facilè decidunt.

AQVIFOLIVM ALTERVM
ceni folio.

Viſitur nobis in quibusdam coenobijs.
Meminit huius Geſnerus in hortis: sed
preter eum alius, quod ſciam, nemo.

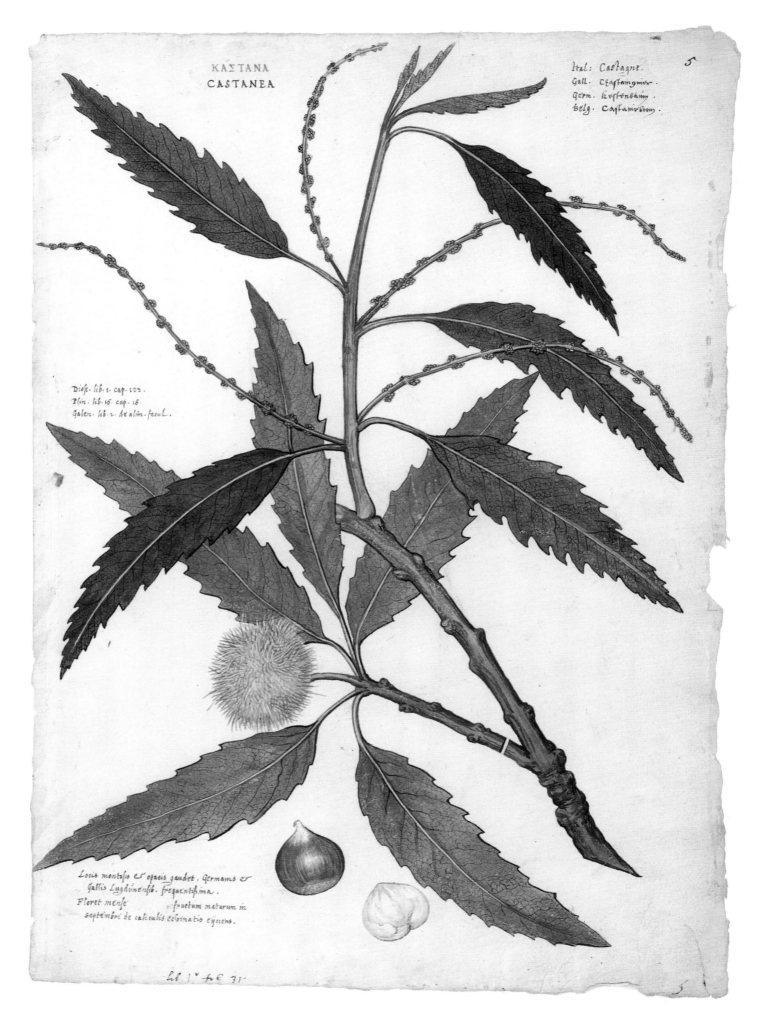

ΚΑΣΤΑΝΑ
CASTANEA

Ital: Castagne.
Gall. Chastaignus.
Germ. kystensaum.
Belg. Castaniboom.

Diosc. lib. 1. cap. 122.
Plin. lib. 16. cap. 18.
Galen. lib. 2. de alim. facul.

Locis montosis & opacis gaudet. Germanis &
Gallis Lugdunensib. frequentissima.
Floret mense fructum maturum in
septembri de caliculis echinatis ejicens.

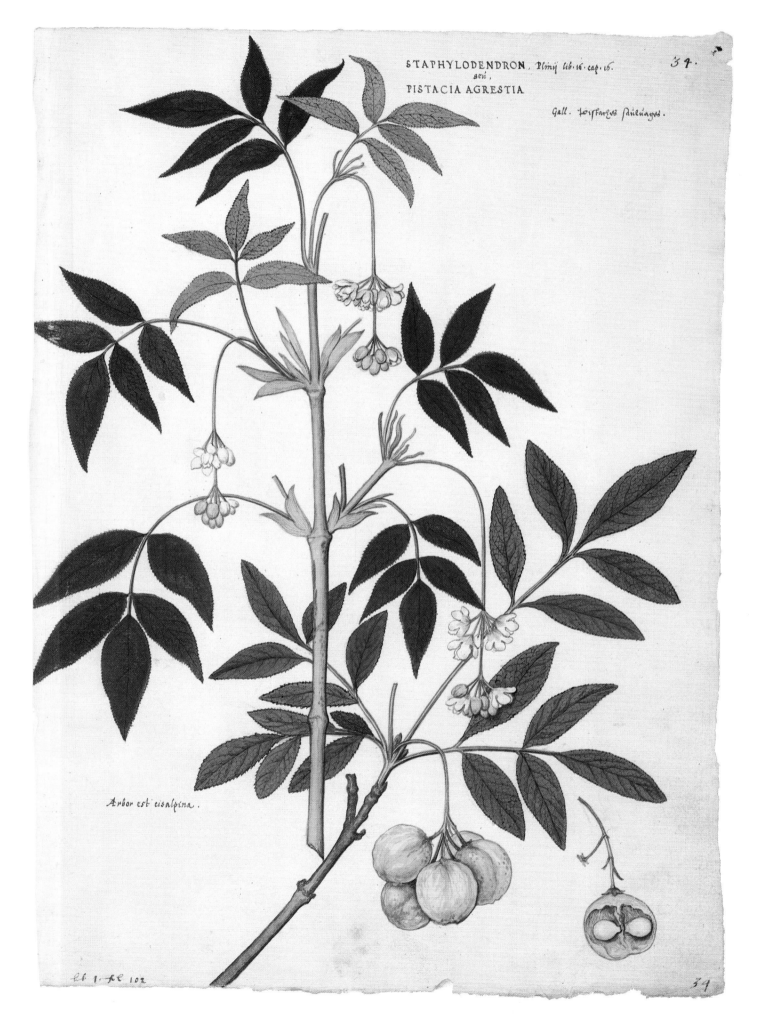

STAPHYLODENDRON, *Plinij lib. 16. cap. 15.*
seu,
PISTACIA AGRESTIA

Gall. Pistachier sauuages.

Arbor est cisalpina.

lib. 1. fol. 102

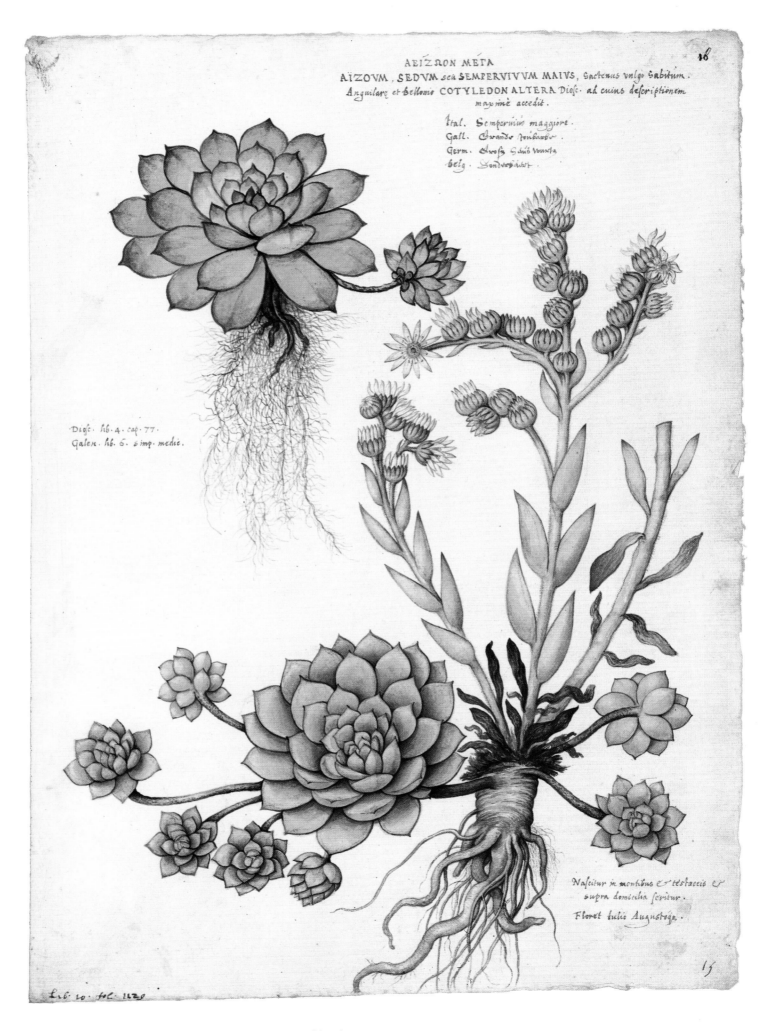

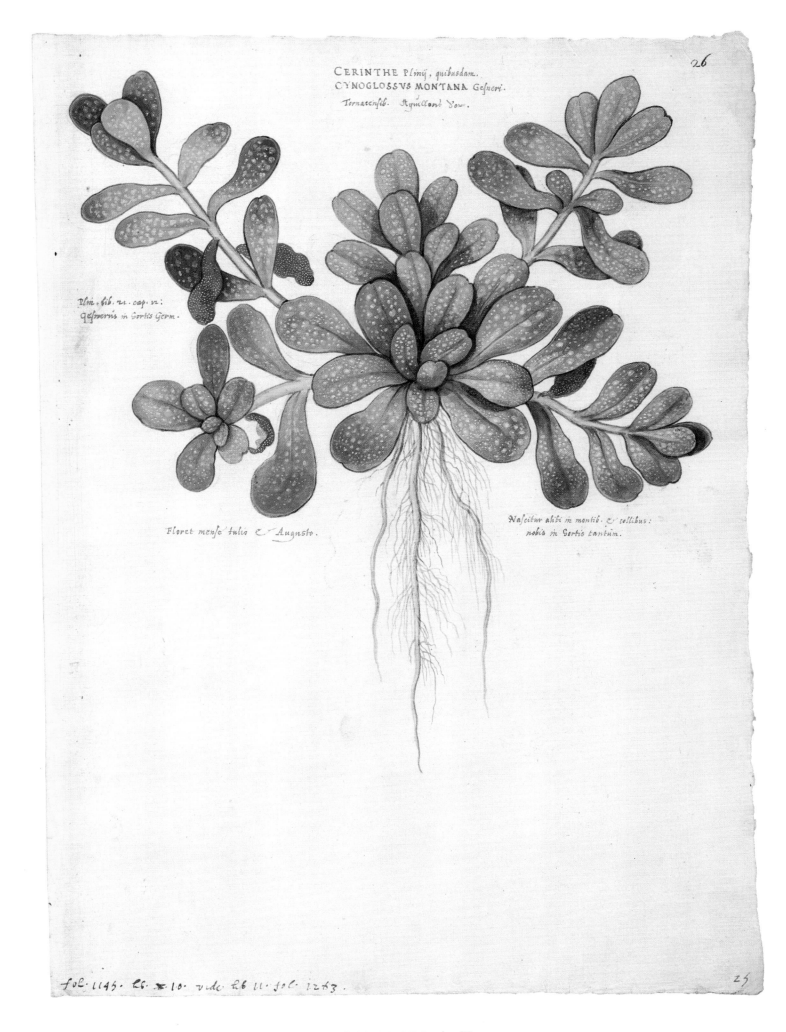

CERINTHE Plinij, quibusdam.
CYNOGLOSSVS MONTANA Gesneri.
Tornacensib. Aquilland Vow.

Plin. lib. 21. cap. 21:
Gesnerus in Hortis Germ.

Floret mense Iulio & Augusto.

Nascitur alibi in montib. & collibus:
nobis in Hortis tantum.

fol. 1145. 26. x. 10. vide lib. 11. fol. 1263.

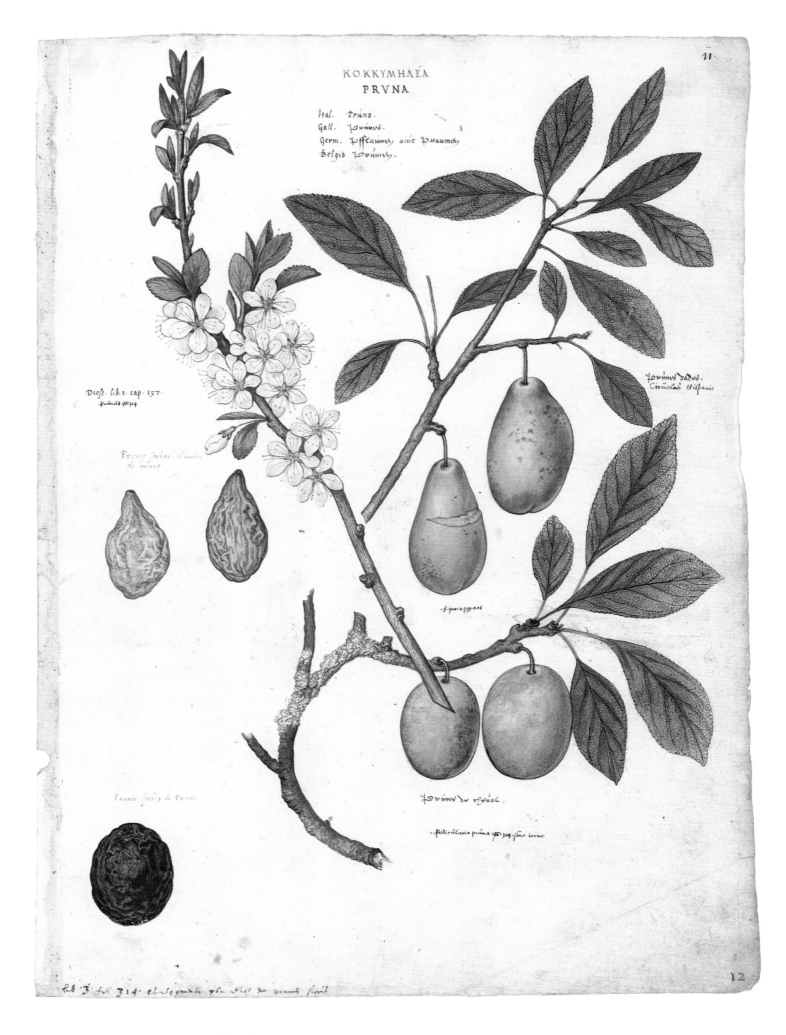

KOKKYMHAEA
PRVNA

Ital. *Pruno.*
Gall. *Prunes.*
Germ. *Pfflaumen, sine Praumen.*
Belgis *Pruimen.*

Diosc. lib. 1. cap. 137.

Prunes seches d'inchou de levant

Prunes spenis de Damas

Prunus dulcis. Ciruelas Hispanis

P. par. 2. pag. 206.

Prunus de Brignal.

Adiviculaia pruina p. 314. sine icone

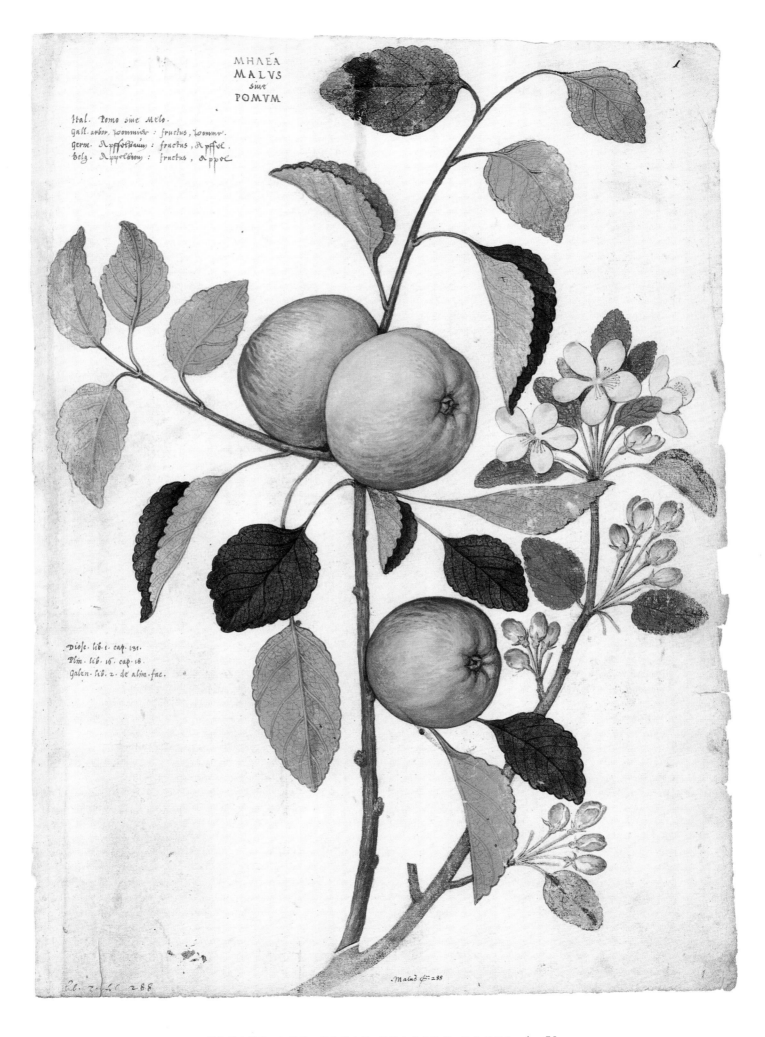

MHΛEA
MALVS
siue
POMVM

Ital. Pomo siue Melo.
Gall. arbor, pommier : fructus, pomme.
Germ. Apffelbaum : fructus, Apffel.
Belg. Appelboom : fructus, Appel.

Diosc. lib. 1. cap. 131.
Plin. lib. 16. cap. 18.
Galen. lib. 2. de alim. fac.

Malus fo: 288

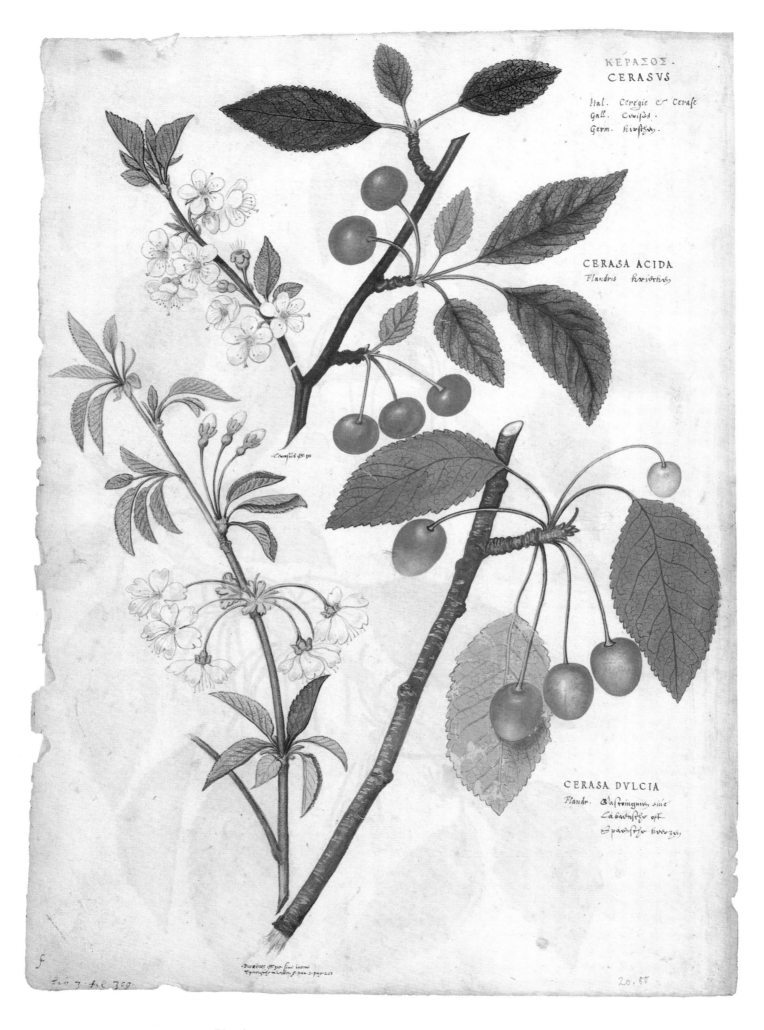

ΚΕΡΑΣΟΣ.
CERASVS

Ital. Ceregie & Cerase
Gall. Cerises.
Germ. kirschen.

CERASA ACIDA
Flandris krieken

CERASA DVLCIA
Flandr. Blasvingnen, sive
Cabawscher oft
Spaansche krieken

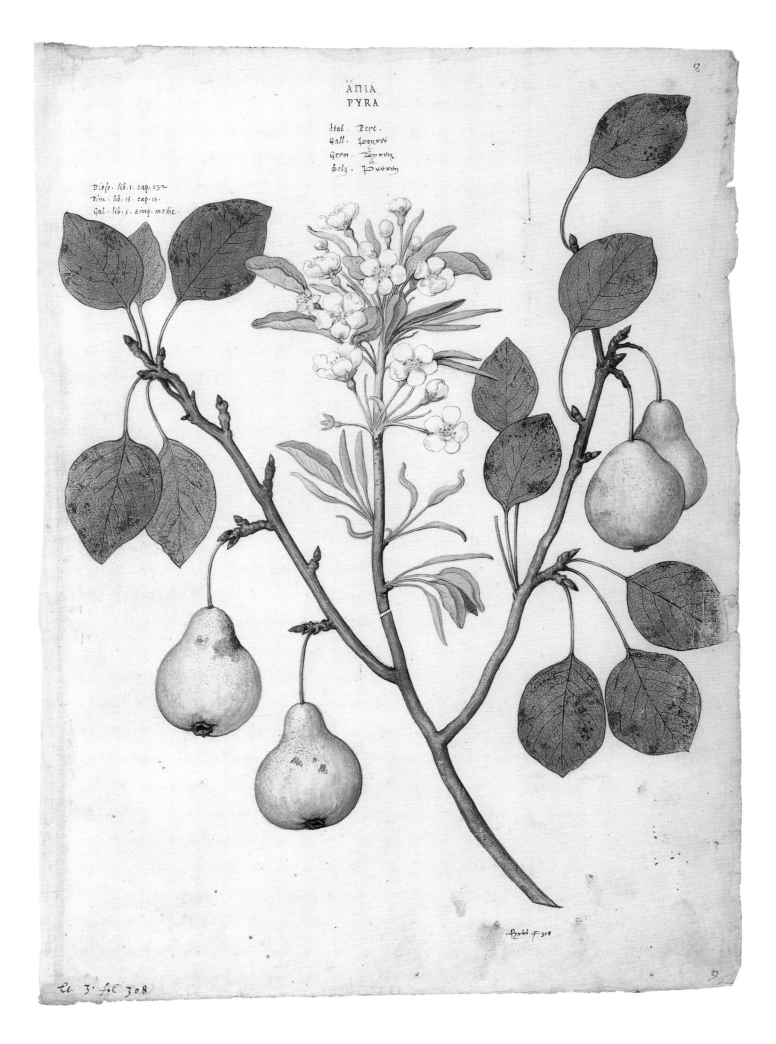

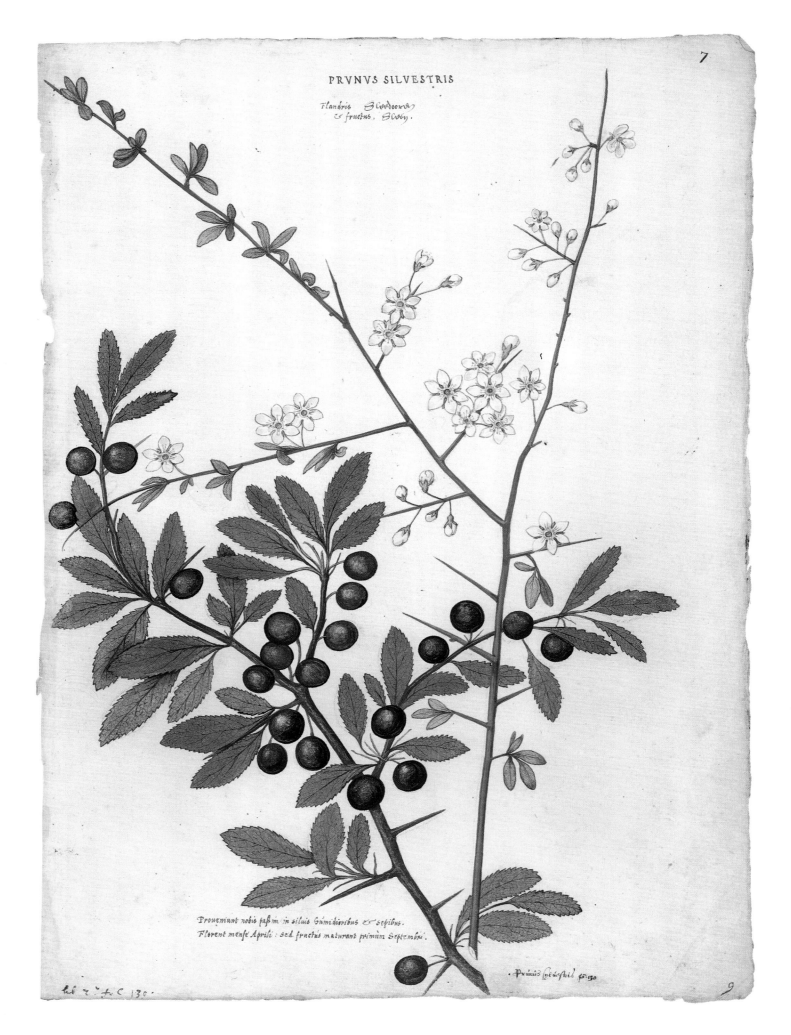

PRVNVS SILVESTRIS

Flandris Sleedoorn
& fructus, Slooy.

Prouemunt nobis paßim in siluis humidioribus & sepibus.
Florent mense Aprili: sed fructus maturant primum Septembri.

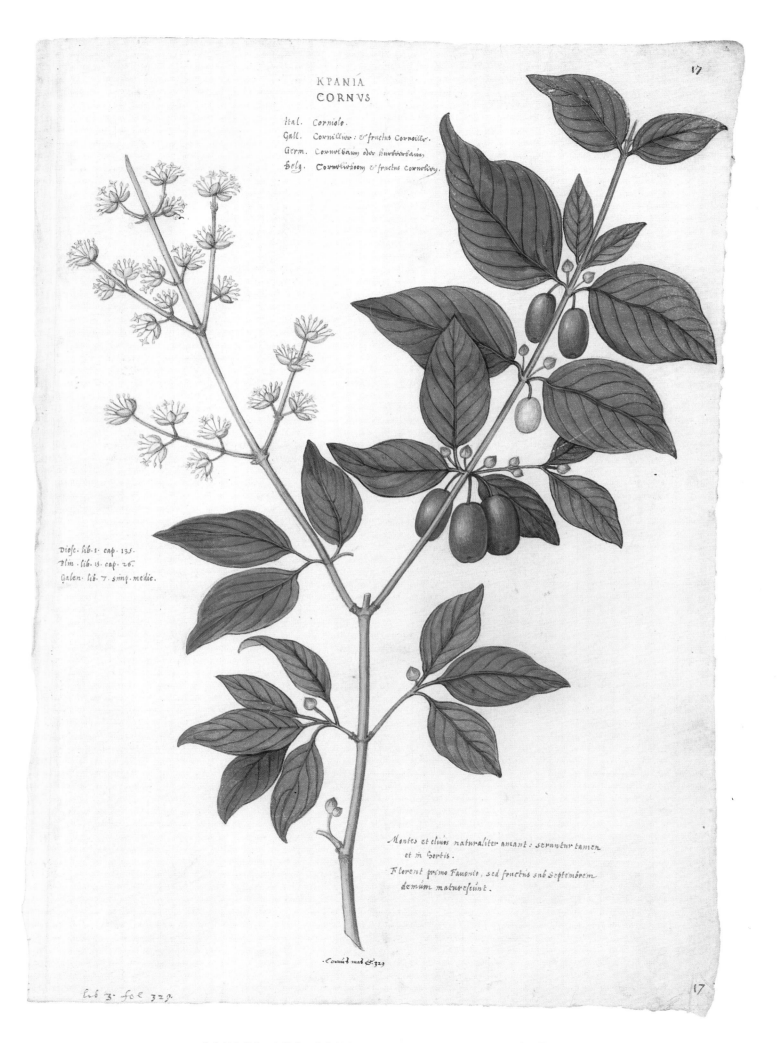

ΚΡΑΝΙΑ
CORNVS

Ital. Corniolo.
Gall. Cornillier: & fructus Cornoille.
Germ. Cornelbaum oder Hurbirbaum,
Belg. Cornelirboom & fructus Cornoliry.

Diosc. lib. 1. cap. 135.
Plin. lib. 15. cap. 26.
Galen. lib. 7. sing. medic.

Montes et cliuos naturaliter amant: seruntur tamen
 et in hortis.
 Florent primo Fauonio, sed fructus sub Septembrem
 demùm maturescunt.

Corniol. mas & 329

lib 3. fol 329

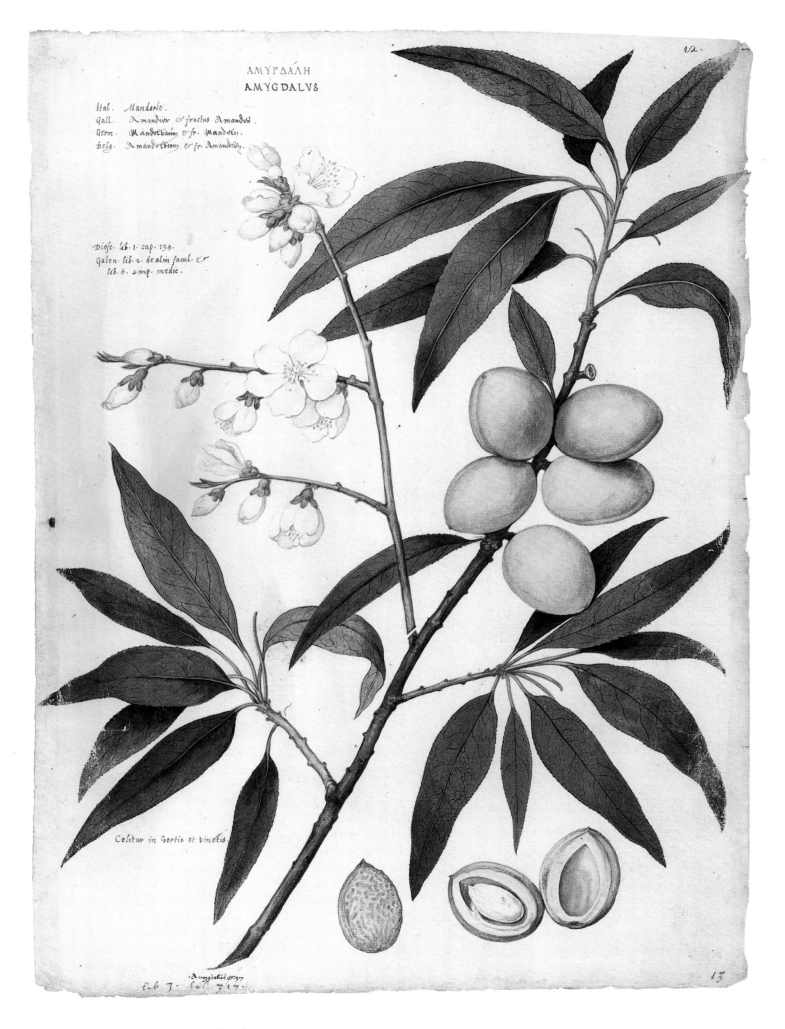

ΑΜΥΓΔΑΛΗ
AMYGDALVS

Ital. Mandorle.
Gall. Amandier & fructus Amandes.
Germ. Mandelbaum & fr. Mandeln.
Belg. Amandelboom, & fr. Amandelen.

Diosc. lib. 1. cap. 139.
Galen. lib. 2. de alim. facul. &
 lib. 6. simp. medic.

Colitur in hortis et vinetis.

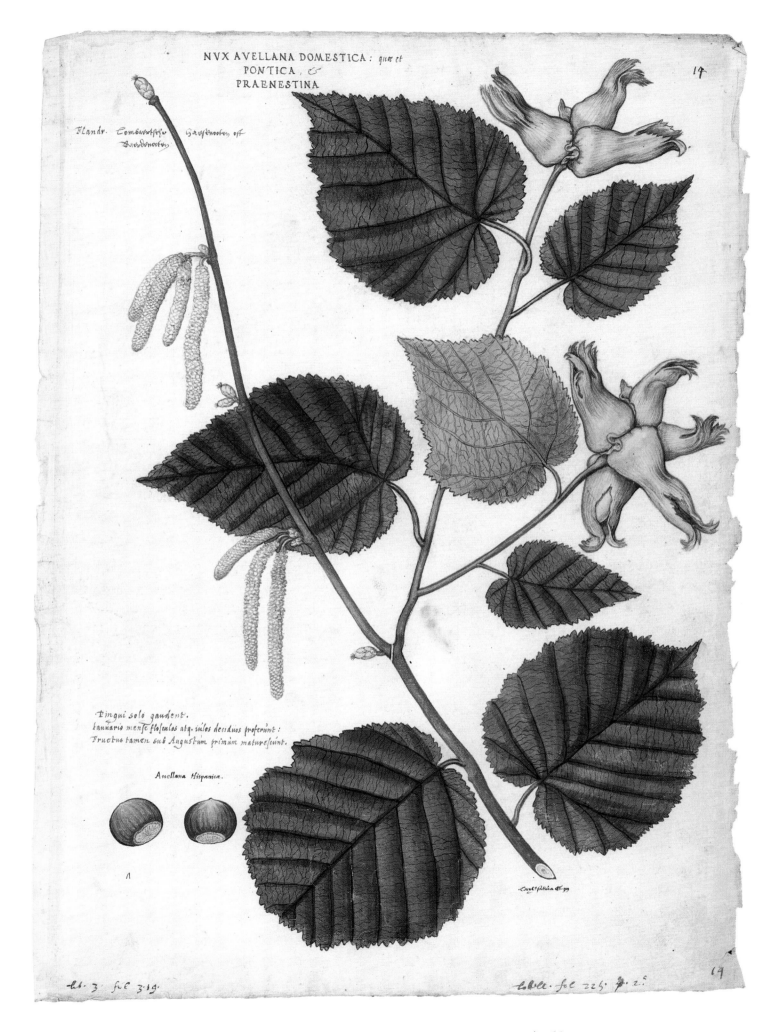

NVX AVELLANA DOMESTICA: *quæ et*
PONTICA, *&*
PRAENESTINA

*Flandr. Combardisque Hartenooten off
 Baerdenooten*

*Pingui solo gaudent.
Ianuario mense flosculos atq. iulos deciduos proferunt:
Fructus tamen sub Augustum primùm maturescunt.*

Auellana Hispanica.

RIBES *vulgaris* RVBEA
GROSSVLARIA RVBRA. *quibusdam.*

Ital: Ribes.
Gall: ~~Ribettes~~ siue ~~Raisins~~ ~~doultremer~~.
Germ: ~~St. Iand~~ ~~treublin~~.
Belg: ~~Beuiuens~~ siue ~~Besbezien~~, siue ~~besien~~ van over ~~Zee~~.

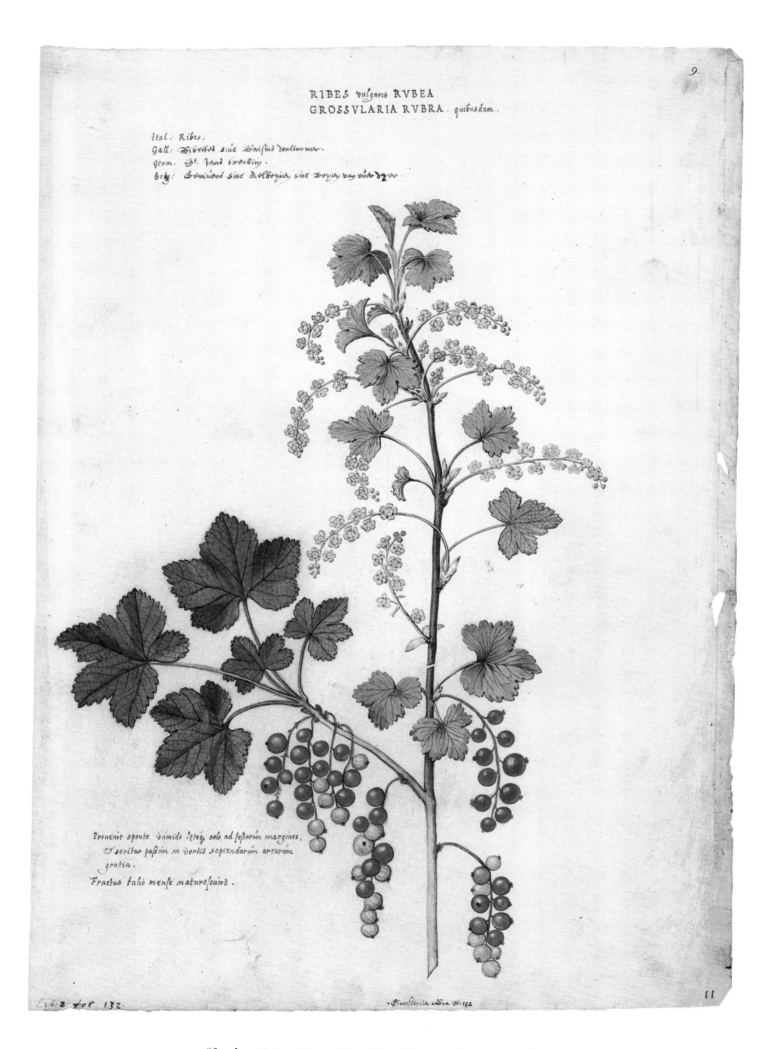

Prouenit sponte humido letóq, solo, ad fossarum margines,
& seritur passim in hortis sepiendarum arearum
gratia.

Fructus Iulio mense maturescunt.

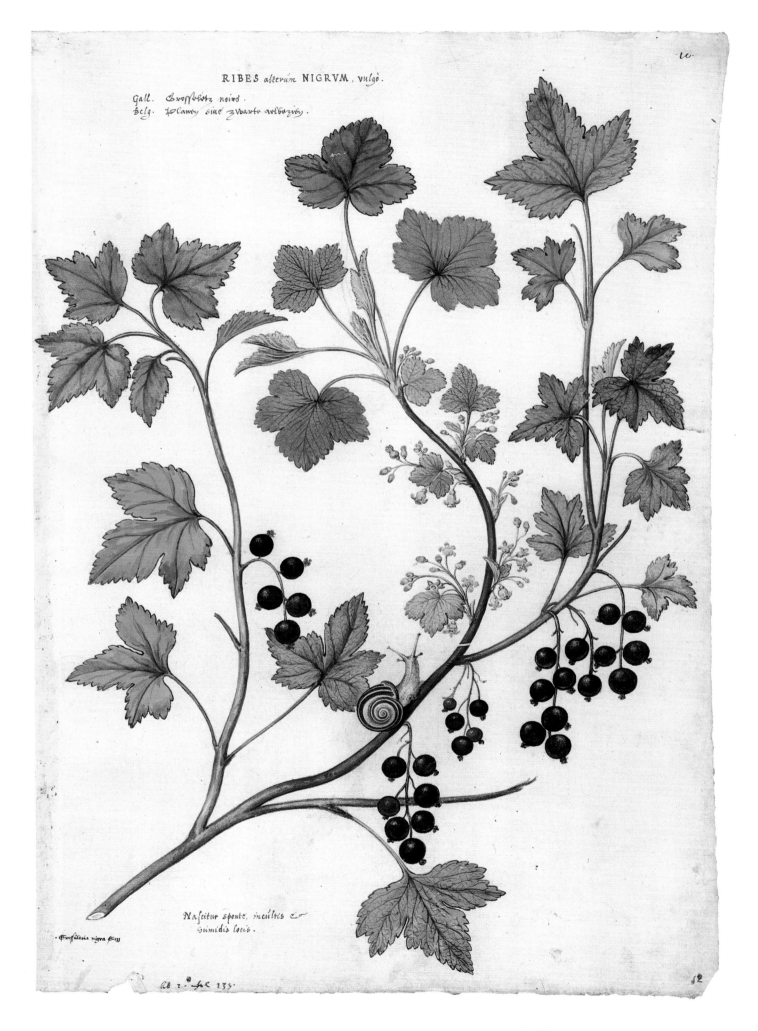

RIBES *alterum* NIGRVM, *vulgò.*

Gall. *Groseilles noirs.*
Belg. *Plamen siue Zwarte aelbeziën.*

Nascitur sponte, incultis &
humidis locis.

Grossularia nigra F. 133

lib. 1.ª fol. 133.

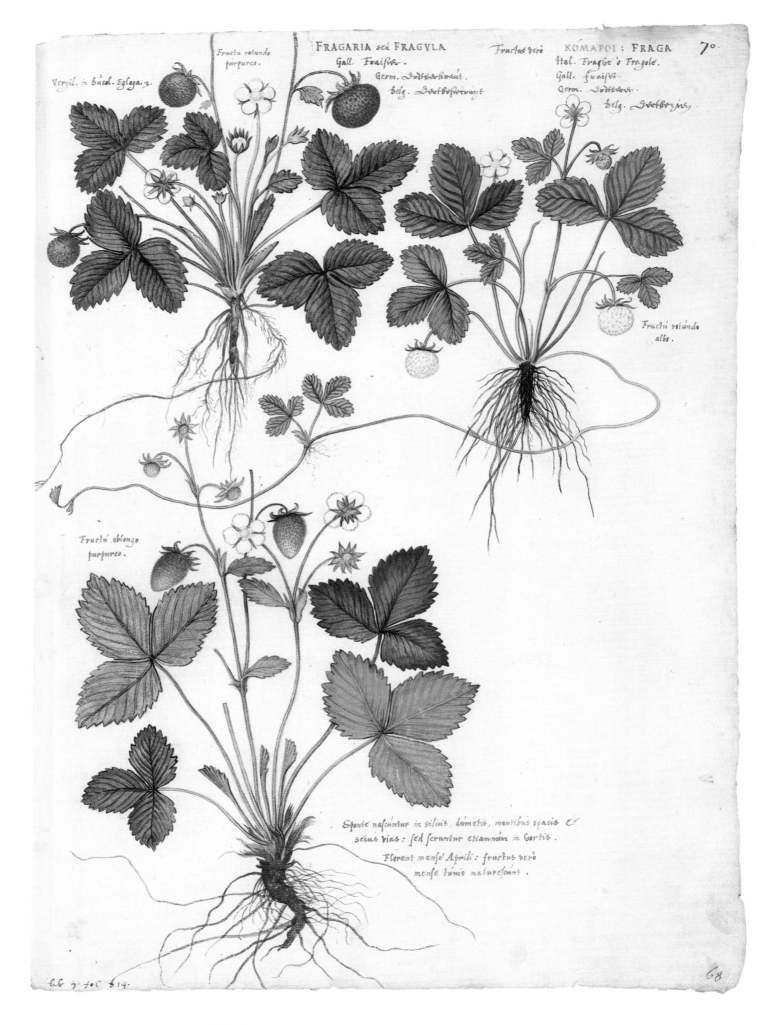

Fructu rotundo
purpureo.

Vergil. in bucol. Egloga. 3.

FRAGARIA seu FRAGVLA
Gall. Fraises.
Germ. Erdbeerkraut.
belg. Eerdbeserruyt

Fructus verò KOMAPOI : FRAGA
Ital. Fraghe ò Fragole.
Gall. fraises.
Germ. Erdbeeren.

belg. Eerdbesien.

Fructu rotundo
albo.

Fructu oblongo
purpureo.

Sponte nascuntur in siluis, dumetis, montibus opacis &
secus vias : sed seruntur etiammūm in hortis.

Florent mense Aprili : fructus verò
mense Iunio maturescunt.

lib. 3. foc 619.

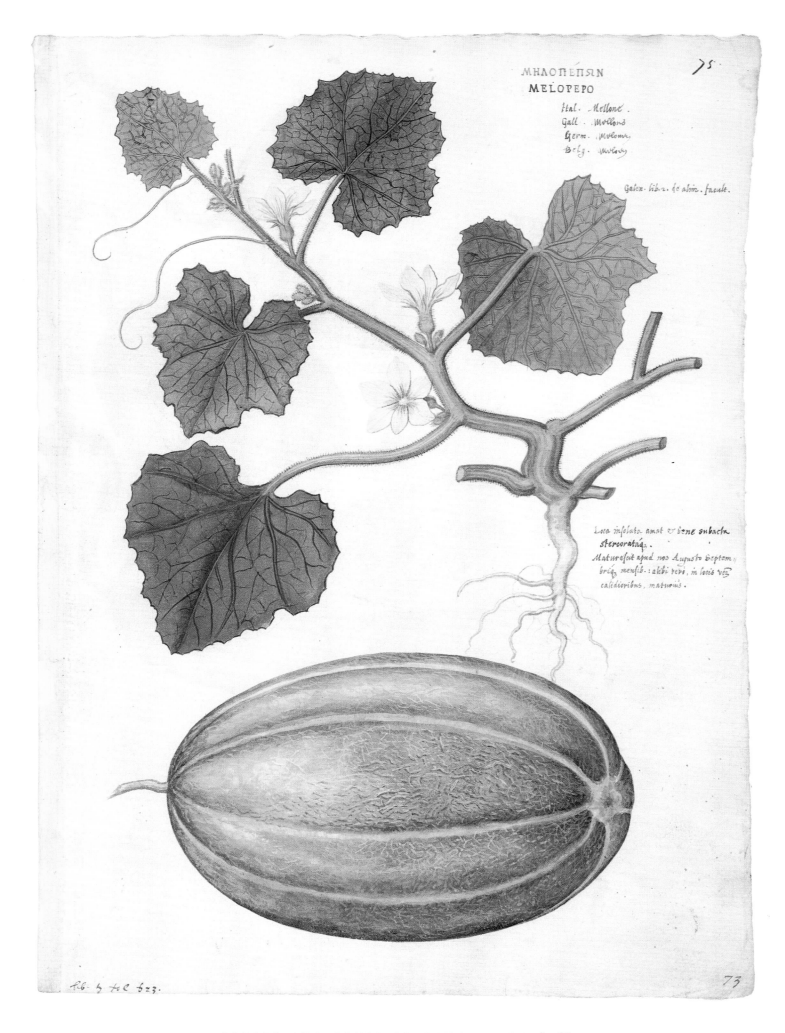

ΜΗΛΟΠΕΠΩΝ
MELOPEPO

Ital. *Mellone*.
Gall. *Mellons*
Germ. *Melone*.
Belg. *melon*

Galen. lib. 2. de alim. facult.

Loca insolata amat & bene subacta
stercorataq.
Maturescit apud nos Augusto Septem,
briq. mensib: alibi vero, in locis veg
calidioribus, maturius.

Fig. by the b=3.

73

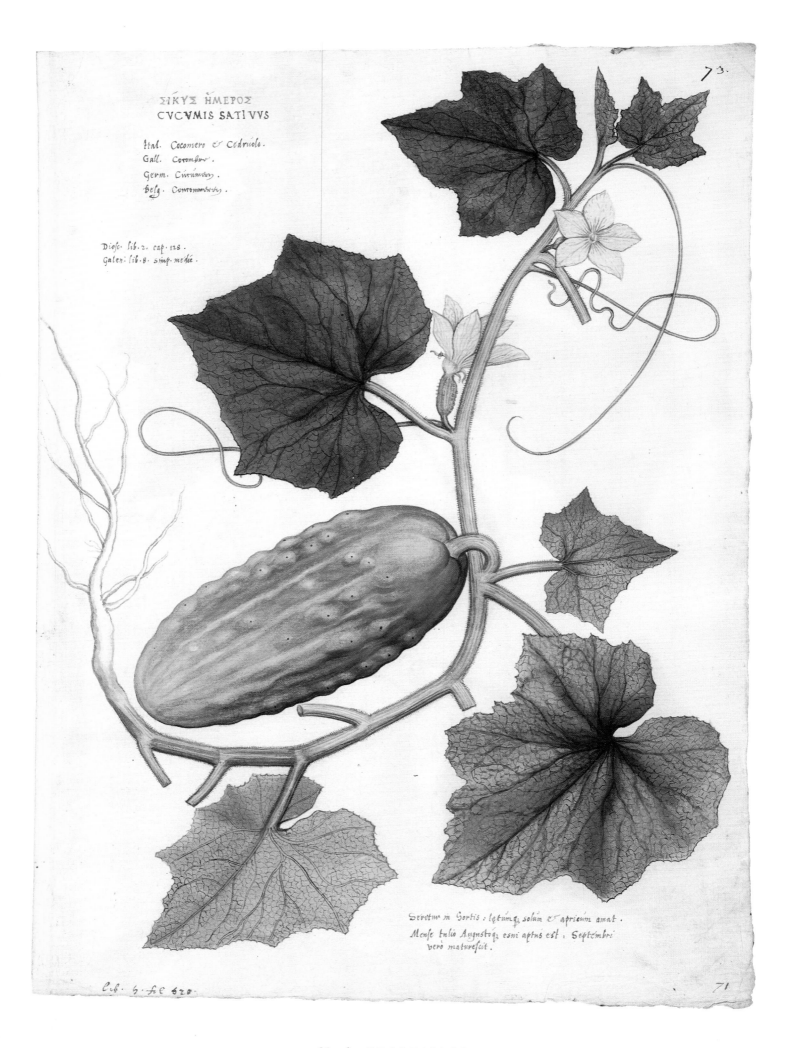

ΣΊΚΥΣ ἬΜΕΡΟΣ
CVCVMIS SATIVVS

Ital. Cocomero & Cedruolo.
Gall. Corombre.
Germ. Cucumern.
Belg. Concommern.

Diosc. lib. 2. cap. 128.
Galen. lib. 8. simp. medic.

Serotin in hortis: lętumq̃ solùm & aprienm amat.
Mense Iulio Augustoq̃ esui aptus est: Septembri
verò maturescit.

lib. 5. fo. 620.

71

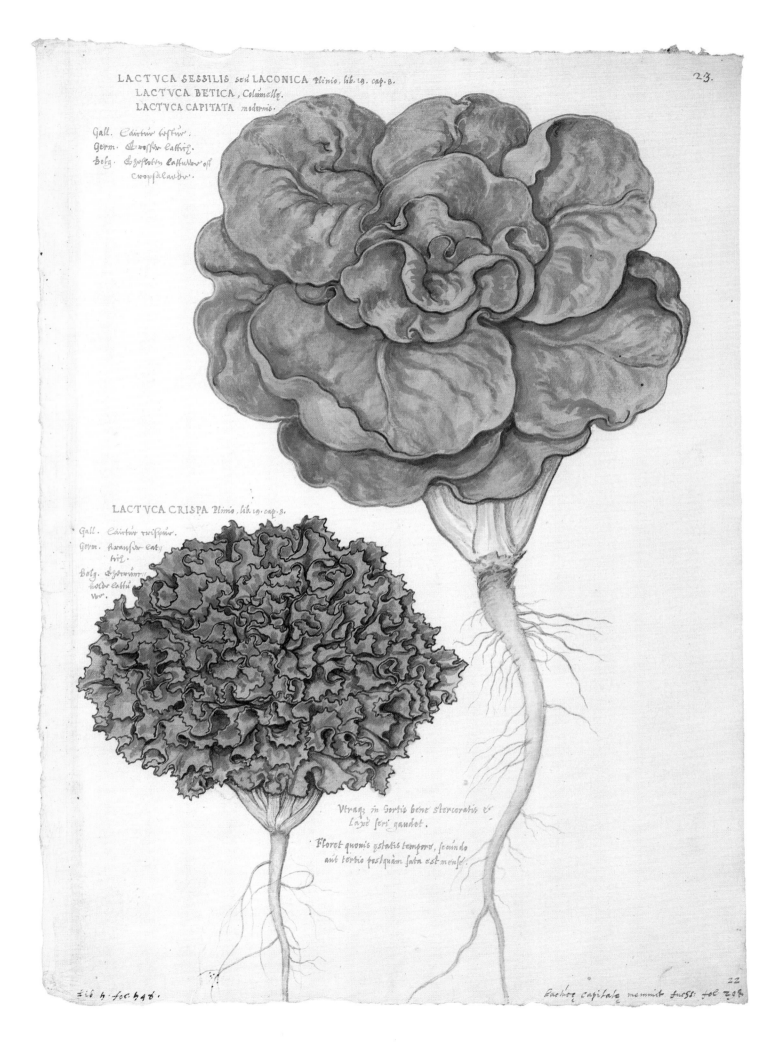

LACTVCA SESSILIS *seu* LACONICA *Plinio, lib. 19. cap. 8.*
LACTVCA BETICA, *Columellæ.*
LACTVCA CAPITATA *modernis.*

Gall. Côirtur tistur.
Germ. Grosser Lattig.
Belg. Geslotin Lattuduu oft
cropselaudu.

LACTVCA CRISPA *Plinio, lib. 19. cap. 8.*

Gall. Côirtur trispur.
Germ. Kraussu Lat-
tig.
Belg. Geternu
bolde Lattu
vuu.

Vtraqz in Hortis bene stercoratis &
Laxè seri gaudet.

Floret quouis ætatis tempore, secundo
aut tertio postquàm sata est mense.

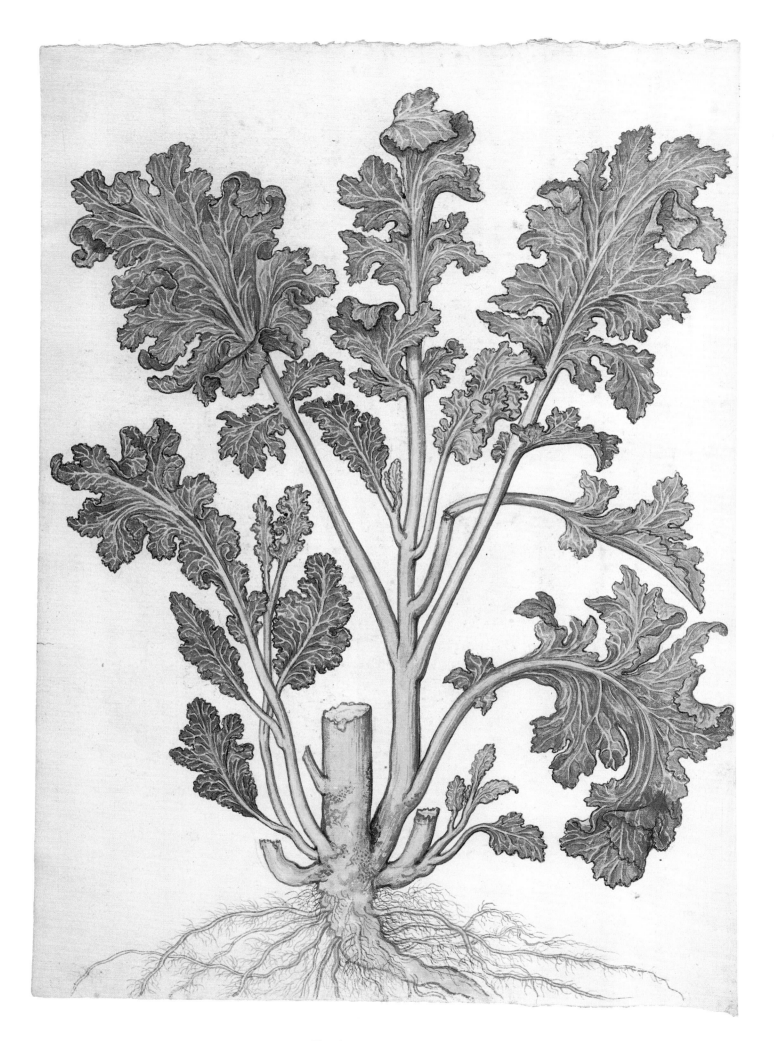

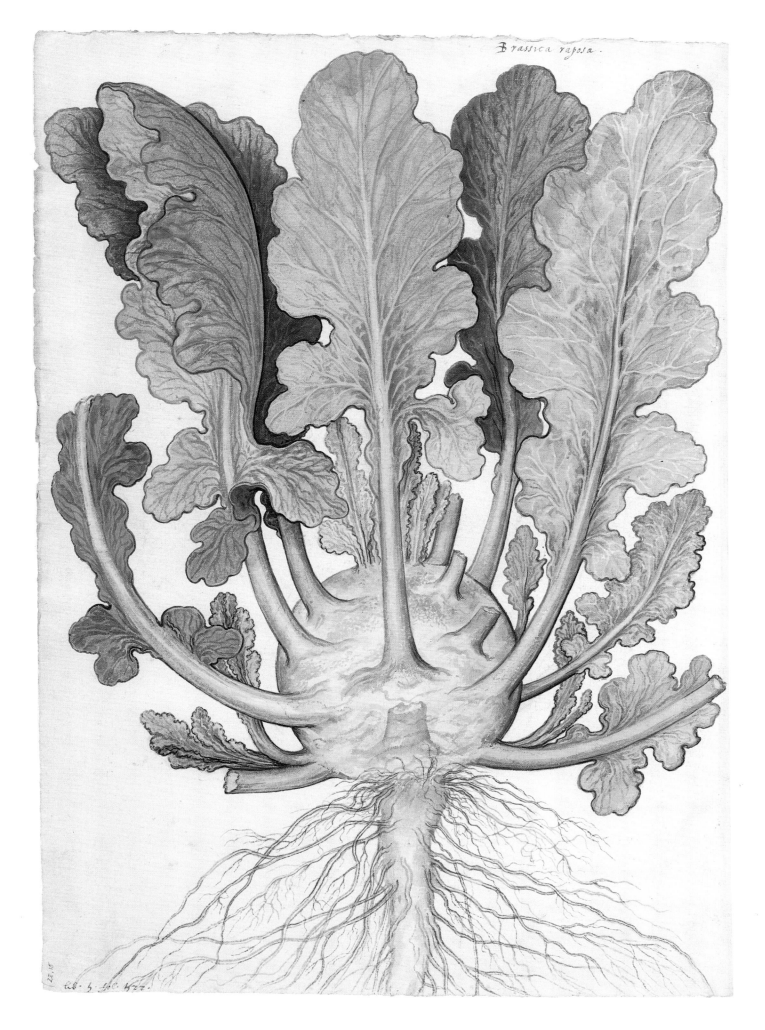

Brassica rapssa.

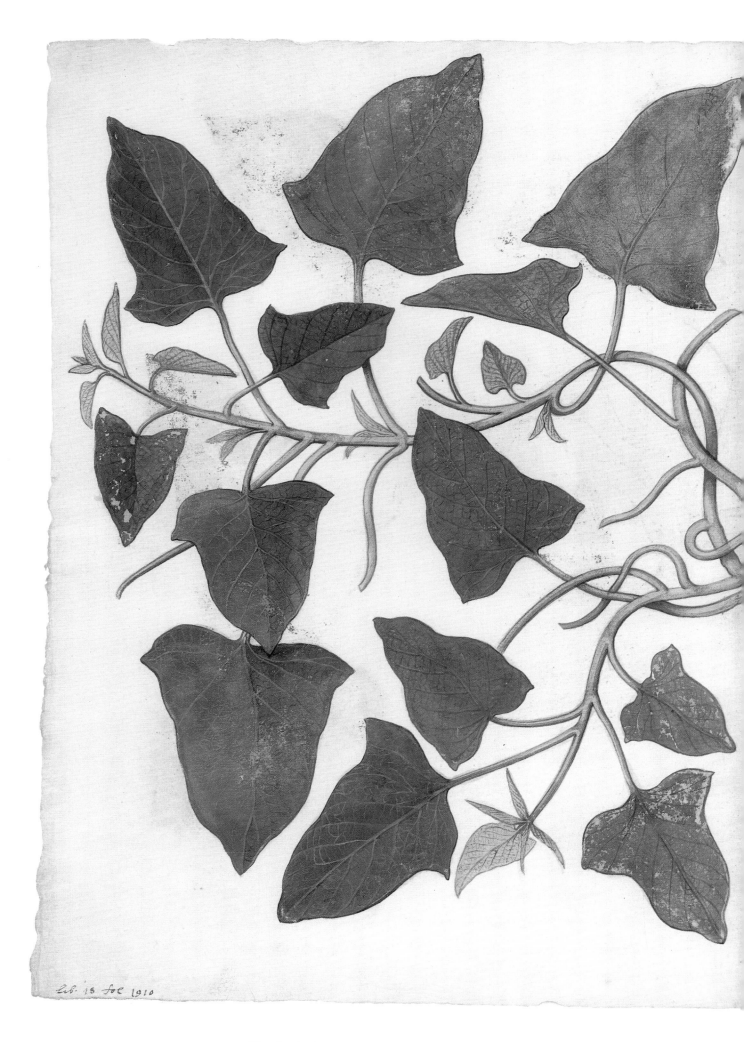

fib. 13 foe 1910

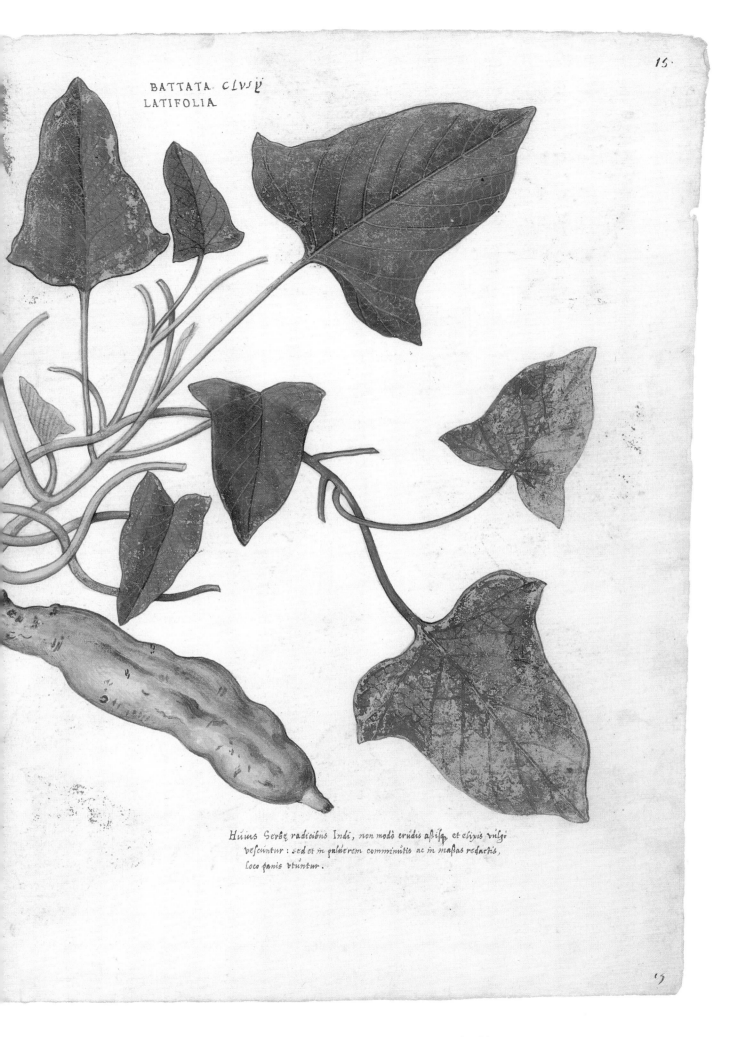

BATTATA *CLVSŸ*
LATIFOLIA

Huius Serbæ radicibus Indi, non modò erudis aßisq̃, et elixis vulgo
vescuntur : sed et in pulverem comminutis ac in massas redactis,
loco panis vtuntur.

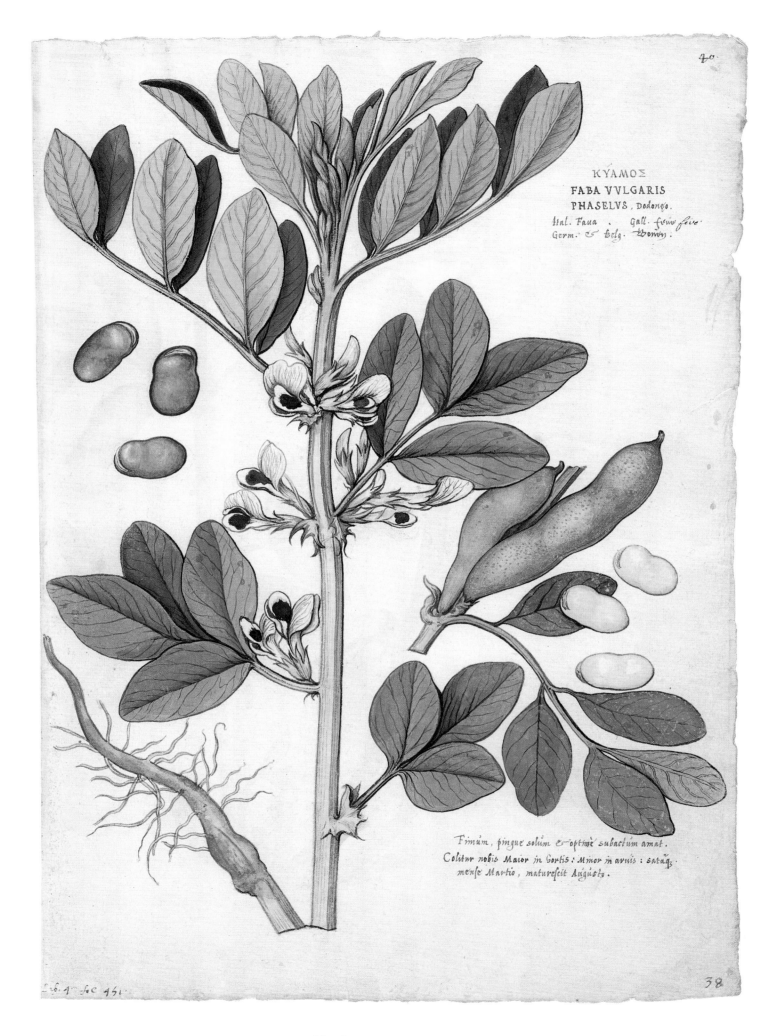

ΚΎΑΜΟΣ
FABA VVLGARIS
PHASELVS, Dodonæo.
Ital. Faua . Gall. fieus feve.
Germ. & Belg. bonen.

Fimum, pingue solum & optimè subactum amat.
Colitur nobis Maior in Gortis: Minor in aruis: sataq̃
mense Martio, maturescit Augusto.

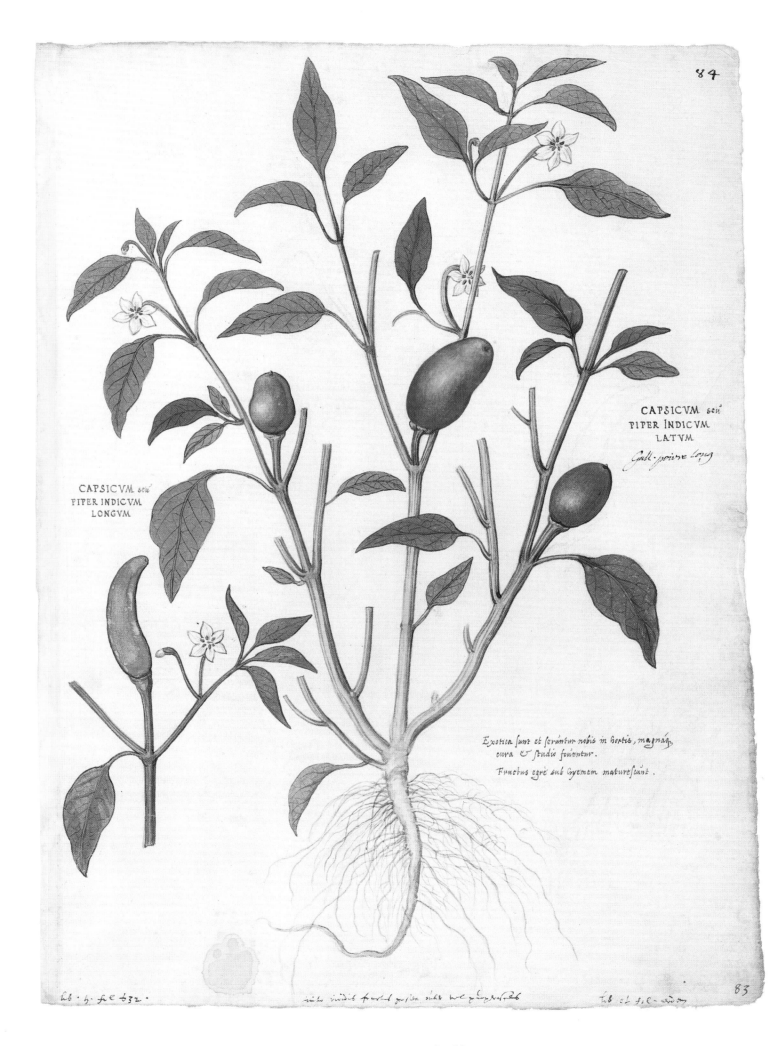

CAPSICVM *seu*
PIPER INDICVM
LATVM

Gall. poivre long

CAPSICVM *seu*
PIPER INDICVM
LONGVM

Exotica sunt et seruntur nobis in hortis, magnaq,
cura & studio fouentur.

Fructus egrè sub hyemem maturescunt.

RAPHANVS NIGER

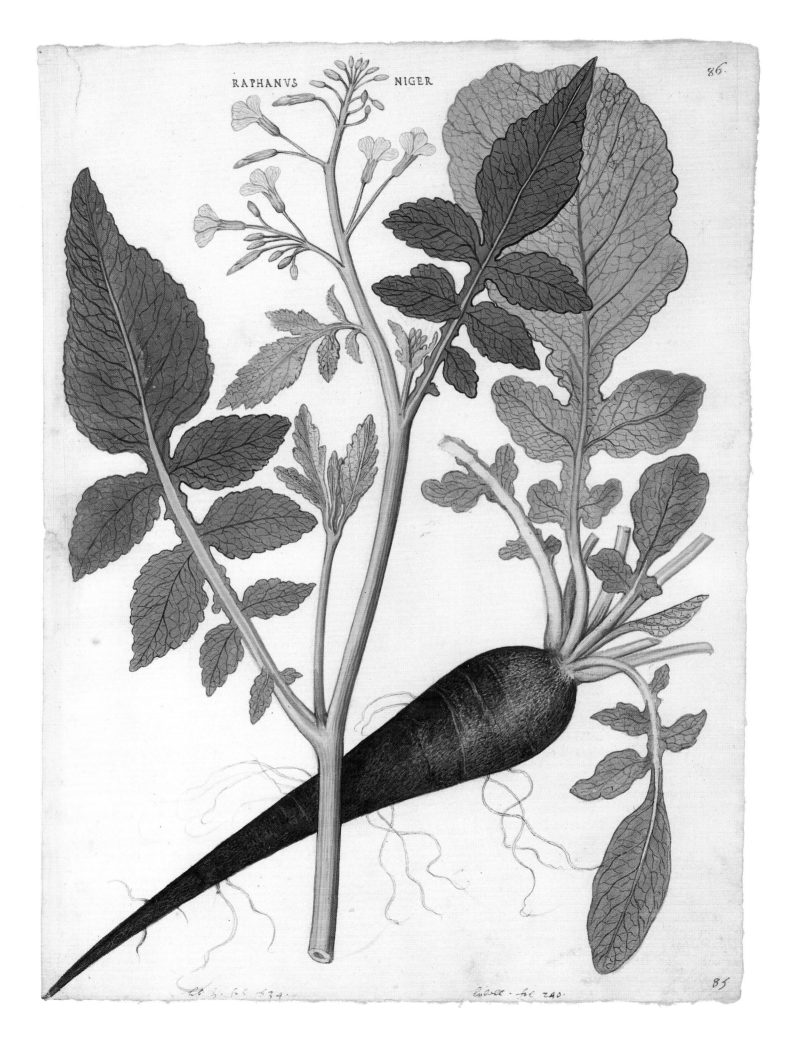

85

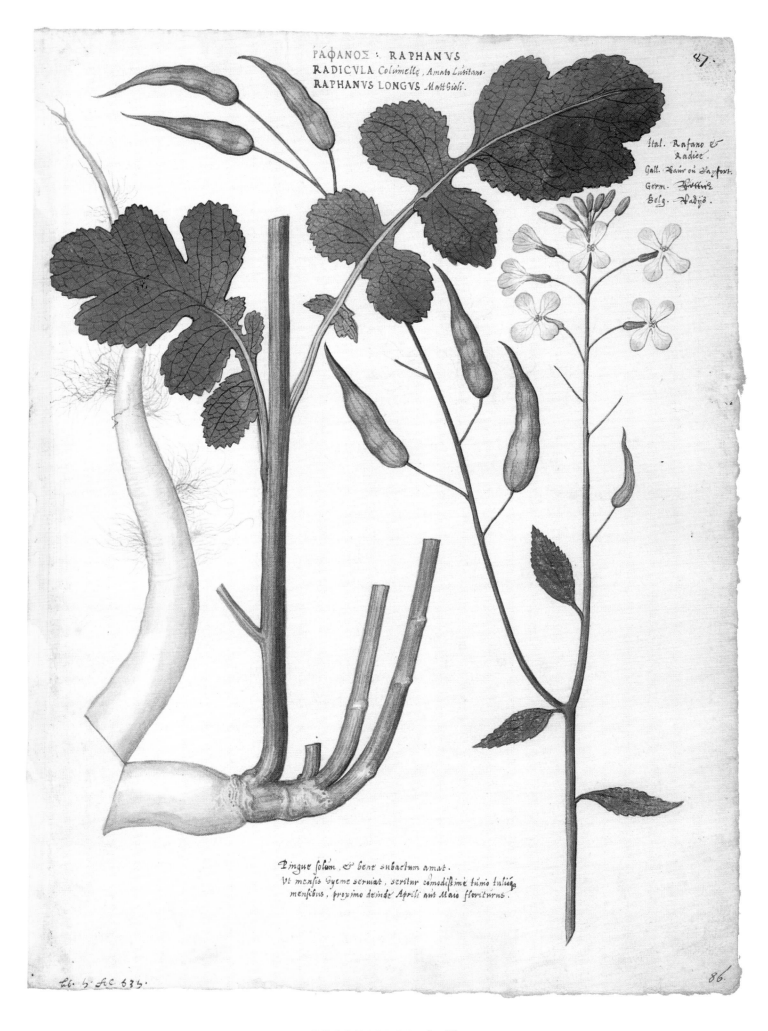

ΡΆΦΑΝΟΣ : RAPHANVS
RADICVLA *Columellæ, Amato Lusitano.*
RAPHANVS LONGVS *Matthioli.*

Ital. *Rafano &*
 Radici.
Gall. *Raur ou Rayfort.*
Germ. *Rettich*
Belg. *Radijs*

Pingue solum, & bene subactum amat.
Vt mensis hyeme seruiat, seritur commodissime Iulio,
mensibus, proximo deinde Aprili aut Maio floriturus.

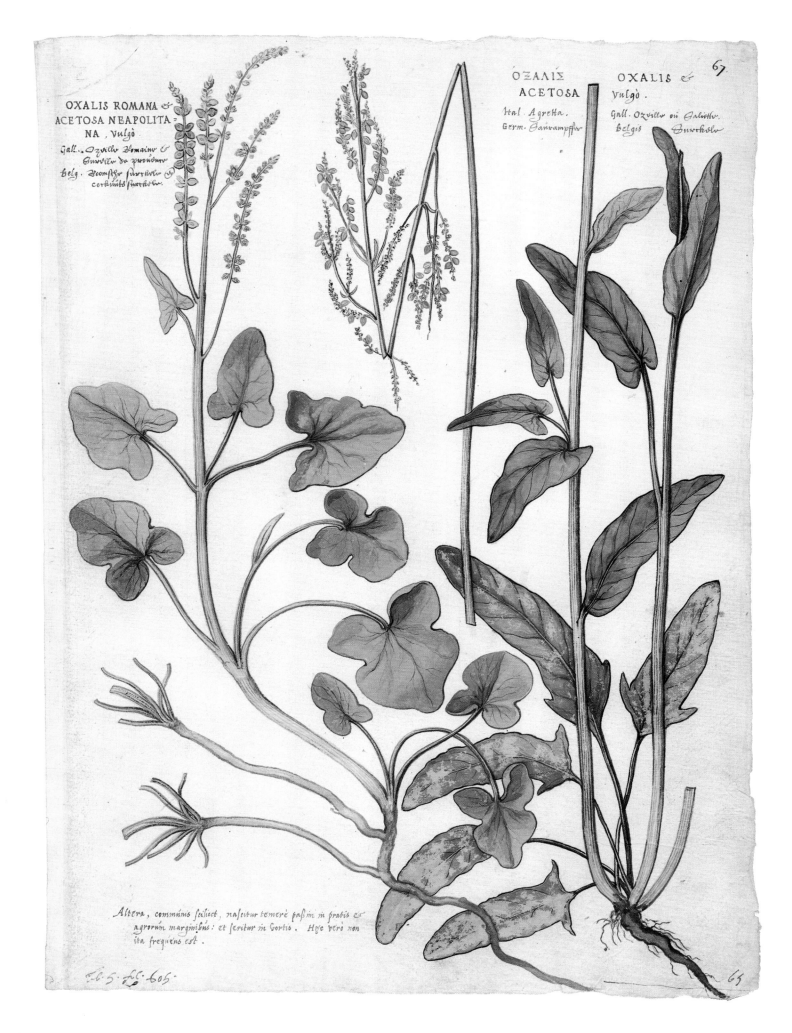

OXALIS ROMANA &
ACETOSA NEAPOLITA=
NA, vulgò

Gall.. *Ozveille Romaine &*
Ouveille de provence
Belg. *Boomsche surckelie, &*
corkruits surckelie.

ΟΞΑΛΙΣ
ΑCETOSA

Hal. *Agretta.*
Germ. *Sauvampffer.*

OXALIS &
vulgò.

Gall. *Ozveille ou Galiotte.*
Belgis *Surckelie.*

Altera, communis scilicet, nascitur temerè passim in pratis &
agrorum marginibus: et seritur in Gortis. Hæc verò non
ita frequens est.

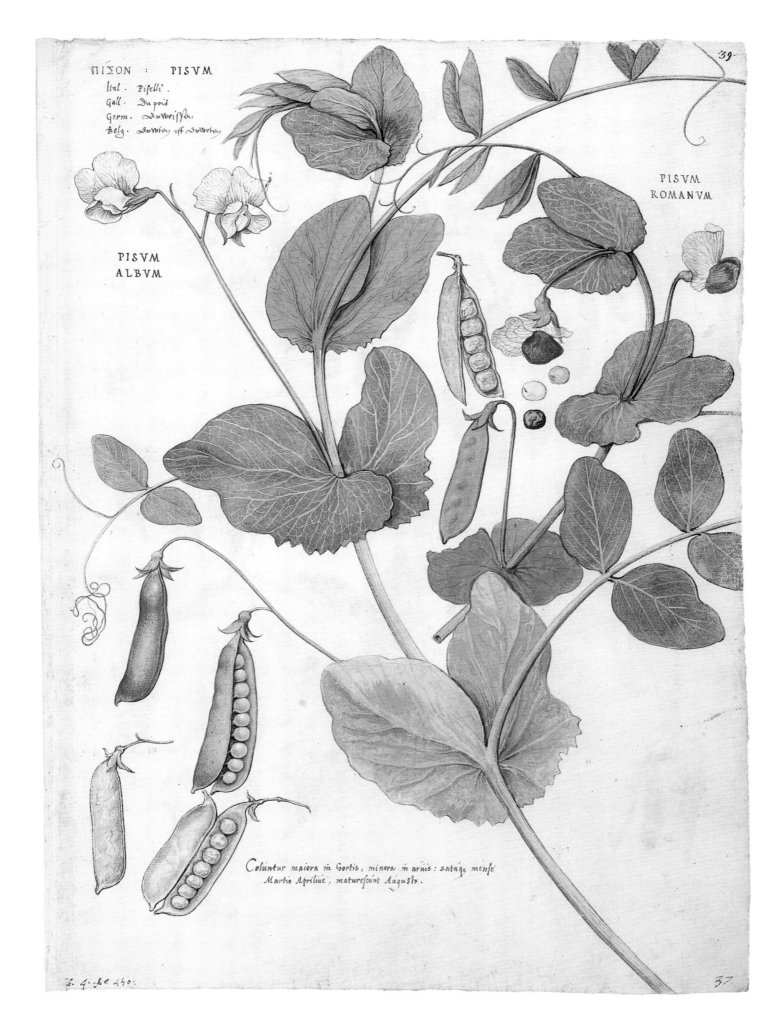

ΠΙΣΟΝ : PISVM
Ital. Piselli.
Gall. Du pois
Germ. Erweissen
Belg. Erweten oft Erweten

PISVM
ROMANVM

PISVM
ALBVM

*Coluntur maiora in Gortis, minora in aruis: satâq, mense
Martio Apriliue, maturescunt Augusto.*

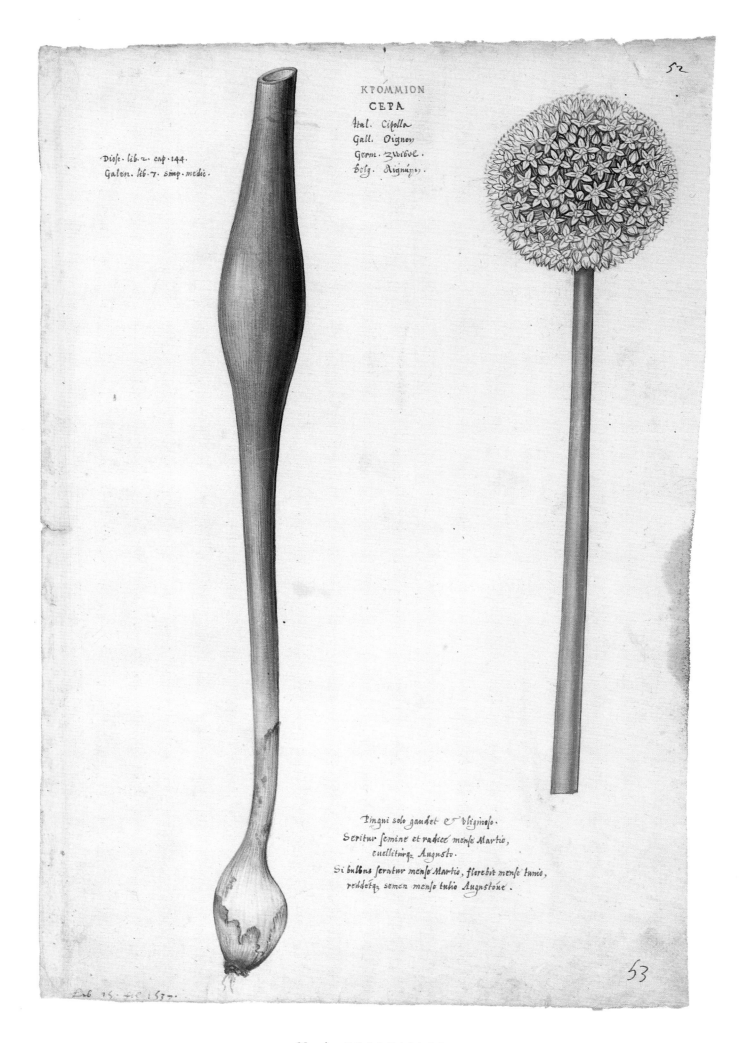

ΚΡΟΜΜΙΟΝ
CEPA
Ital. Cipolla
Gall. Oignon
Germ. Zwibel.
Belg. Aignuyn.

Diosc. lib. 2. cap. 144.
Galen. lib. 7. simp. medic.

Pingui solo gaudet et uliginoso.
Seritur semine et radice mense Martio,
euelliturq, Augusto.
Si bulbus seritur mense Martio, florebit mense Iunio,
reddetq, semen mense Iulio Augustoue.

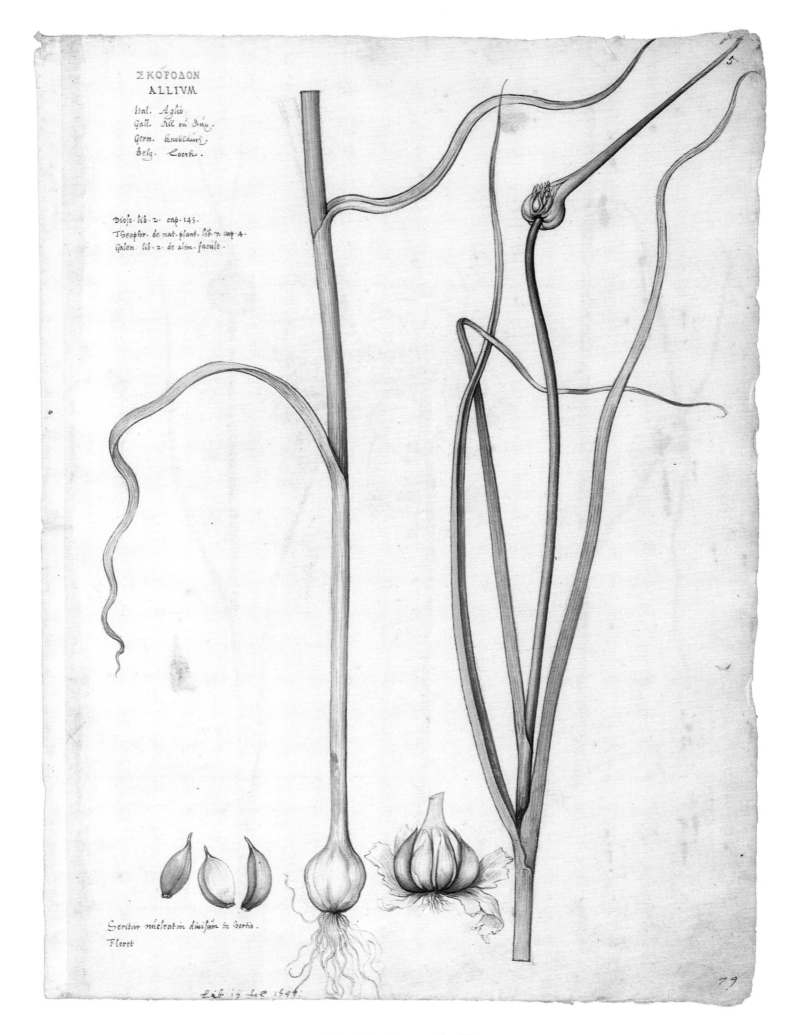

ΣΚΌΡΟΔΟΝ
ALLIVM

Ital. *Aglio.*
Gall. *Ail ou Aux.*
Germ. *knoblauch.*
Belg. *Loork.*

Diosc. lib. 2. cap. 145.
Theophr. de nat. plant. lib. 7. cap. 4.
Galen. lib. 2. de alim. facult.

Seritur nucleatim divisum in hortis.
Floret

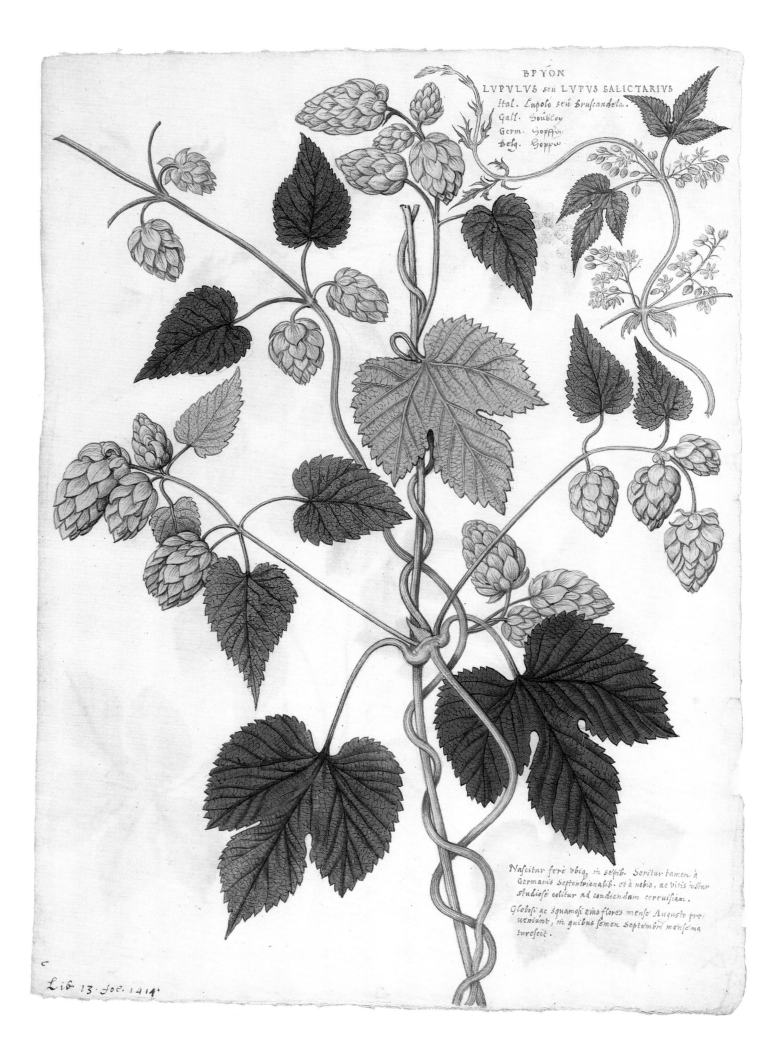

BPYON
LVPVLVS seu LVPVS SALICTARIVS
Ital. Lupolo seu Bruscandela.
Gall. Soubloy
Germ. Hopffen
Belg. Hoppe

Nascitur ferè vbiq, in sepib. Seritur tamen à
Germanis Septentrionalib. et à nobis, ac vitis instar
studiosè colitur ad condiendam cereuisiam.

Globosi ac squamosi eius flores mense Augusto pro:
ueniunt, in quibus semen Septembri mense ma:
turescit.

Lib 13 fol. 1414

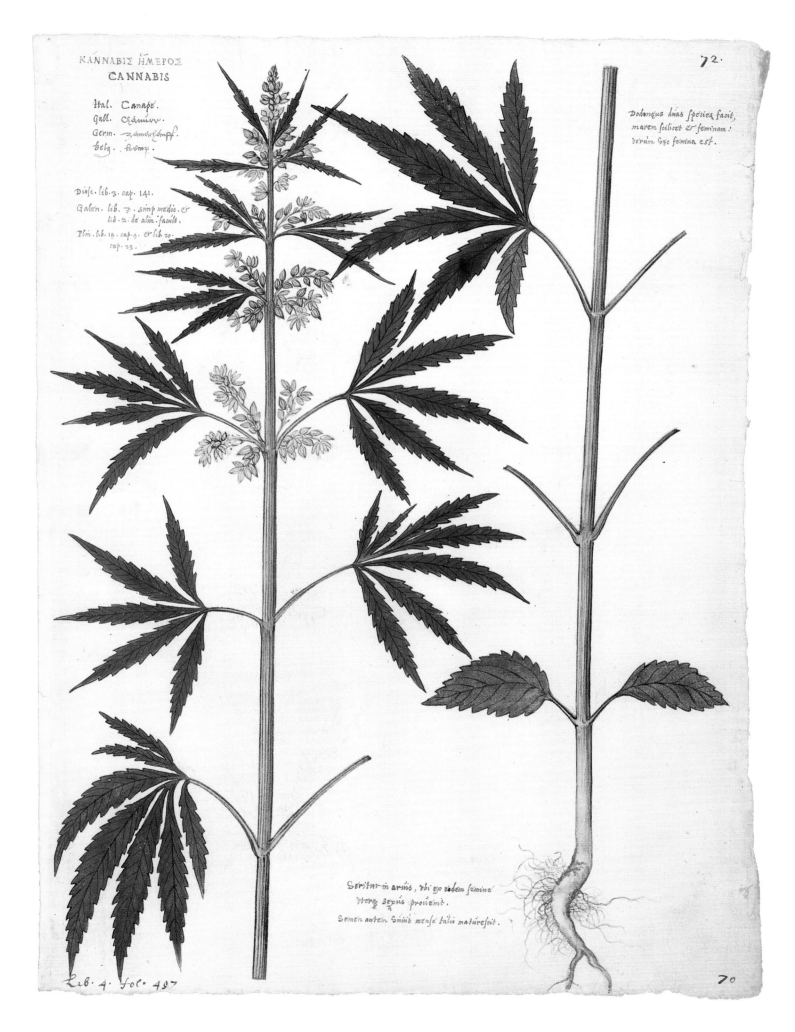

ΚΑΝΝΑΒΙΣ ἭΜΕΡΟΣ
CANNABIS

Ital. Canape.
Gall. Chanvre.
Germ. zamefchauff.
Belg. kemp.

Diosc. lib. 3. cap. 141.
Galen. lib. 7. simp medic. et
lib. 2. de alim. facult.
Plin. lib. 19. cap. 9. et lib. 20.
cap. 23.

Dodonæus duas species facit,
marem scilicet et feminam:
verum hæc femina est.

Seritur in arvis, ubi ex eodem semine
uterque sæpius provenit.
Semen autem huius mense Iulii maturescit.

Lib. 4. fol. 497

70

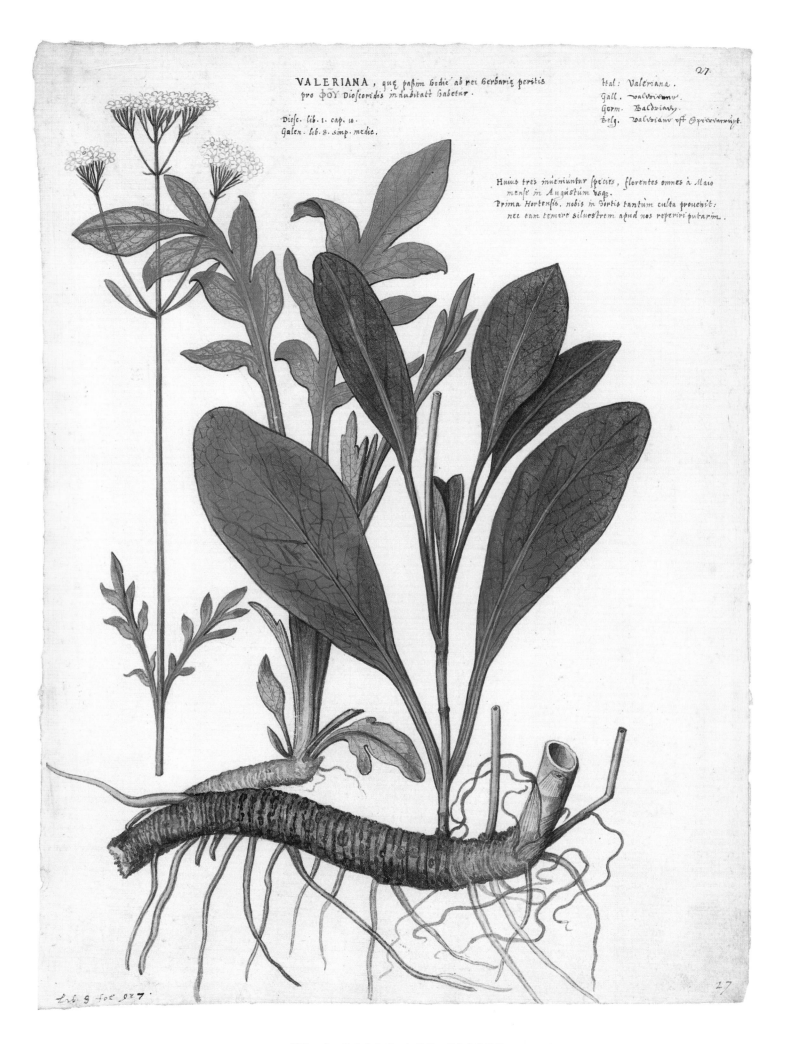

VALERIANA, quæ paßim hodie ab rei herbariæ peritis
pro ΦΟΥ Dioscoridis indubitate habetur.

Diosc. lib. 1. cap. 10.
Galen. lib. 8. simp. medic.

Ital: Valeriana.
Gall. valeriane.
Germ. Baldrian.
Belg. valeriaen vst Speerwurtel.

Huius tres inueniuntur species, florentes omnes à Maio
mense in Augustum vsqz.
Prima Hortensis, nobis in Hortis tantùm culta prouenit:
nec eam temere siluestrem apud nos reperiri putarim.

lib. 9 fol. 227.

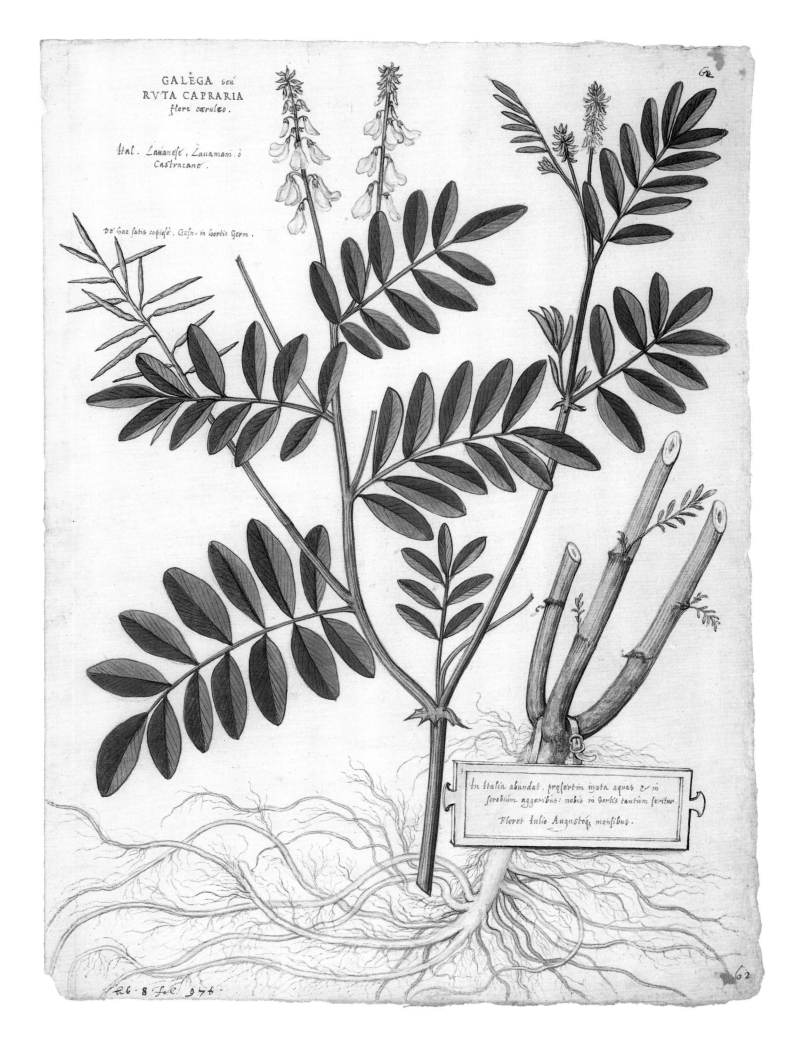

GALEGA seu
RVTA CAPRARIA
flore cæruleo.

Ital. Lauanese, Lauamani, ò
Castracane.

De hac satis copiose, Gesn. in hortis Germ.

In Italia abundat, presertim iuxta aquas & in
scrobium aggeribus: nobis in hortis tantùm seritur.

Floret Iulio Augustoq, mensibus.

lib. 8 fol. 376.

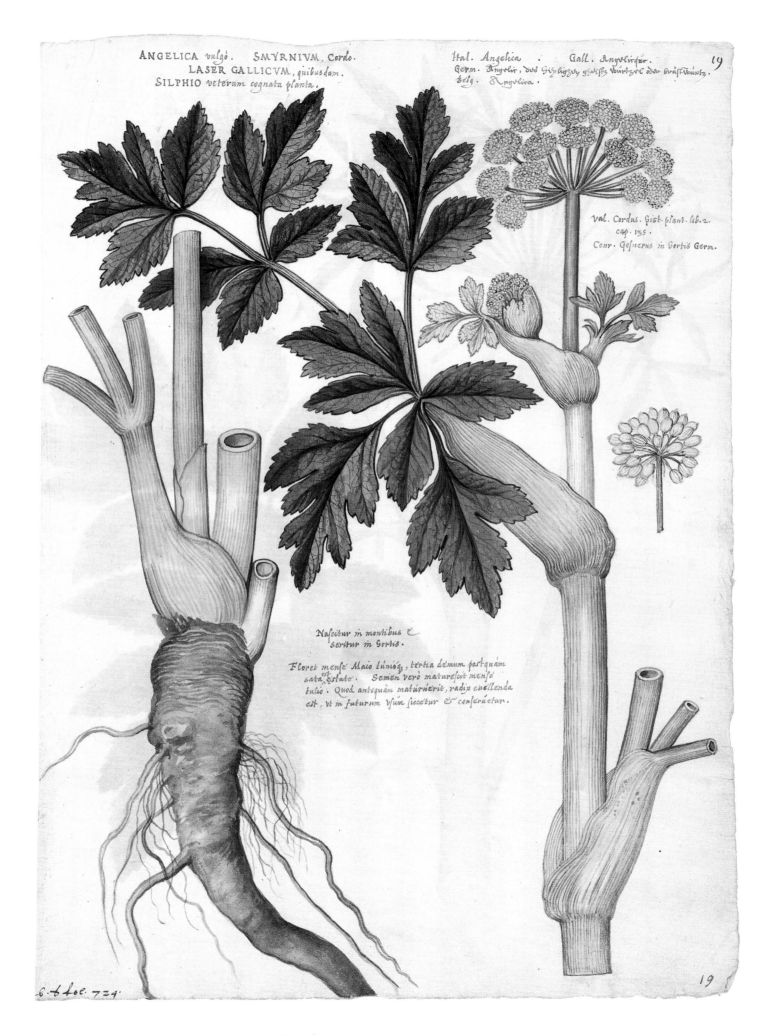

ANGELICA vulgò. SMYRNIVM, Cordo. Ital. Angelica. Gall. Angelicqser.
LASER GALLICVM, quibusdam. Germ. Angelir, dvs Giybiggery ghebiʃʃ boirtzel odder brust boirtz.
SILPHIO veterum cognata planta. belg. Angelica.

19

Val. Cordus. Gist-plant. lib.2.
cap. 135.
Conr. Gesnerus in Hortis Germ.

Nascitur in montibus &
seritur in Hortis.

Floret mense Maio Iunioq̃, tertia demum postquàm
sata est slato. Semen verò marescit mense
Iulio. Quod antequàm maturuerit, radix euellenda
est, vt in futurum vsum siccetur & conseruetur.

6. b fol. 724.

19

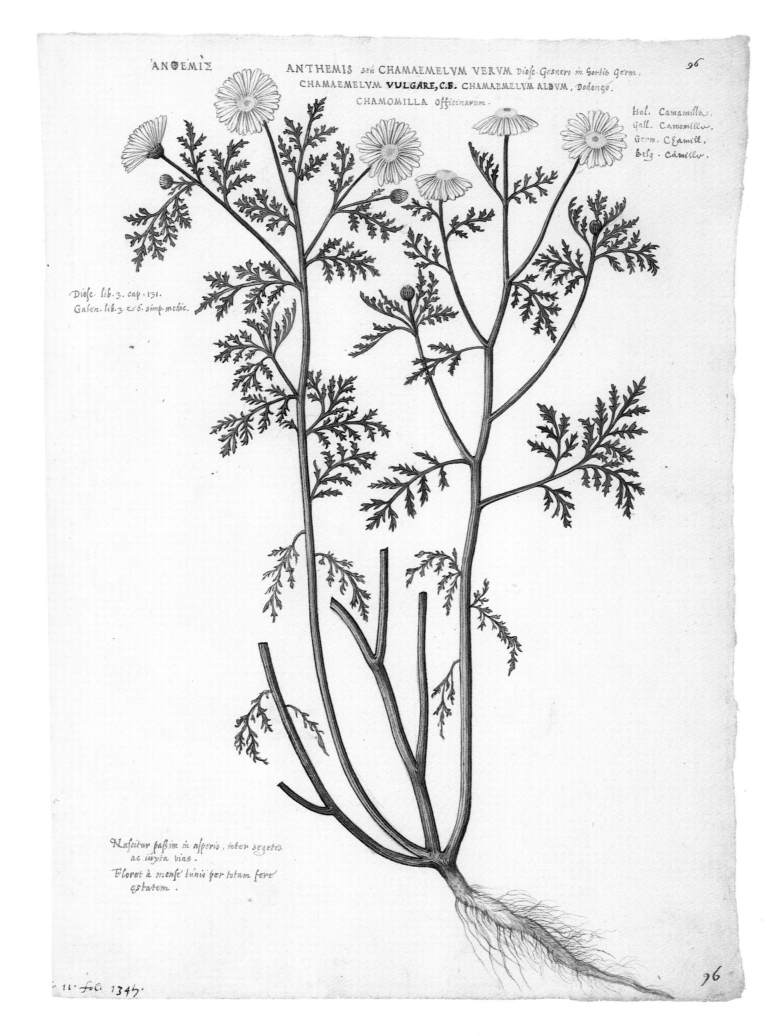

ΑΝΘΕΜΙΣ

ANTHEMIS *seu* CHAMAEMELVM VERVM *Diosc. Gesnero in Hortis Germ.*
CHAMAEMELVM **VVLGARE, C.B.** CHAMAEMELVM ALBVM, *Dodonæo.*
CHAMOMILLA *officinarum.*

Ital. Camamilla.
Gall. Camomilla.
Germ. CRamill.
Belg. Camilla.

Diosc. lib. 3. cap. 131.
Galen. lib. 3 & 6. simp. medic.

Nascitur passim in asperis, inter segetes
ac iuxta vias.
Floret à mense Iunio per totam fere
æstatem.

11. fol. 1345.

96

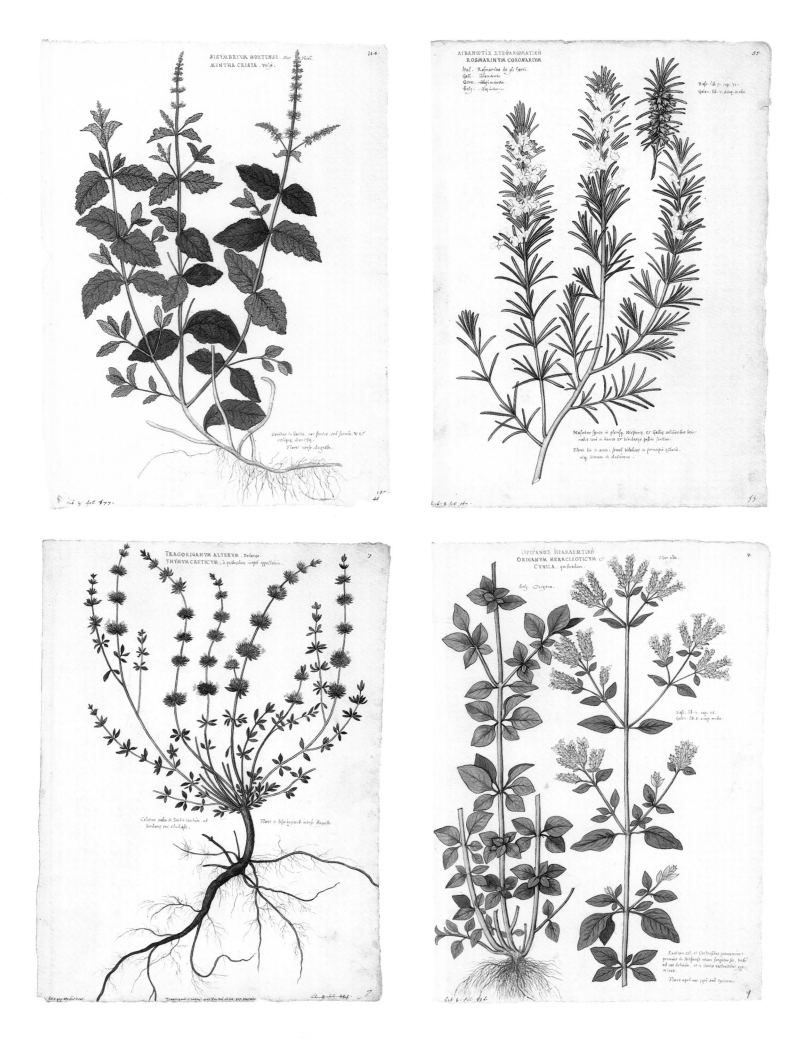

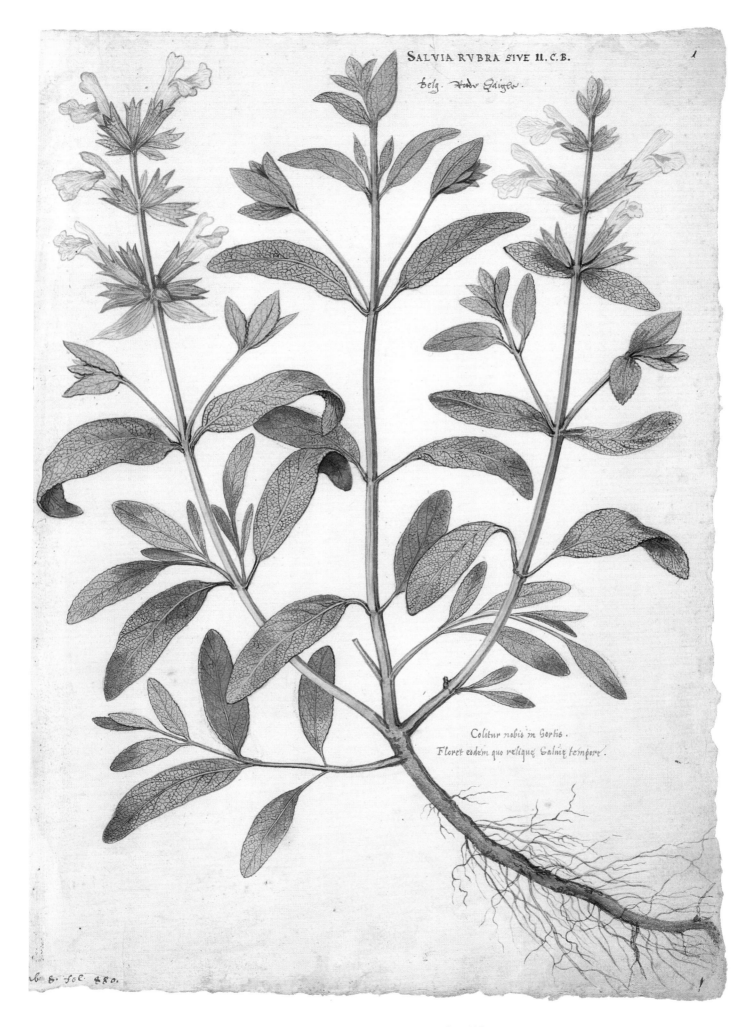

Belg. *Hodr Galighw.*

Colitur nobis in Hortis.
Floret eodem quo reliquæ Salviæ tempore.

N. 8. fol. 280.

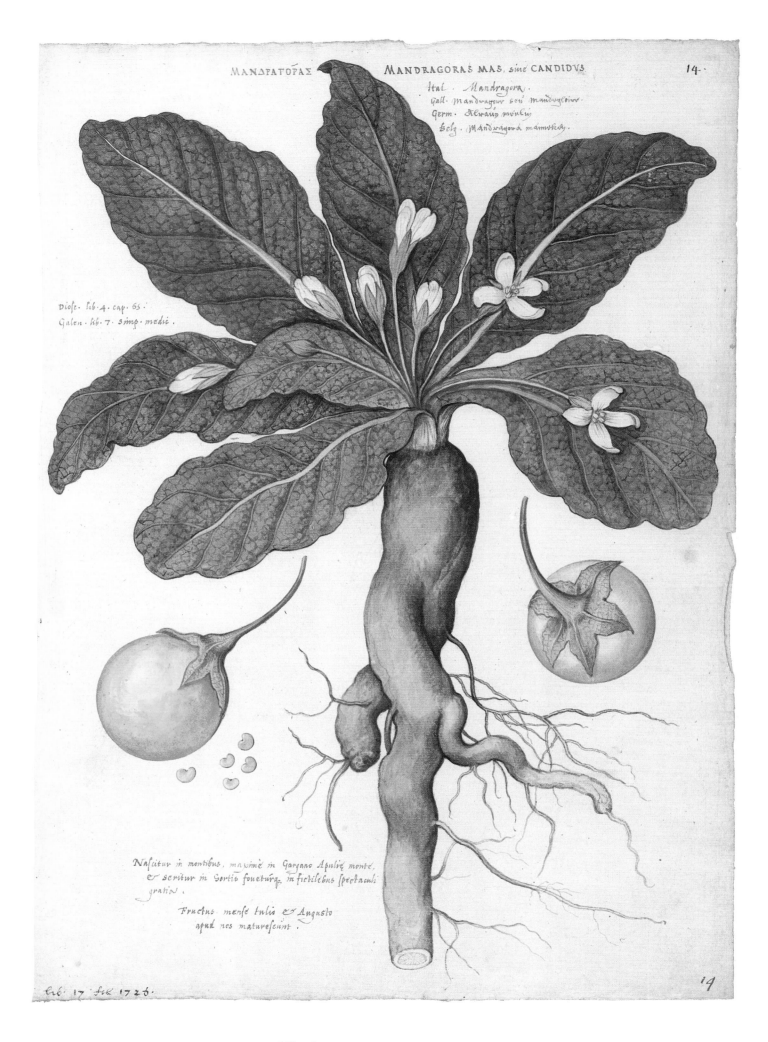

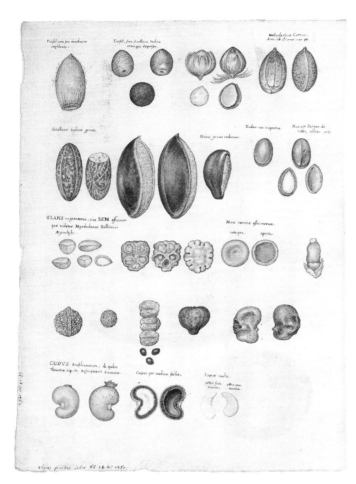

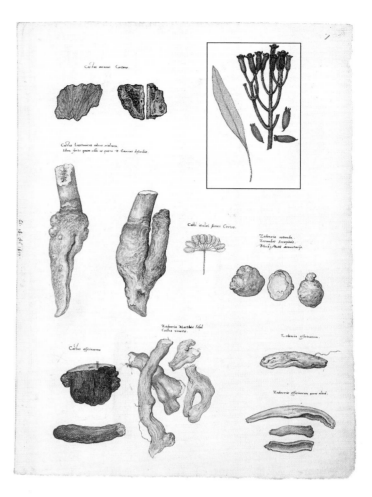

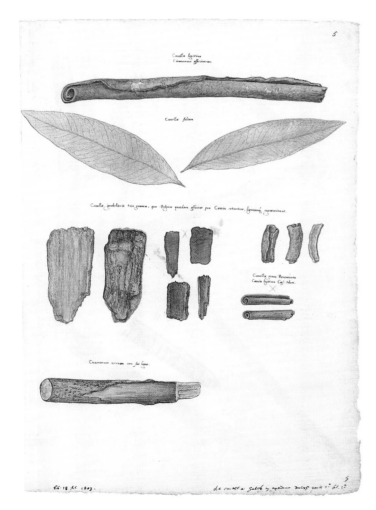

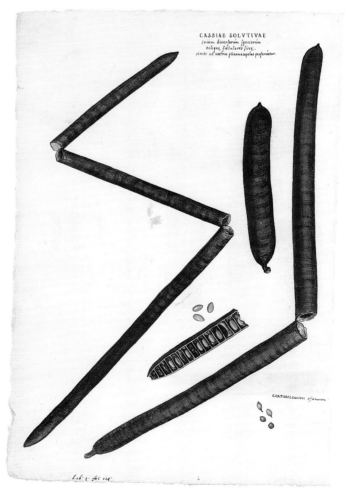

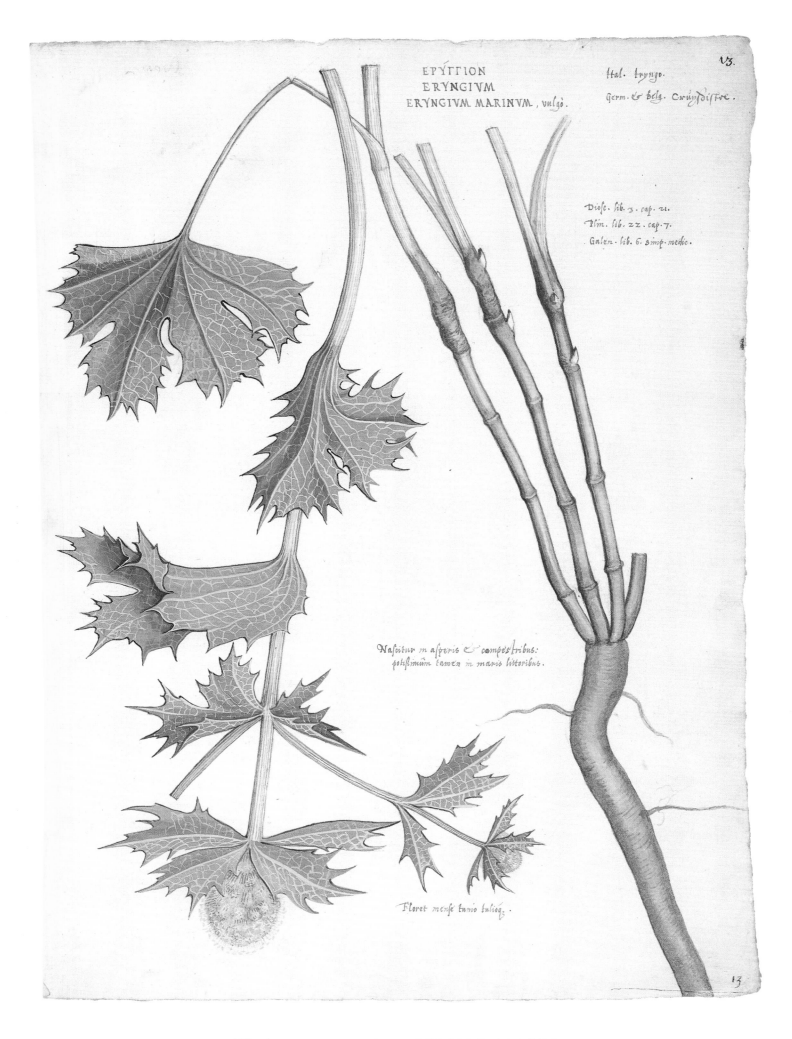

EPYTTION
ERVNGIVM
ERVNGIVM MARINVM, vulgò.

Ital. tryngo.

Germ. & belg. Cruydiſtre.

Dioſc. lib. 3. cap. 21.
Plin. lib. 22. cap. 7.
Galen. lib. 6. ſimp. medic.

Naſcitur in aſperis & campeſtribus:
potiſſimùm tamen in maris littoribus.

Floret menſe iunio iuliòq.

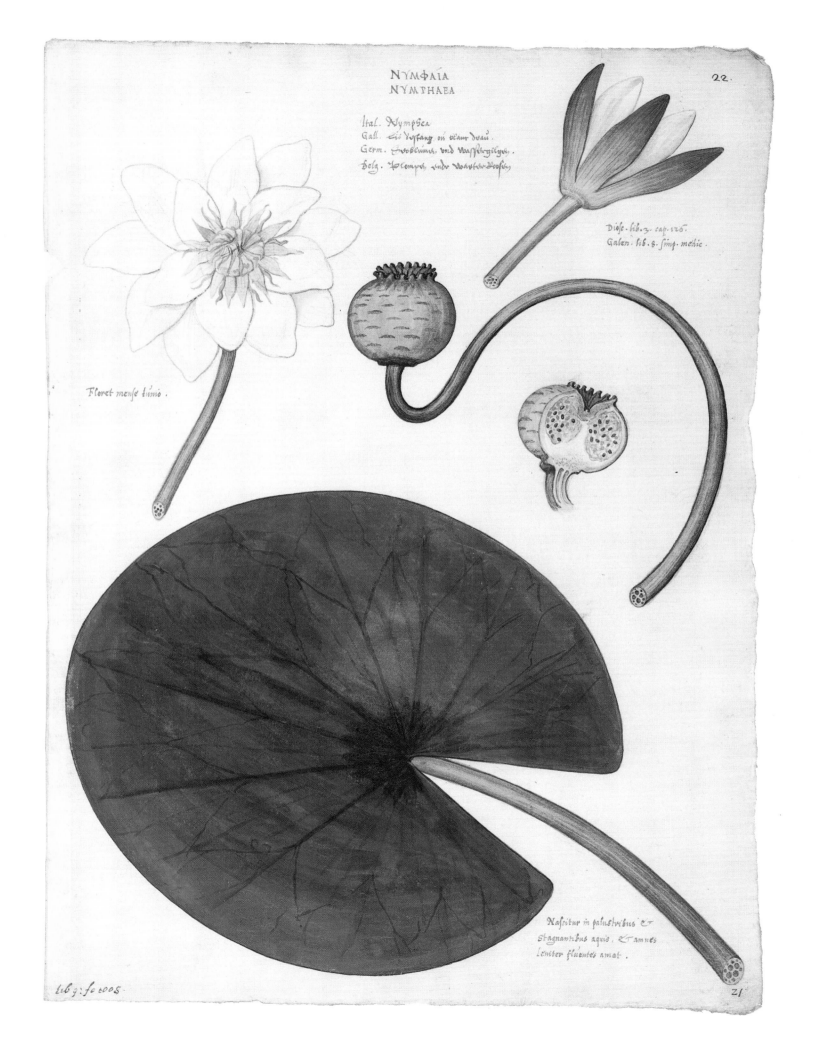

ΝΥΜΦΑΙΑ
ΝΥΜΦΑΕΑ

Ital. Nymphea
Gall. Lis Vestang ou blanc deau
Germ. Seeblumen und Wassergilgen.
Belg. Plompen, ende Wauterdoosen.

Diosc. lib. 3. cap. 126.
Galen. lib. 8. simp. medic.

Floret mense Iunio.

Nascitur in palustribus et
Stagnantibus aquis, et amnes
leniter fluentes amat.

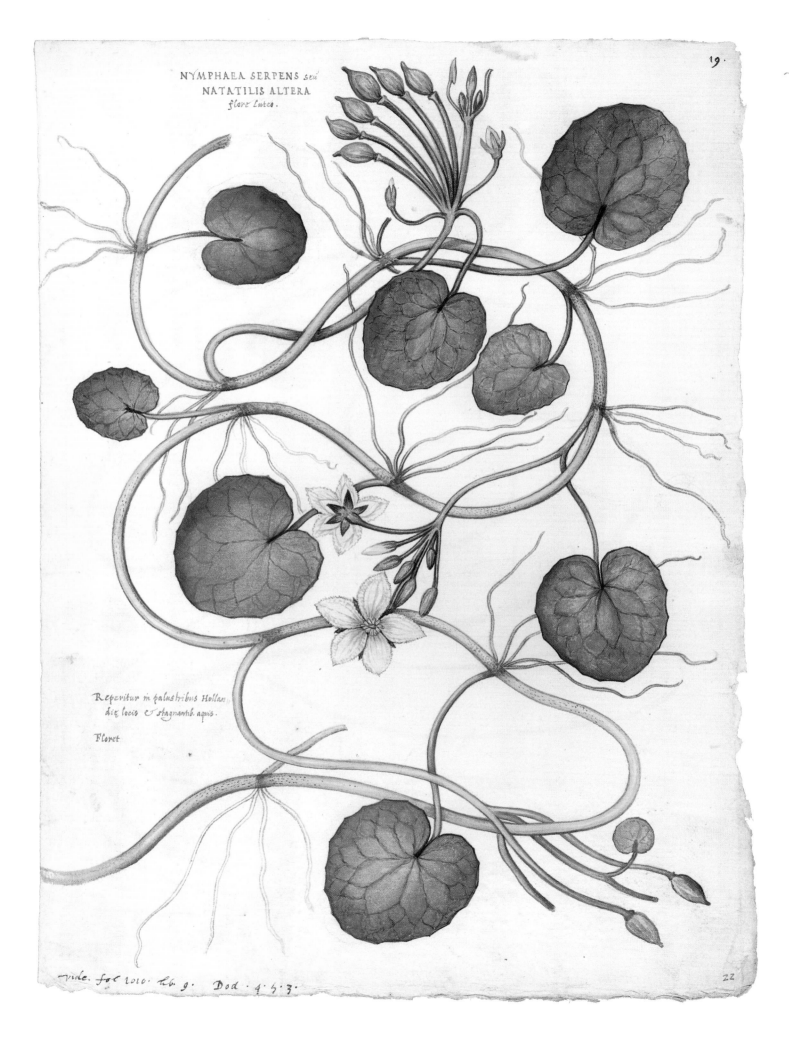

NYMPHAEA SERPENS seu
NATATILIS ALTERA
flore luteo.

Reperitur in palustribus Hollan
diæ locis et stagnantib. aquis.

Floret

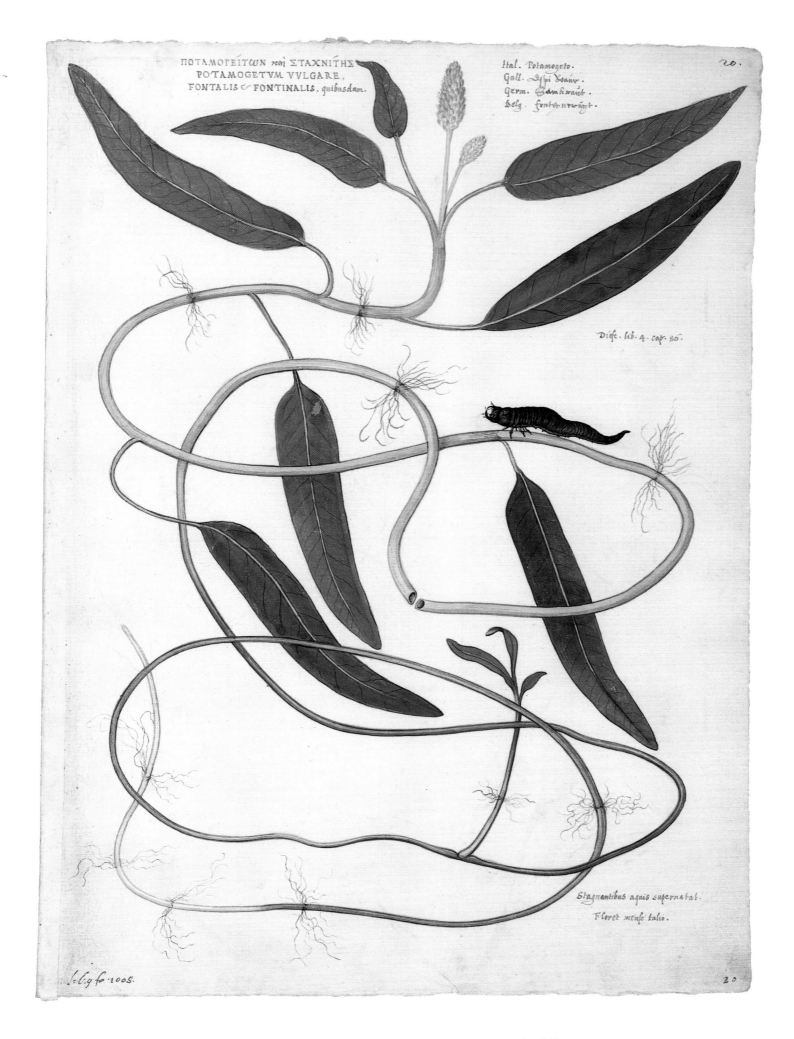

ΠΟΤΑΜΟΓΕΙΤΩΝ καὶ ΣΤΑΧΝΙΤΗΣ
POTAMOGETVM VVLGARE,
FONTALIS & FONTINALIS, quibusdam.

Ital. Potamogeto.
Gall. *l'herbe d'eau*.
Germ. *Samkrant*.
Belg. *fonteyncruyt*.

Diose. lib. 4. cap. 86.

Stagnantibus aquis supernatat.

Floret mense Iulio.

20.

lib. 9 fo. 1008.

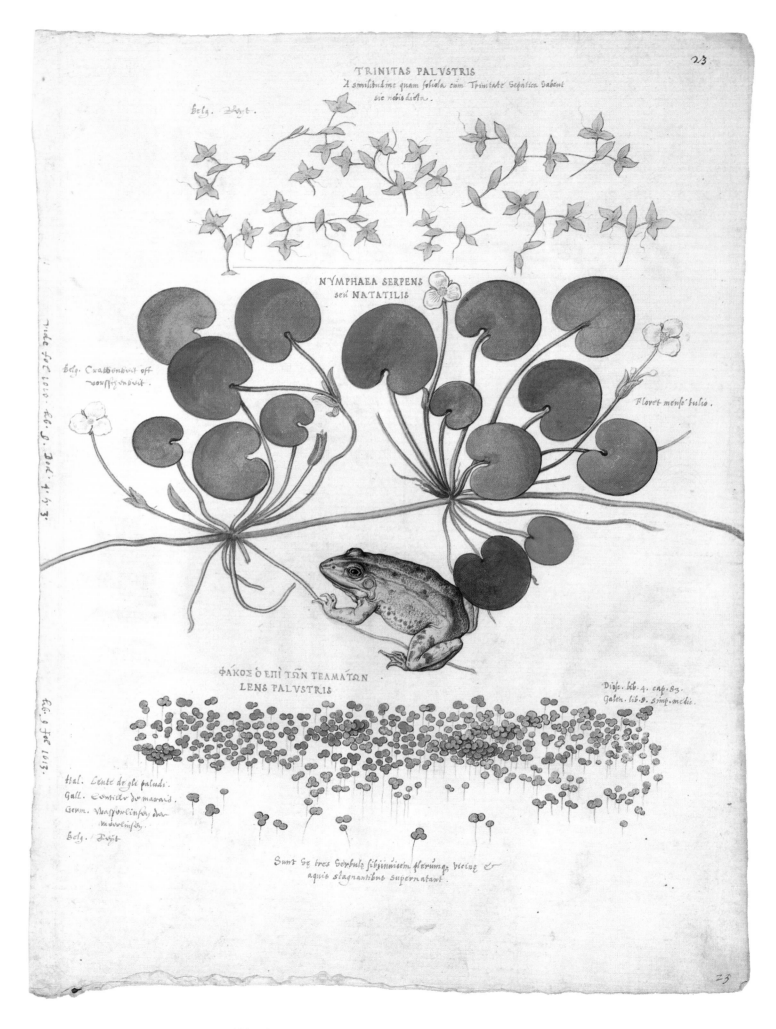

TRINITAS PALVSTRIS
A similitudine quam foliola cum Trinitate Sepatica habent
sic nobis dicta.

Belg. Phyt.

NYMPHAEA SERPENS
seu NATATILIS

Belg. Crassenbout off
coustsonbuit.

Floret mense Iulio.

ΦΑΚΟΣ Ο ΕΠΙ ΤΩΝ ΤΕΛΜΑΤΩΝ
LENS PALVSTRIS

Diosc. lib. 4. cap. 83.
Galen. lib. 9. simp. medic.

Ital. Lente de gli paludi.
Gall. Lentille de marais.
Germ. Wassorlinsen, dan
Moerlinsen.
Belg. Phyt.

Sunt de tres herbulae sibi invicem plerumq; viciae &
aquis stagnantibus supernatant.

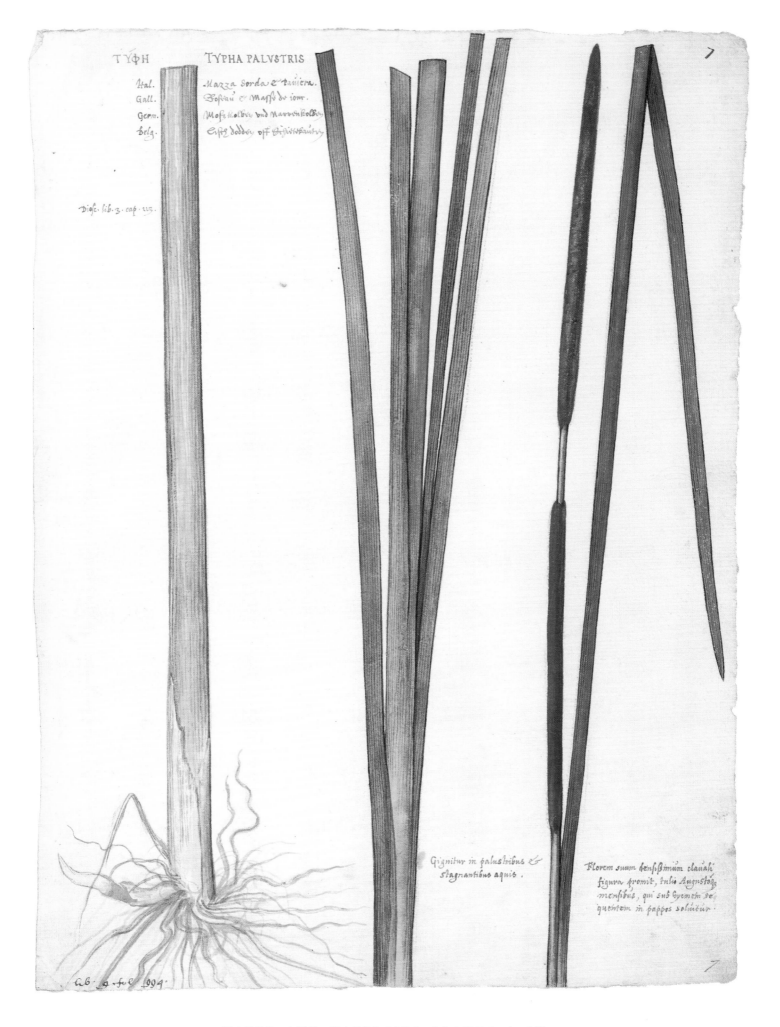

ΤΥΦΗ TYPHA PALVSTRIS

Ital. *Mazza sorda & maniera.*
Gall. *Bossau & Masse de ionc.*
Germ. *Mosz kolben und Narrenkolben*
Belg. *Cisse dodden oft Digittenauten*

Diosc. lib. 3. cap. 115.

Gignitur in palustribus &
stagnantibus aquis.

Florem suum densissimum clauali
figura promit, Iulio Augustoq;
mensibus, qui sub hyemem se-
quentem in pappos soluitur.

cib. 6. feb. 1094.

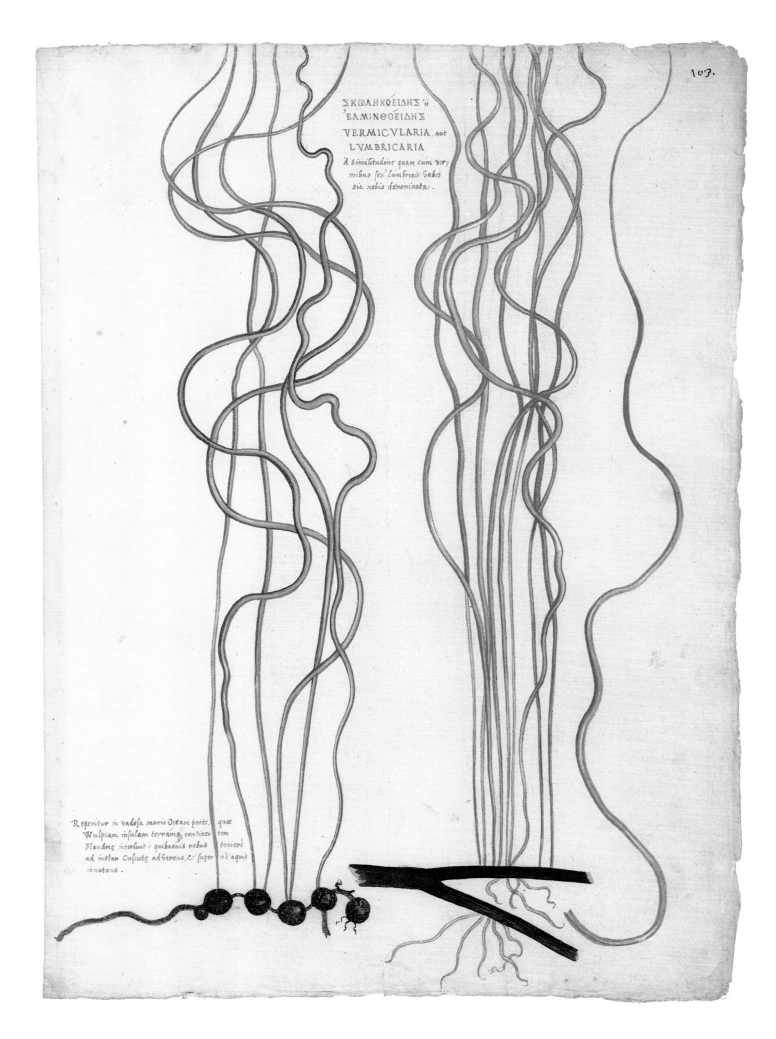

ΣΚΩΛΗΚΟΕΙΔΗΣ ἤ
ʹΕΛΜΙΝΘΟΕΙΔΗΣ
VERMICVLARIA, aut
LVMBRICARIA
À similitudine quam cum ver-
mibus seu Lumbricis habet
sic nobis denominata.

Reperitur in vadosa maris Oceani parte, quæ
Wulpiam insulam terramq́, continen tem
Flandriæ interluit: quibusuis rebus temeré
ad instar Cuscutæ adhærens, & super né aquis
innatans.

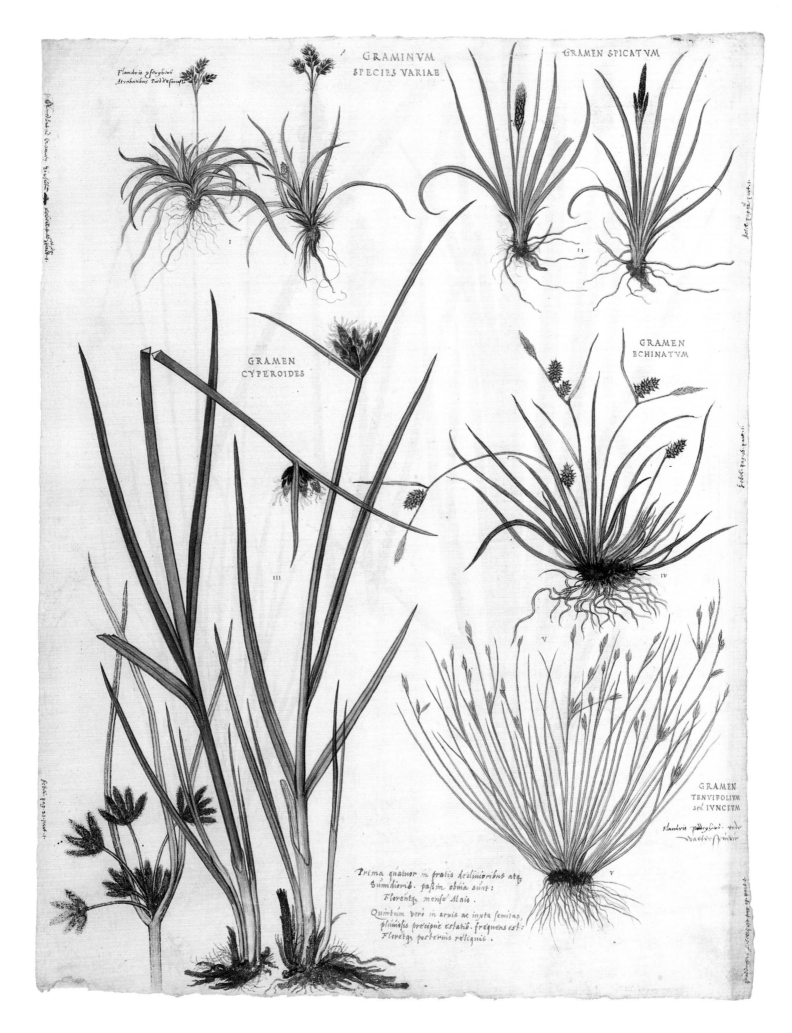

GRAMINVM
SPECIES VARIAE

GRAMEN SPICATVM

GRAMEN
CYPEROIDES

GRAMEN
ECHINATVM

GRAMEN
TENVIFOLIVM
seu IVNCEVM

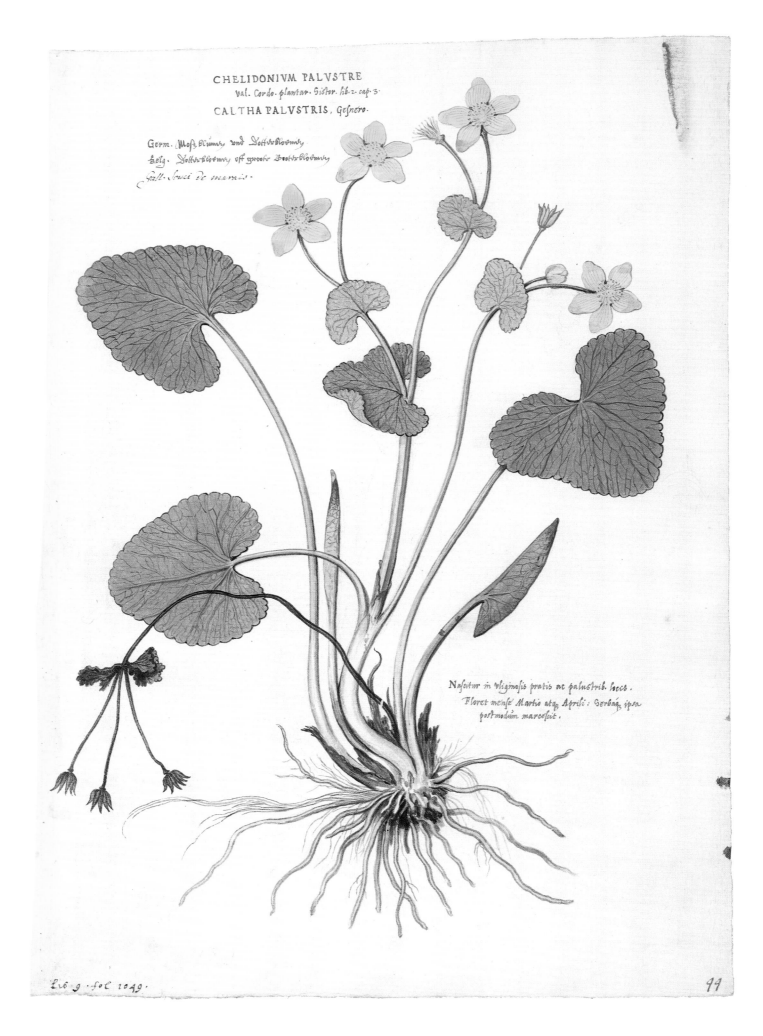

CHELIDONIVM PALVSTRE
Val. Cordo. plantar. histor. lib. 2. cap. 3.
CALTHA PALVSTRIS, Gesnero.

Germ. Mosz Blumen vnd Dotterbloemen
belg. Dotterbloemen off groote Dotterbloemen
Gall. Souci de marais.

Nascitur in vliginosis pratis ac palustrib. locis.
Floret mense Martio ataz Aprili: herbaz ipsa
postmodum marcescit.

Lib. 9. fol. 1049.

99

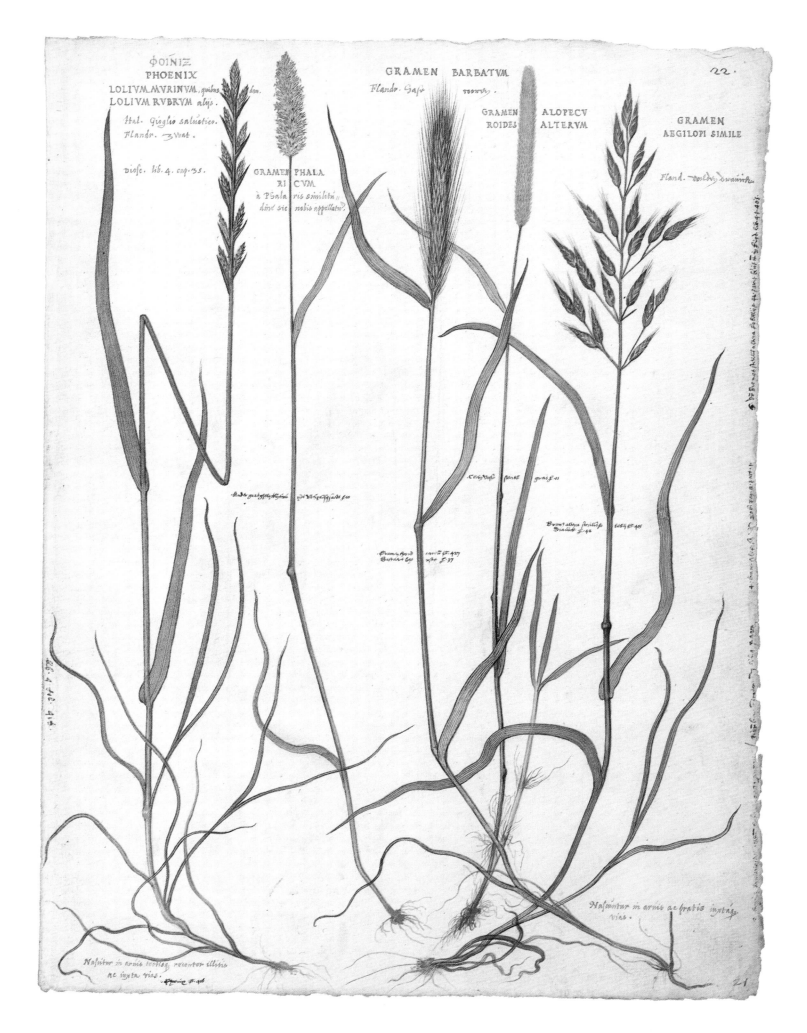

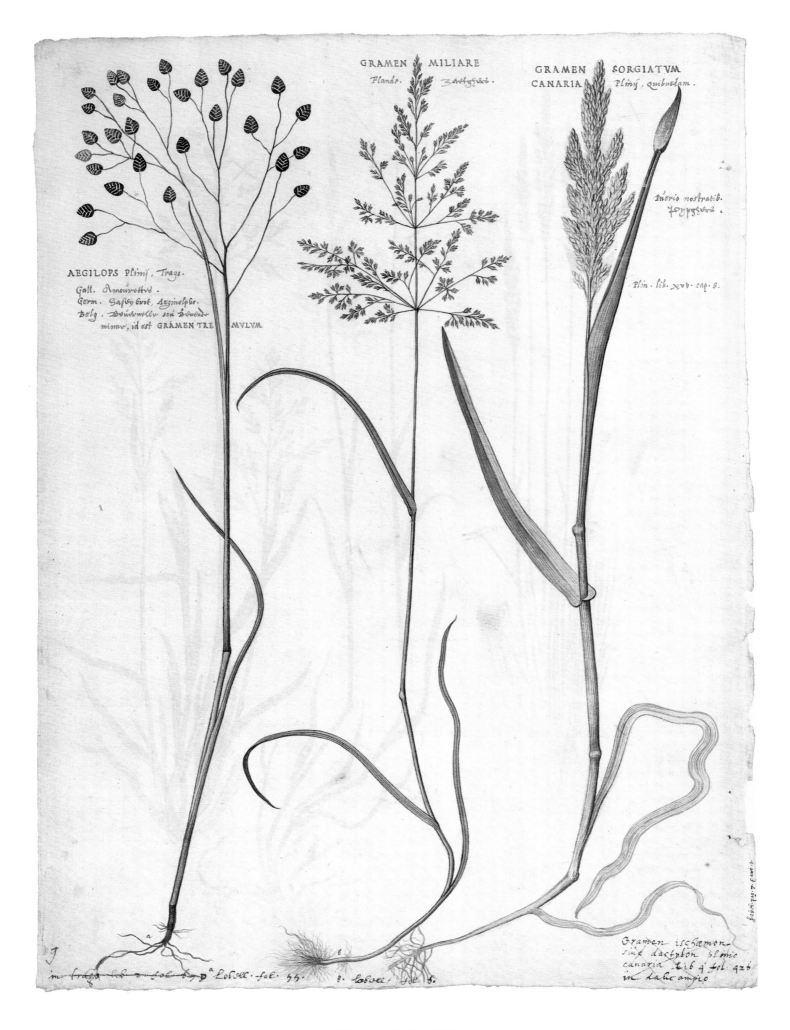

GRAMEN MILIARE
Flandr. Zartgras.

GRAMEN SORGIATVM
CANARIA Plinij, quibusdam.

AEGILOPS Plinij, Trago.
Gall. Amourettes.
Germ. Gasteorot, Aeginolpho.
Belg. Beuenelle seu bibender
minor, id est GRAMEN TRE MVLVM.

Pueris nostratib.
Poppegras.

Plin. lib. xvb. cap. 8.

Gramen ischamon
siue dactylon semie
canaria Lib 4 fol 426
in dalic ampio

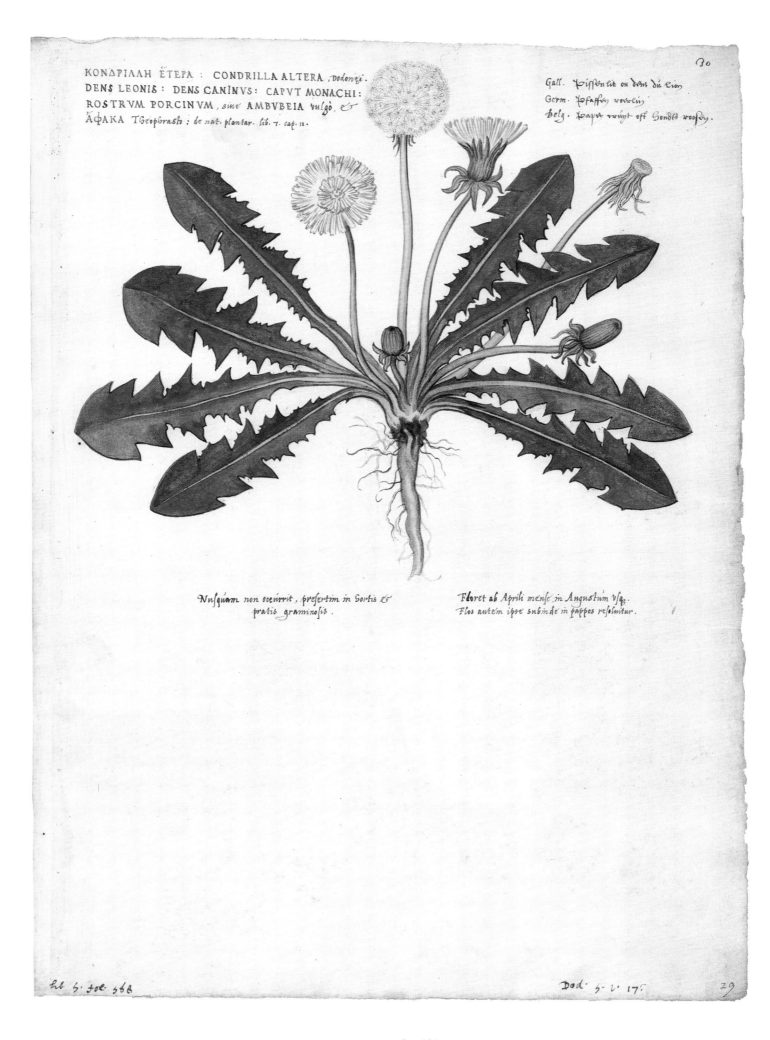

ΚΟΝΔΡΙΛΛΗ ΕΤΕΡΑ : CONDRILLA ALTERA , Dodonæi.
DENS LEONIS : DENS CANINVS : CAPVT MONACHI :
ROSTRVM PORCINVM , sive AMBVBEIA vulgò , &
ΑΦΑΚΑ Theophrasto : de nat. plantar. lib. 7. cap. 11.

Gall. Piffenlit ou dent du Lion
Germ. Josaffen rosslein
Belg. Papen cruyt oft Sondts roosen

Nusquam non occurrit, presertim in Sortis &
pratis graminosis.

Floret ab Aprili mense in Augustum vsq.
Flos autem ipse subinde in pappos resoluitur.

lib. 5. fol. 568

Dod. 5. 2. 175

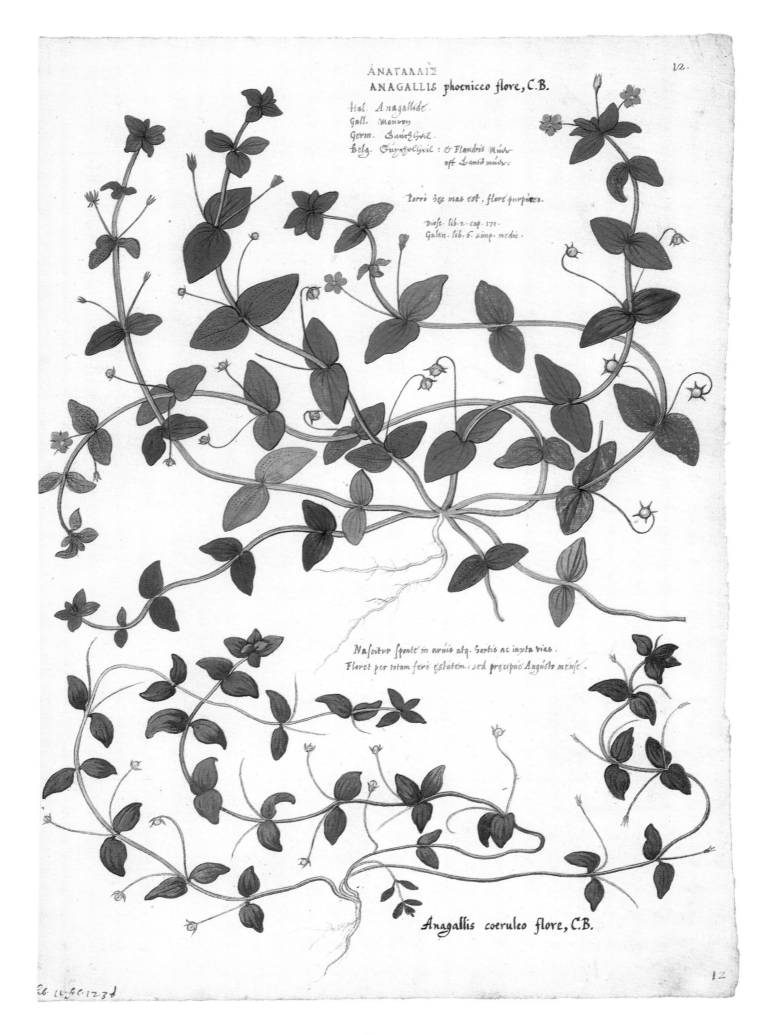

ÁNAΓAΛΛÌΣ
ANAGALLIS phoeniceo flore, C.B.

Ital. *Anagallide.*
Gall. *Mouron*
Germ. *Gauchheil.*
Belg. *Guychheil : & Flandris Mur-*
oft Santd muer.

Porrò hec mas est, flore purpureo.

Diosc. lib. 2. cap. 171.
Galen. lib. 6. simp. medic.

Nascitur sponte in arvis atq. hortis ac iuxta vias.
Floret per totam ferè estatem. sed præcipuè Augusto mense.

Anagallis coeruleo flore, C.B.

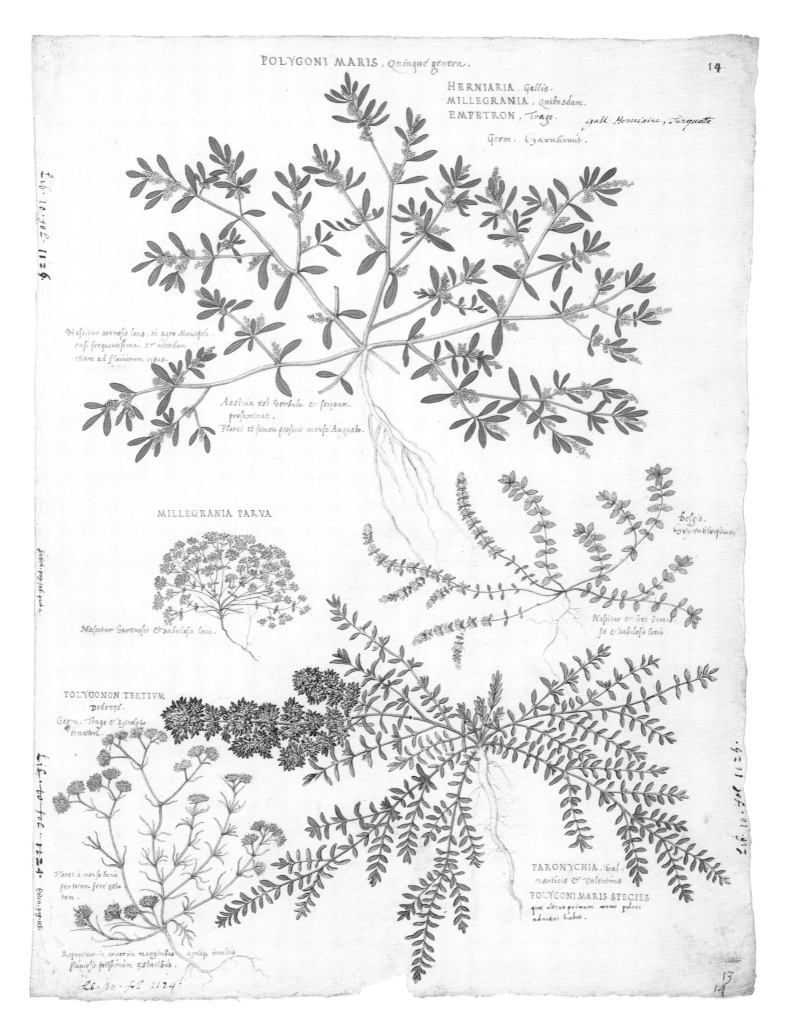

POLYGONI MARIS, *Quinque genera.*

HERNIARIA, *Gallis.*
MILLEGRANIA, *Quibusdam.*
EMPETRON, *Trago.* *gall. Herniaire, Turquette*

Germ. *Garnkraut.*

Nascitur arenosis locis, in agro Monspeliensi frequentissima, et interdum etiam ad fluviorum ripas.

Aestiva est herbula et seipsam proseminat.
Floret et semen perficit mense Augusto.

MILLEGRANIA PARVA

Belgis.
By en bloeysomen

Nascitur arenosis & sabulosis locis.

Nascitur et hac arenosis & sabulosis locis.

POLYGONON TERTIVM
Dodonei.
Germ. *Trago & Eginolpho*
Knavvel.

Floret à mense Iunio, per totam fere aestatem.

PARONYCHIA, *Salmanticis & Valentinis*
POLYGONI MARIS SPECIES
quae altero primum anno palens adnatas habet.

Reperitur in aruorum marginibus agrisq. incultis fluuiosis potissimùm aestatibus.

ΤΡΑΓΟΠΟΓΩΝ
HIRCI BARBVLA, flore
purpureo.

Ab 9 fol 1079.

73.

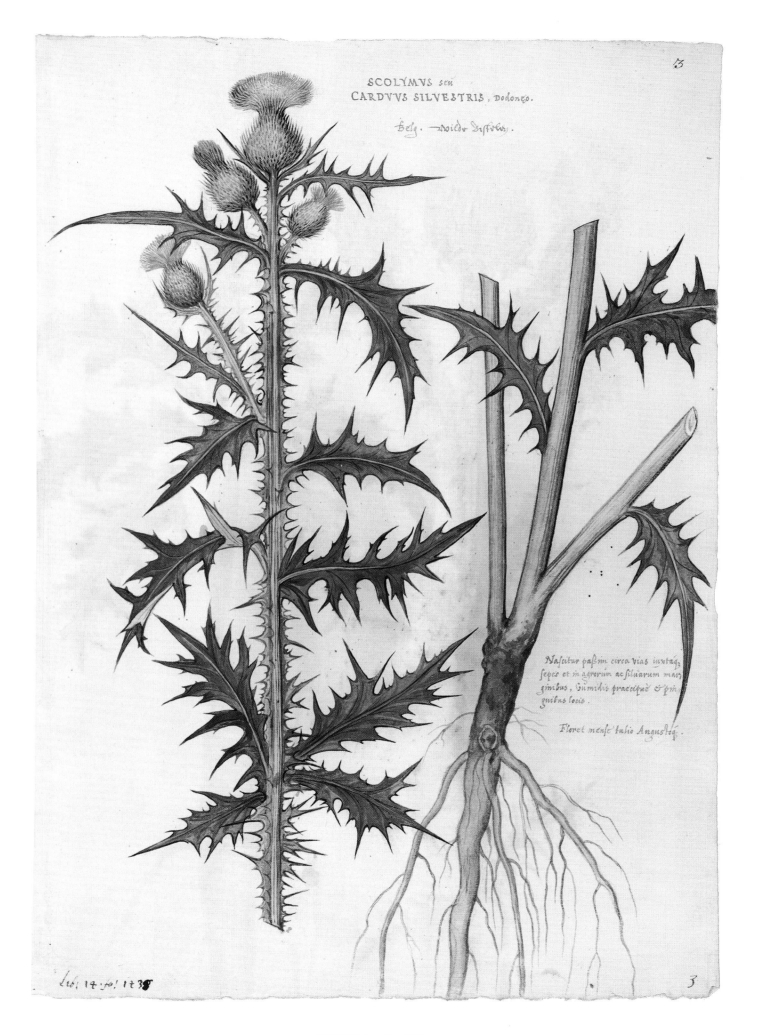

SCOLYMVS seu
CARDVVS SILVESTRIS, Dodonæo.

Belg. wilde Distelen.

Nascitur passim circa vias iuxtaq;
sepes et in agrorum ac siluarum mar-
ginibus, humidis praecipue & pin-
guibus locis.

Floret mense Iulio Augustoq;.

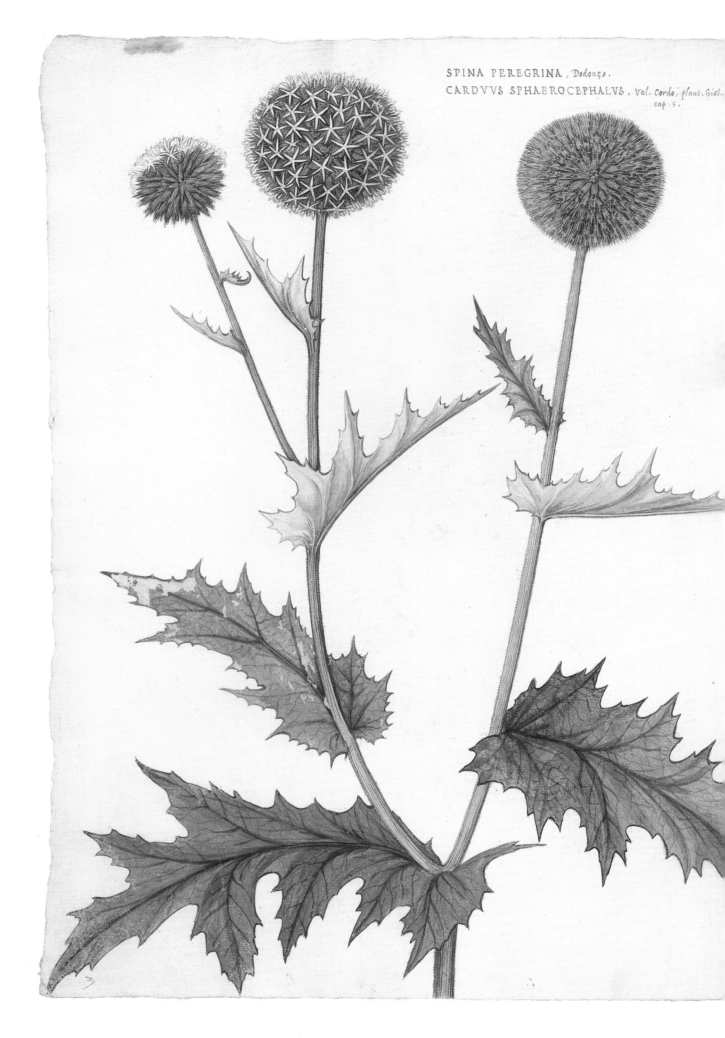

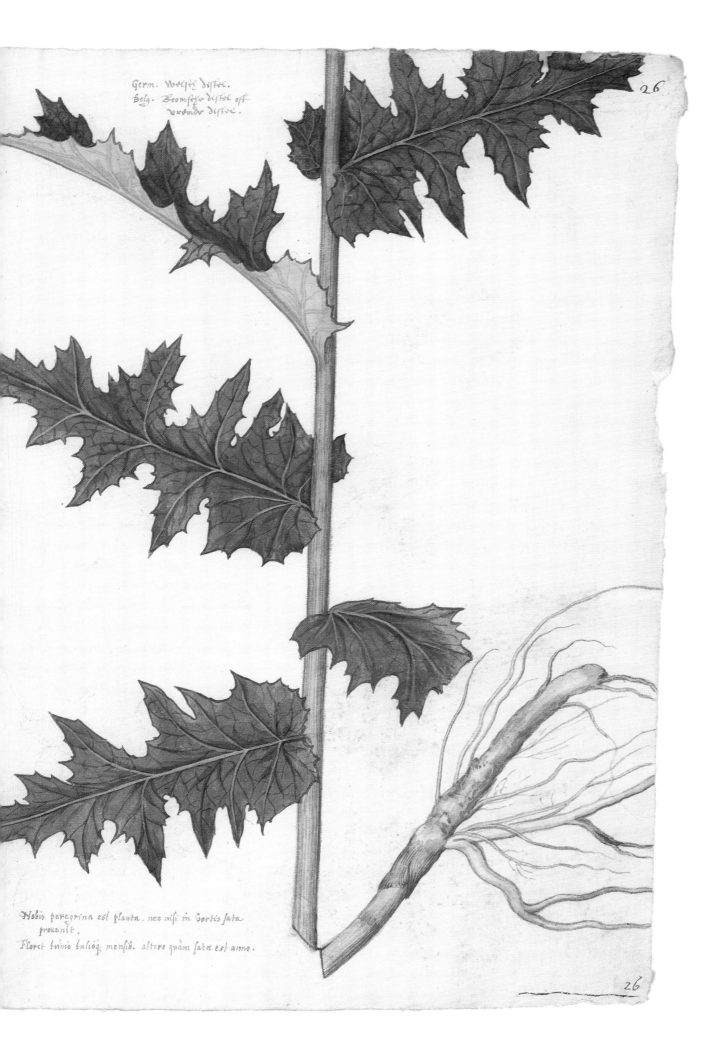

Germ. vocesss diffol.
Belg. Boomscht diffol oft
vremder diffol.

Nobis peregrina est planta, nec nisi in hortis sata
prouenit.
Floret primo tulióq; mensib. altero quàm sata est anno.

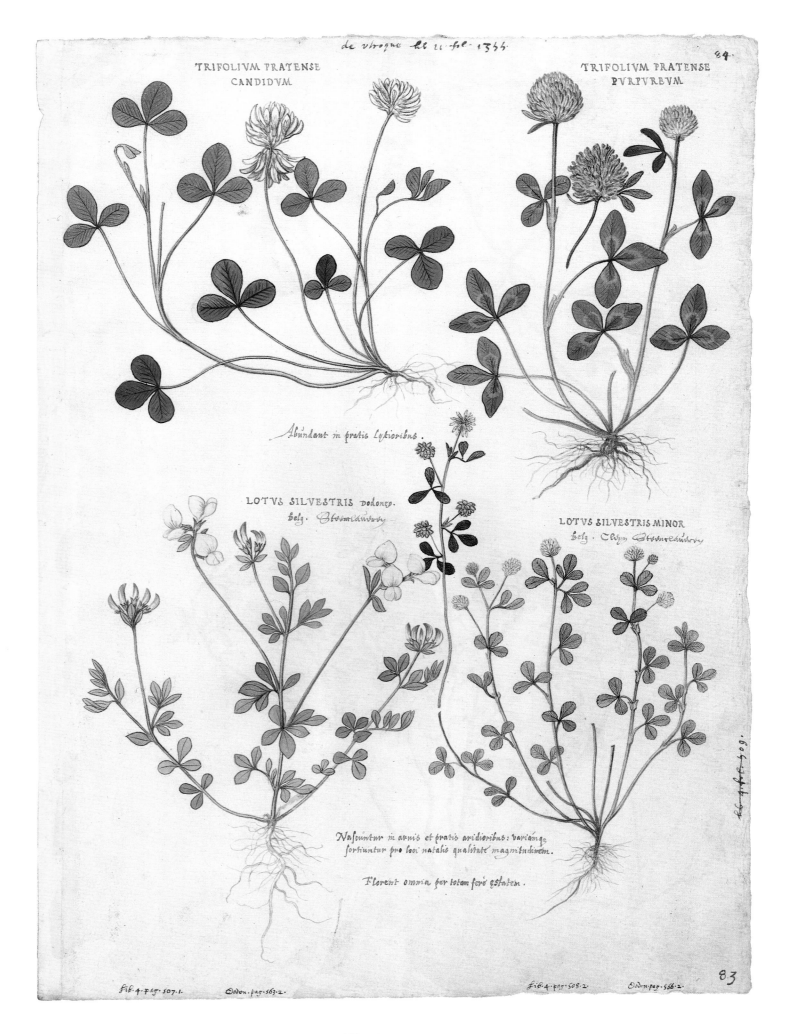

de vroque hl ii fil 1344

84.

TRIFOLIVM PRATENSE
CANDIDVM

TRIFOLIVM PRATENSE
PVRPVREVM

Abundant in pratis letioribus.

LOTVS SILVESTRIS Dodonæo.
Belg. Steenclauvrey

LOTVS SILVESTRIS MINOR
Belg. Cleyn Steenclauvrey

Nascuntur in arvis et pratis aridioribus: variámq̃
sortiuntur pro loci natalis qualitate magnitudinem.

Florent omnia per totam ferè æstatem.

fib. 4. fig. 507.1. Dodon. pag. 563.2.

fib. 4. pag. 508.2. Dodon. pag. 566.2.

83.

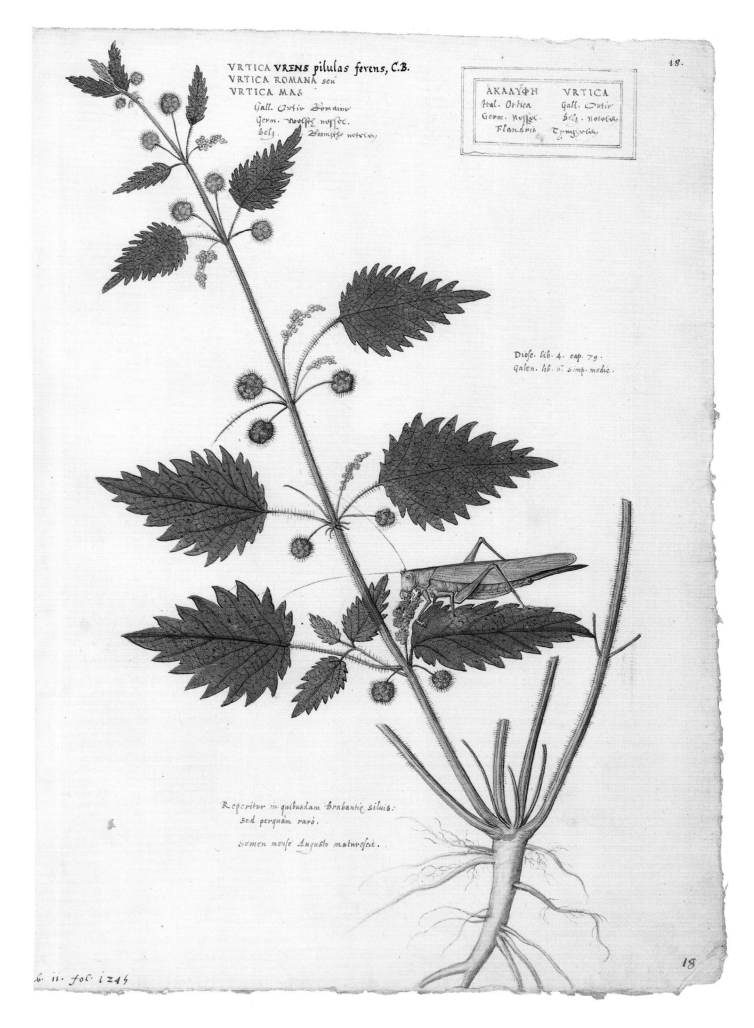

VRTICA **VRENS** pilulas ferens, C.B.
VRTICA ROMANA seu
VRTICA MAS

Gall. *Ortie Romaine*
Germ. *woelff nessel.*
Belg. *Roomsche netelen.*

ΑΚΑΛΥΦΗ VRTICA
Ital. Ortica Gall. Ortie
Germ. Nessel. Belg. Netelen.
Flandris Tyngruen

Diosc. lib. 4. cap. 79.
Galen. lib. 6. simp. medic.

Reperitur in quibusdam Brabantiæ siluis:
sed perquàm rarò.

Semen mense Augusto maturescit.

li. II. fol. 1244

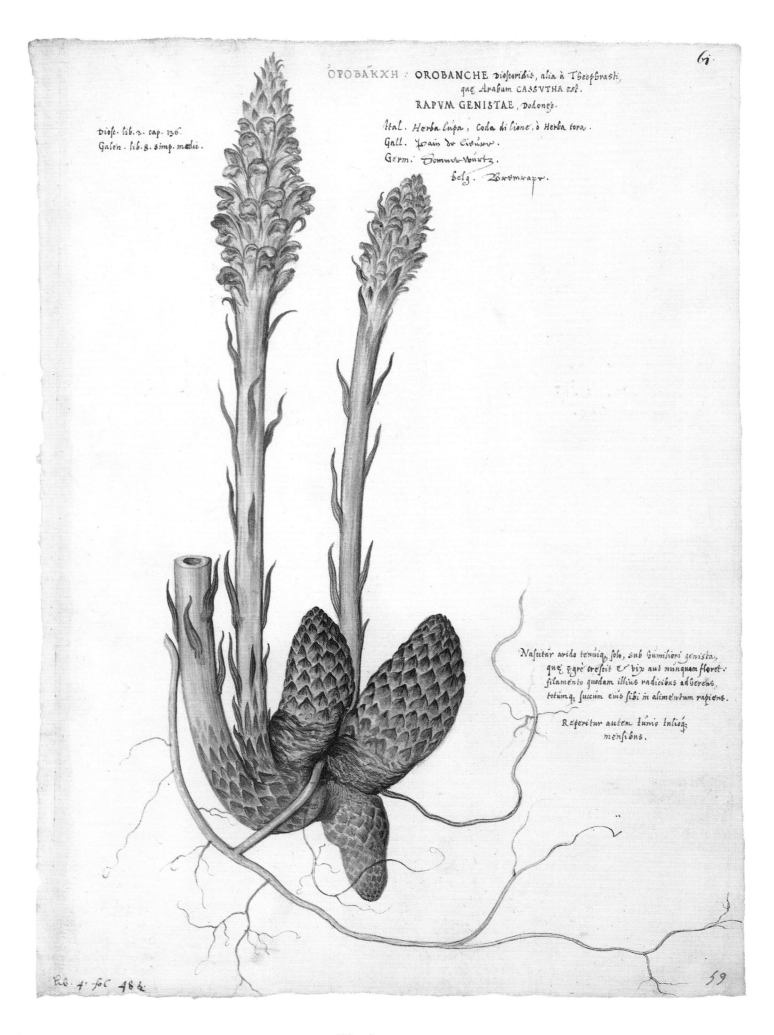

ΟΡΟΒΆΚΧΗ : OROBANCHE *Dioscoridis, alia à Theophrasti,*
quȩ Arabum CASSVTHA *est.*
RAPVM GENISTAE, *Dodongß.*

Diosc. lib. 2. cap. 136.
Galen. lib. 8. simp. medic.

Ital. Herba lupa , Coda di lione, ò Herba tora .
Gall. Irain de Cieusu .
Germ. Sommer-wurtz.

belg. Bromrapr .

Nascitur arido tenuiq. solo, sub humiliori genista,
quȩ ȩgrè crescit & vix aut nunquam floret.
filamento quodam illius radicibus adhȩrens,
totúmq. succum eius sibi in alimentum rapiens.

Reperitur autem Iunio Iulioq.
mensibus.

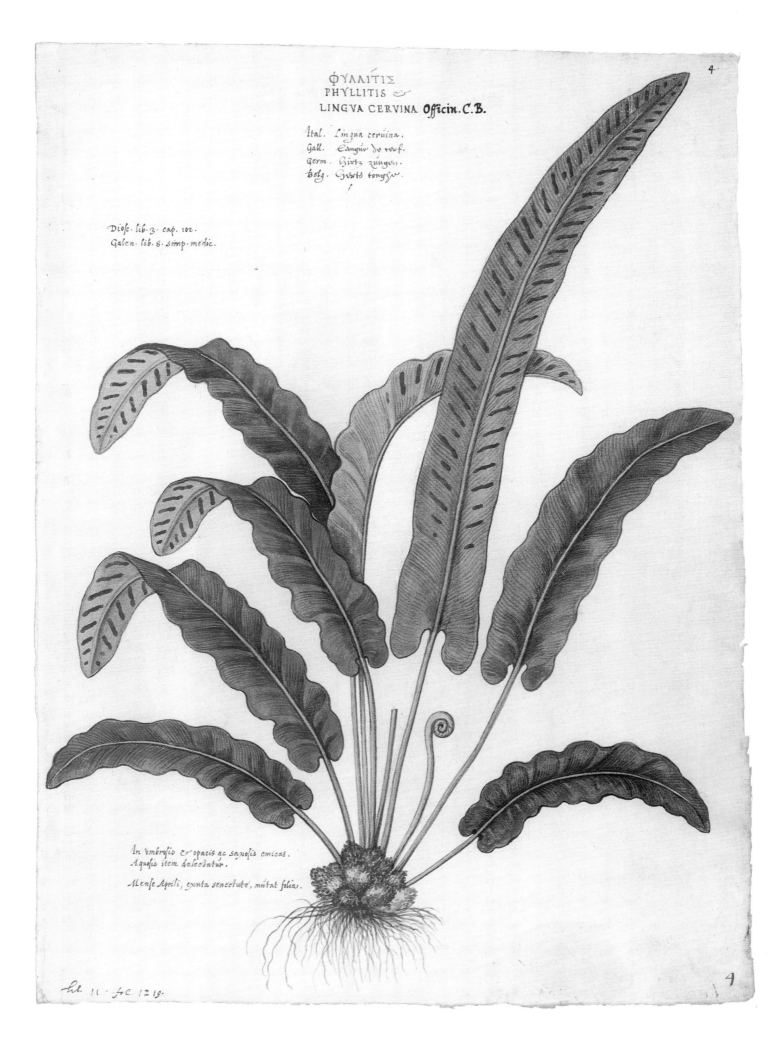

ΦΥΛΛΙΤΙΣ
PHYLLITIS &
LINGVA CERVINA **Officin. C.B.**

Ital. Lingua ceruina.
Gall. Langue de cerf.
Germ. Hirtz zungen.
Belg. Herts tonghe.

Diosc. lib. 3. cap. 102.
Galen. lib. 8. simp. medic.

In vmbrosis & opacis ac saxosis emicat.
Aquosis item delectatur.

Mense Aprili, exuta senectute, mutat folia.

lib. 11. fol 1219.

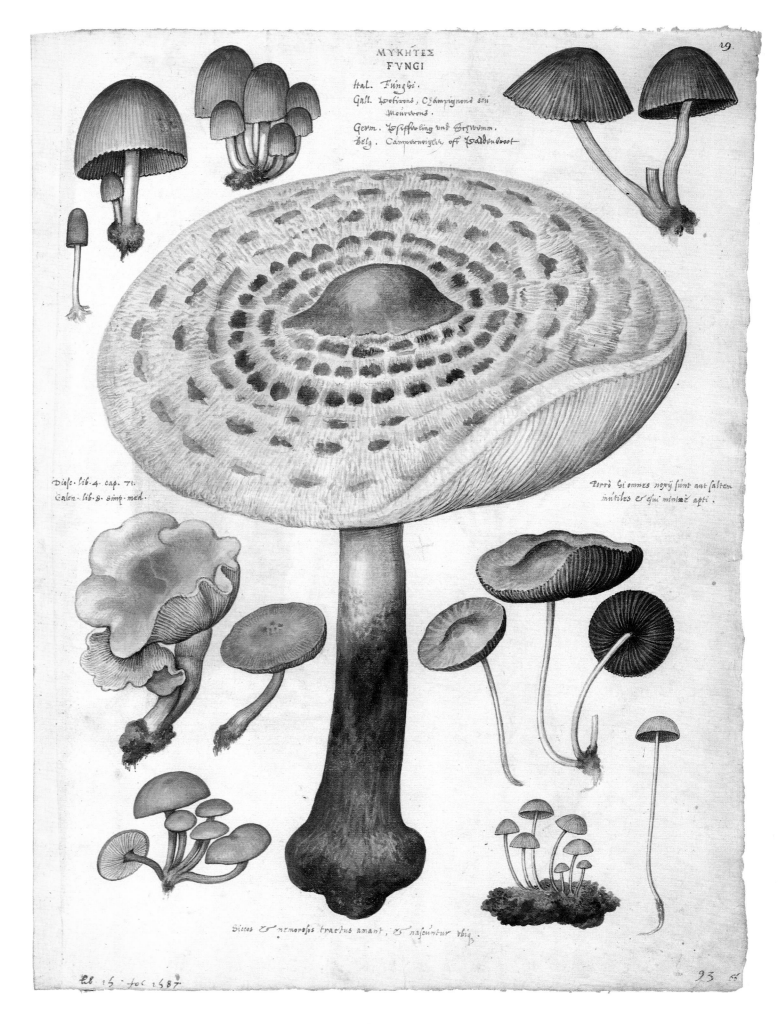

ΜΥΚΗΤΕΣ
FVNGI

Ital. *Funghi.*
Gall. *Lostrons, Champignons seu Mousrons.*
Germ. *Schswling und Schwumm.*
Belg. *Campernoigen off Paddenbrot.*

Diosc. lib. 4. cap. 71.
Galen. lib. 8. simp. med.

Porrò hi omnes noxij sunt aut saltem inutiles et esui minimè apti.

Siccos et nemorosos tractus amant, et nascuntur vbiq.

Ab 15. Fol. 1587.

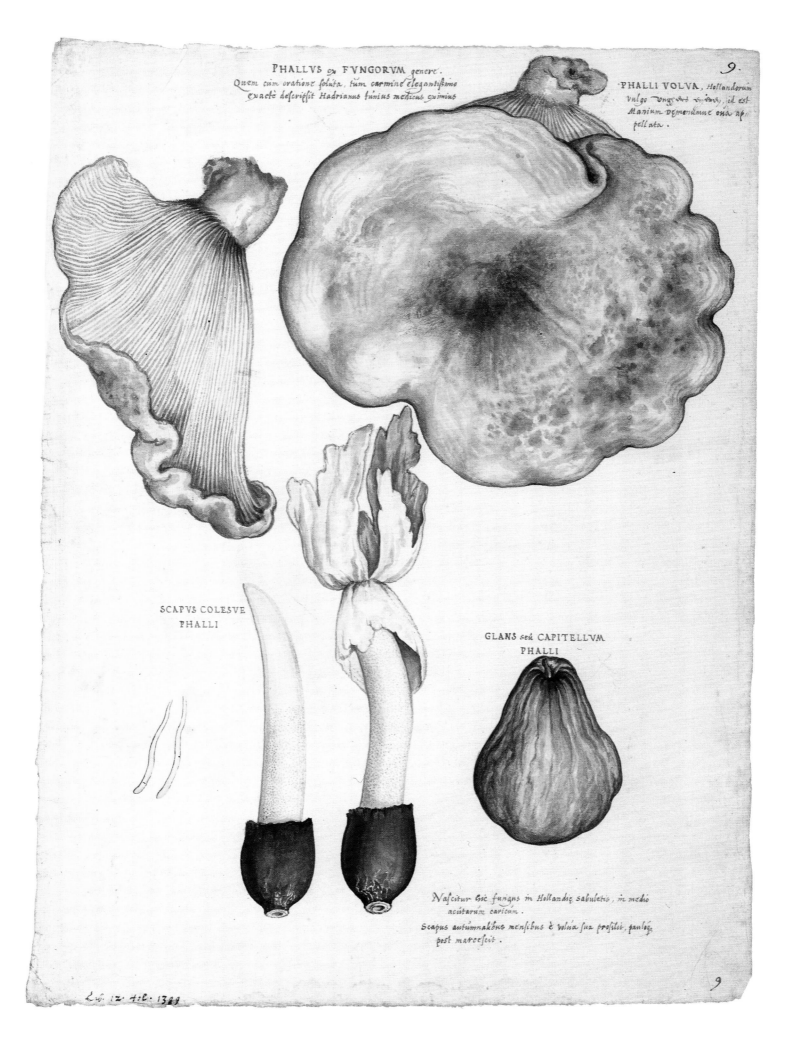

PHALLVS ex FVNGORVM genere.
Quem cum oratione soluta, tum carmine elegantissimo
exacte descripsit Hadrianus Iunius medicus eximius

PHALLI VOLVA, Hollandorum
vulgo Ungar het vijtimes, id est
Manium Dæmonumue ona ap-
pellata.

SCAPVS COLESVE
PHALLI

GLANS seu CAPITELLVM
PHALLI

Nascitur hic fungus in Hollandiæ sabuletis, in medio
acutarum caricum.

Scapus autumnalibus mensibus è volua sua prosilit, pauloq
post marcescit.

Lib. 12. fol. 1389

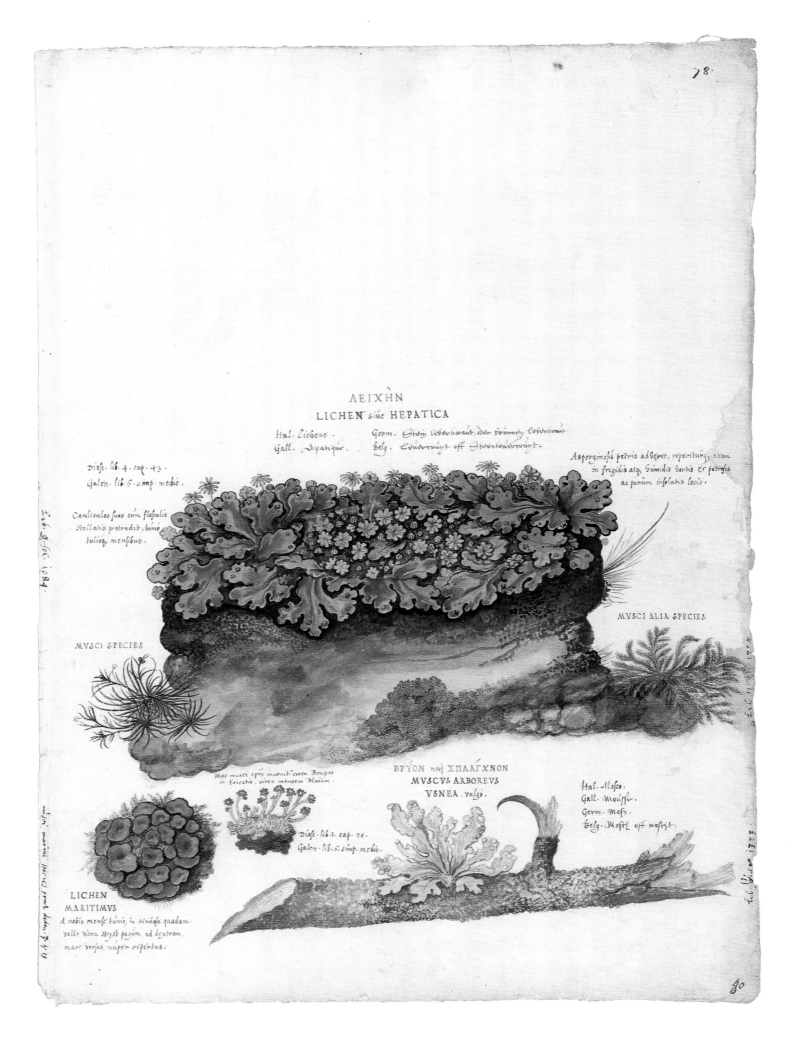

ΛΕΙΧΉΝ
LICHEN siue HEPATICA

Ital. Lichene. *Germ.*
Gall. Lepatique. *Belg.*

ΒΡΎΟΝ καὶ ΣΠΛΆΓΧΝΟΝ
MVSCVS ARBOREVS
VSNEA, vulgo.

Ital. Mosco.
Gall. Mousse.
Germ. Moss.
Belg.

MVSCI SPECIES

MVSCI ALIA SPECIES

LICHEN
MARITIMVS

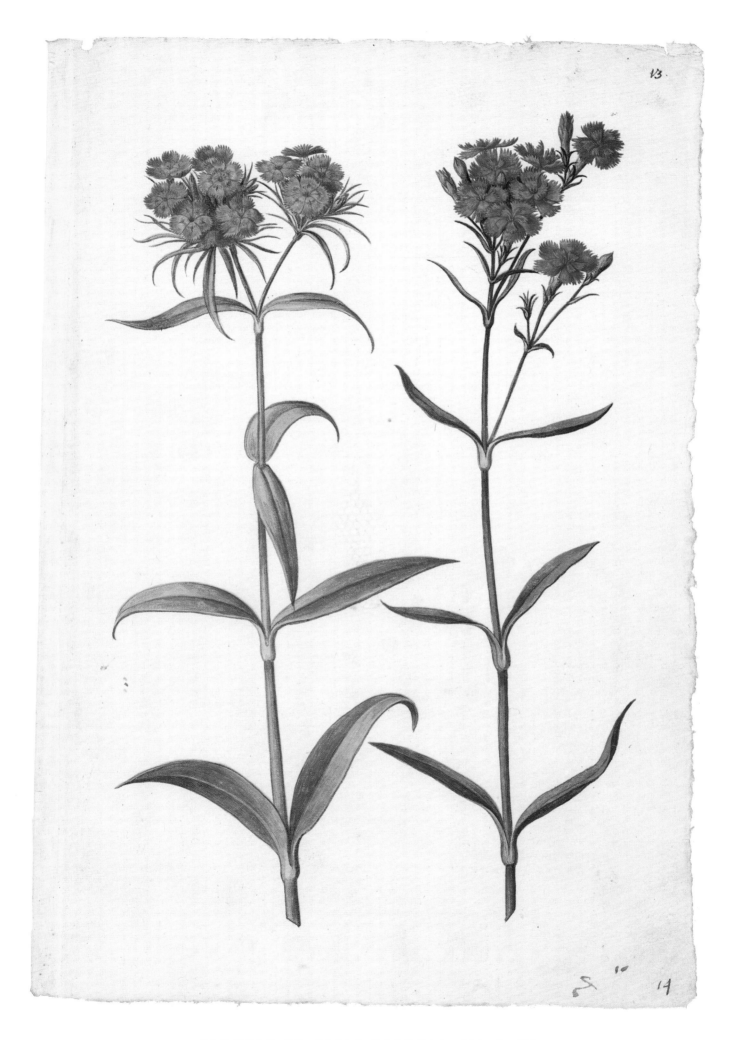

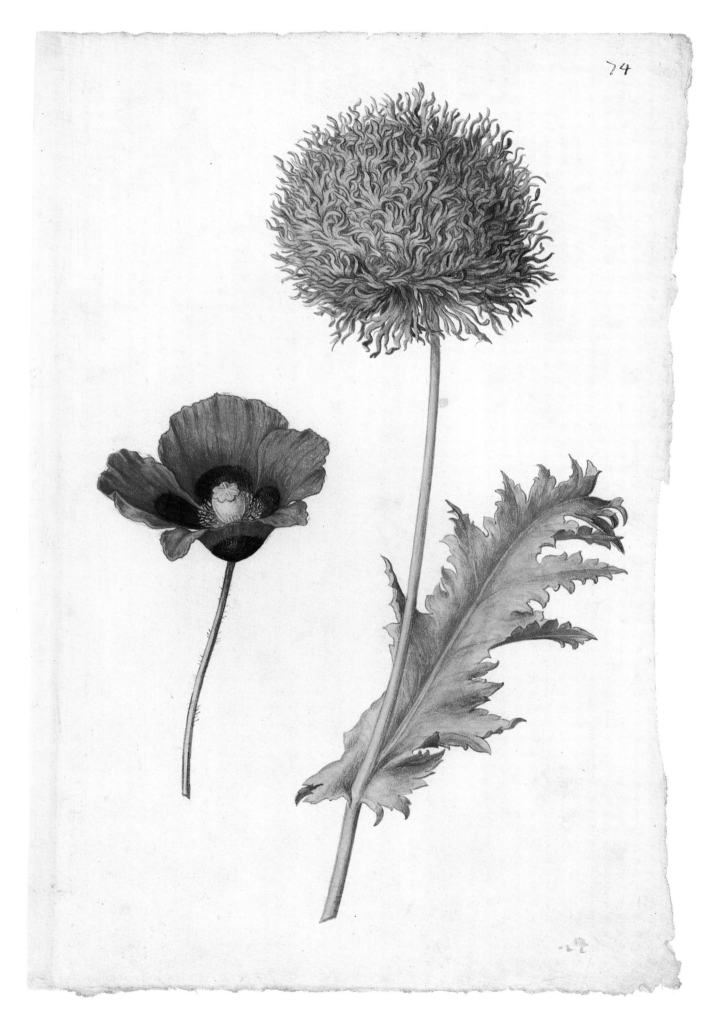

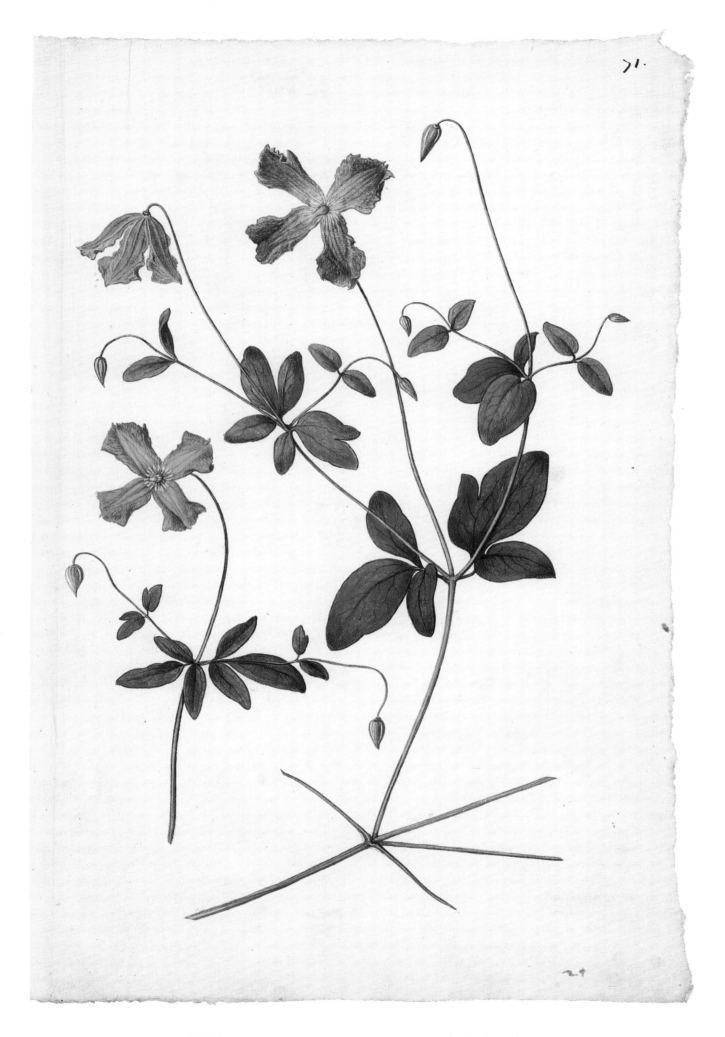

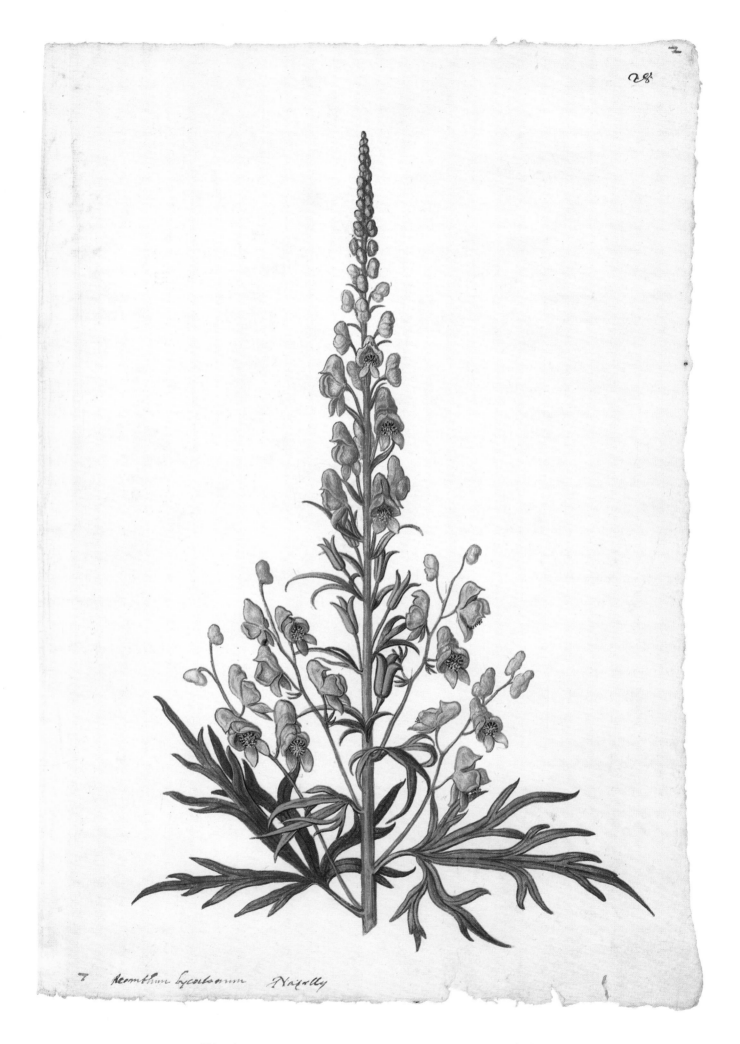

Acomthum Lycoctonum

Acomthum lycoctonum Nagelly

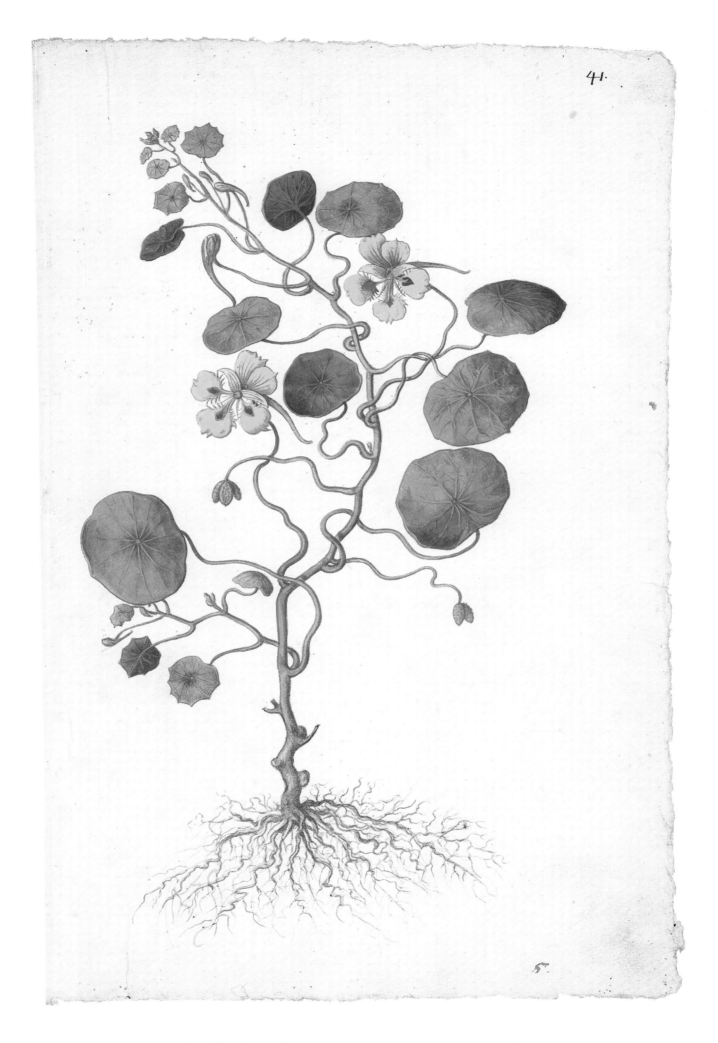

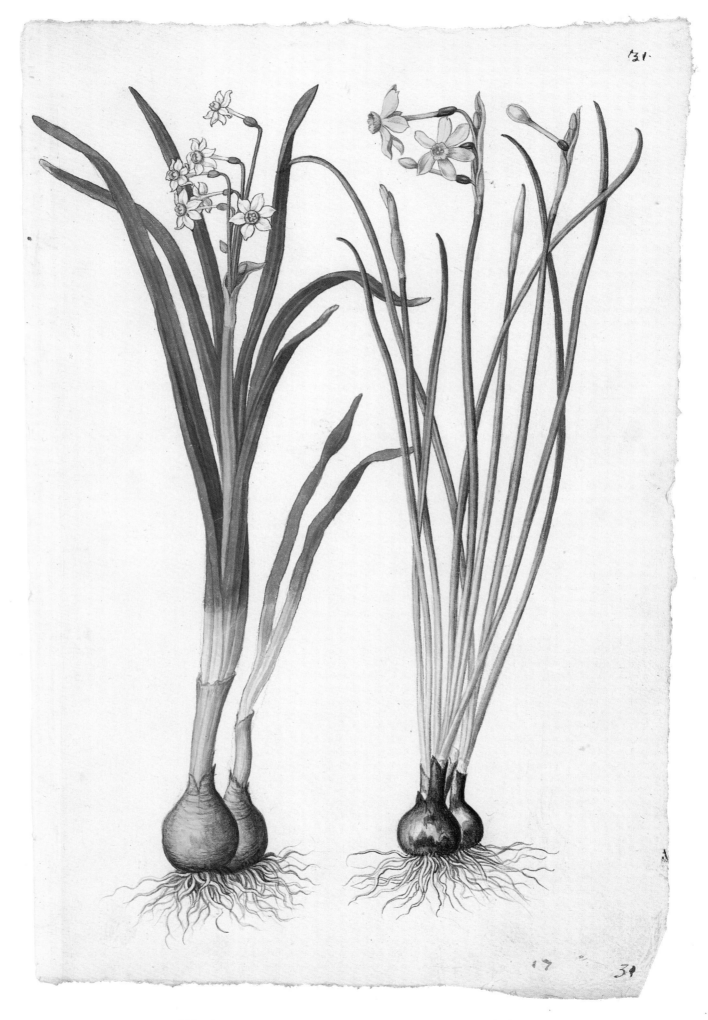

17 31

140 → FLOWERS BY ELIAS VERHULST(?)

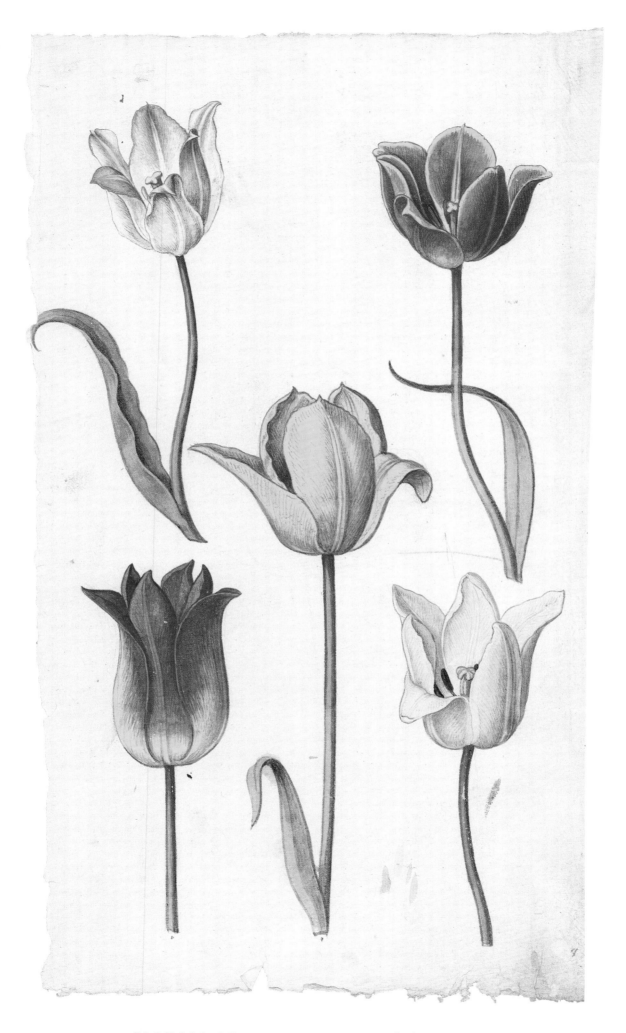

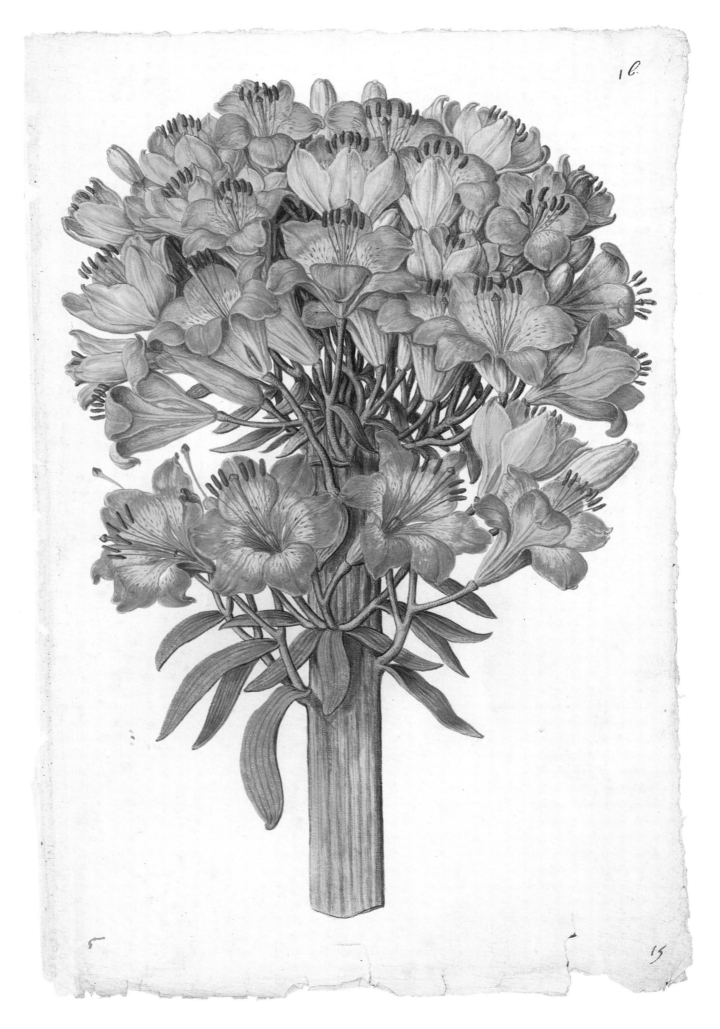

16.

5 15

SELECTED

BIBLIOGRAPHY

Arber, Agnes. *Herbals, Their Origin and Evolution: A Chapter in the History of Botany, 1470–1650.* Cambridge, England: Cambridge University Press, 1986 (1st ed., 1912).

Blunt, Wilfrid, and Sandra Raphael. *The Illustrated Herbal.* New York: Thames and Hudson, 1979.

Blunt, Wilfrid, and William T. Stearn. *The Art of Botanical Illustration.* Woodbridge, England: Antique Collectors' Club, rev. ed., 1994.

Brenninkmeyer-de Rooij, Beatrijs. *Roots of Seventeenth-century Flower Painting: Miniatures, Plant Books, Paintings.* Leiden: Primavera Pers, 1996.

Coppens, Christian, et al. *L'Empire de Flore: Histoire et Représentation des fleurs en Europe du XVIᵉ au XIXᵉ siècle.* Brussels: La Renaissance du Livre, 1996.

Leidse Universiteit 400: Stichting en eerste bloei 1575–ca. 1650. Exh. cat. Amsterdam: Rijksmuseum, 1975.

Maselis, M.-C., et al., eds. *De Albums van Anselmus de Boodt (1550–1632): Geschilderde natuurobservatie aan het Hof van Rudolf II te Praag.* Tielt: Lannoo, 1993.

de Munck, Guy, et al. *Peeter van Coudenberghe Apotheker-Botanicus (1517–1599) en Tijdgenoten.* Exh. cat. Antwerp: KAVA, 1996.

de Nave, F., et al., eds. *Botany in the Low Countries (End of the Fifteenth Century–ca. 1650).* Exh. cat. Antwerp: Plantin Moretus Museum, 1993.

Pinault, Madeleine. *The Painter as Naturalist from Dürer to Redouté,* trans. Philip Sturgess. Paris: Flammarion, 1990.

Rix, Martyn. *The Art of Botanical Illustration.* New York: Arch Cape Press, 1981.

Segal, Sam. *Flowers and Nature: Netherlandish Flower Painting of Four Centuries.* The Hague: SDU Publishers, 1990.

Whitehead, P. J. P., G. van Vliet, and W. T. Stearn. "The Clusius and Other Natural History Pictures in the Jagiellon Library, Kraków." *Archives of Natural History* 16 (1989): 15–32.

EDITOR: Eve Sinaiko
DESIGNER: Dana Sloan
RIGHTS AND REPRODUCTIONS: Lauren Boucher

LIBRARY OF CONGRESS CATALOGING-IN-PUBLICATION DATA
Swan, Claudia.
 The Clutius botanical watercolors : plants and flowers of the
 Renaissance / Claudia Swan.
 p. cm.
 Includes bibliographical references (p.) and index.
 ISBN 0–8109–4095–7 (clothbound)
 1. Botanical illustration. 2. Medicinal plants—Pictorial works. 3. Water-
color painting, Renaissance. 4. Clutius, Theodorus, 1546–1598—Natural
history collections. 5. Biblioteka Jagiellońska—Natural history
collections. I. Title.
QK98.S93 1998
580' .22'2—dc21 97–48851

Printed and bound in Italy

Harry N. Abrams, Inc.
100 Fifth Avenue
New York, N.Y. 10011
www.abramsbooks.com